Devils and Angels

For Eamonn Devereux.

Devils and Angels

Television, Ideology and the Coverage of Poverty

Eoin Devereux

The financial assistance of Radio Telefís Éireann and the College of Humanities, University of Limerick is gratefully acknowledged.

UNIVERSITY
UP *of* JL
LUTON PRESS

British Library Cataloguing in Publication Data
A catalogue record for this book is available from the British Library

ISBN: 1 86020 545 3

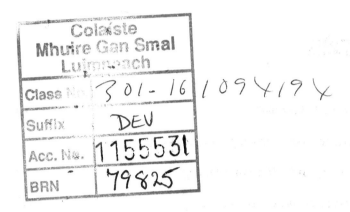
Published by
ULP/John Libbey Media
University of Luton
75 Castle Street
Luton
Bedfordshire LU1 3AJ
United Kingdom

Tel: +44 (0)1582 743297; Fax: +44 (0)1582 743298
e-mail: ulp@luton.ac.uk

Cover Design by Simon Walker
Typeset in Palatino and Helvetica
Printed in Great Britain by Redwood Books, Trowbridge.

Contents

'I'd like to drop my trousers to the Queen

Every sensible child will know

What this means

The poor and the needy

Are selfish and greedy

On her terms ...'

Acknowledgements

I would like to thank the following individuals and organisations for their help. RTÉ Television, provided the financial support and access which were crucial for the development and completion of this project as both a PhD and as a book. The financial assistance of the College of Humanities, University of Limerick is also gratefully acknowledged. In particular, I would like to thank Tony Fahy of RTÉ's Audience Research Department for his assistance from the beginning. Those who work in RTÉ and who were willing to help me with my study in the form of access and interviews deserve credit for their honesty and concern.

For their encouragement and support I would like to record my thanks to Professor Farrel Corcoran, Dr. Helena Sheehan and Professor Peter Golding. At Dublin City University I was helped along by Des McGuinness, Brian Trench and the always cheerful Pamela Galvin. Credit is also due to Professor Chris Curtin, Dr. Tony Varley and Michael D. Higgins at University College Galway who first turned me on to the study of sociology. My colleagues at the Department of Government and Society, University of Limerick proved immensely supportive and I would like to specifically thank Mary O'Donoghue, Mary B. Kelly, Brian Keary, Dr. John Logan, Dr. Padraig Lenihan, Dr. Bernadette Whelan and Dr. Patrick O'Connor.

Thanks to IMP (Ltd) for permission to reproduce lyrics from the song 'Nowhere Fast' by Morrissey and Marr.

Thanks also to Ger Fitzgerald, Sarah Moore, Michael O'Flynn, John O' Brien and Sandra Loftus all of whom have had to endure my enthusiasm for this project over the last few years.

I would like to acknowledge the support of my family and my parents in particular. My mother has taught me the value of common sense, my late father the value of being critical.

Most of all I would like to record my love and gratitude to my wife and best friend Liz Devereux and our son Joe. Liz left me alone (most of the time) to write this book and Joe, being Joe, regularly attacked the computer! Thankfully, all four of us survived!

This book is dedicated to the memory of my late father Eamonn Devereux.

1

Searching for the Irish poor

Introduction

In recent times Irish society has been characterised by record levels of unemployment, and in comparative European terms, a very high level of relative poverty. This book is concerned with a heretofore unexplored dimension of the Irish poverty question. It examines how the Irish public service broadcaster Radio Telefís Éireann (RTÉ) ideologically constructs stories about Irish poverty on its two television stations RTÉ One and Network Two. In doing so, it accepts the relative definition of poverty and assumes the media to be a powerful force in society.

The study asks whether there are a set of dominant messages about Irish poverty evident in factual, fictional and fund-raising television. In identifying the dominant themes of RTÉ's television coverage of poverty, the study opts for a research model which amalgamates a qualitative analysis of poverty texts with an attempt to understand the organisational and production contexts from which those texts emerge. Methodologically, therefore, it adopts an approach which combines a critical content analysis of a range of television programmes and a series of ethnographic accounts of their production.

The genesis of this book lies partly in my own experiences as a researcher with RTÉ. In 1990 after graduation from university, I worked for a number of months as a researcher with *The Pat Kenny Show*, then a mid-morning current affairs radio programme on the Irish national radio service RTÉ Radio One. Filled with a mixture of excitement and apprehension, I began my work with this popular radio show, writing and researching programme items. For me, it was to be an important experience in terms of not only working with a prominent radio programme, but also in terms of learning about the factors which influence the production of radio stories.

I had come to the programme with a great deal of experience in working on local radio, but also as a person with a large number of contacts in the world of social research. As a researcher, it was my task to suggest ideas for the programme at production meetings. Given my links with those

involved in undertaking research into poverty, I had occasion to suggest items relating to poverty, the Travelling community, homelessness and unemployment. Although I did have some success in getting coverage for particular poverty stories, such as the alleged ill-treatment of women in a refuge for battered wives, I experienced frustration in gaining the interest of the programme makers in poverty issues. Stories might be turned down because of a perceived lack of interest which the audience might have in such items, or the fact that another current affairs programme might have recently covered a poverty issue.

More often than not, stories would be rejected because it was felt that there was nothing 'new' in them. After working on this programme, I returned to the academic world to teach sociology. The relatively short experience which I had in the world of national broadcasting was, however, to leave an indelible mark on my thinking on how the media works. As part of a series of courses which I began to give at the University of Limerick on the sociology of media, I started to think about the ways in which the media treat of the phenomenon of poverty.

I was intrigued by, as I saw it, two interconnected issues. It was apparent to me that there was quite a gap between the reported extent of poverty and unemployment in Irish society, and the extent to which these issues were visible in the media. In addition, I was curious about the make-up of the small number of stories which did actually make it on to the airwaves. In the context of the general invisibility of poverty, what had influenced their selection by broadcasters and what did the stories tell us, if anything, about the attitudes of those in television towards poverty?

As somebody from a working class family who had made the leap into third level education, I was personally aware of the invisibility of the lives of my family, friends and neighbours, not only in school and university text books, but also in the mainstream media. I began to question why the poverty experienced by the people living in the housing estates, with which I was familiar, was not newsworthy or of particular interest to the media, save perhaps when they engaged in moral panics about violence, drug abuse or robberies. The struggle to survive, to make ends meet, amongst the people with which I was readily familiar, was to my mind all but invisible in the newspapers that I read and the television programmes that I viewed. If and when the working class – or with increasing frequency the underclass – came within the gaze of the television camera, typically the focus was on the symptoms of marginalisation such as welfare fraud or petty crime and not on poverty itself.

My experience as a researcher within RTÉ convinced me that I should attempt to combine a critique of the dominant television images of poverty, with an appreciation of the factors which shaped their production. RTÉ, to their credit, agreed to fund the study upon which this book is based, as part of their PhD Fellowship Scheme for the period 1991–1995. The decision by RTÉ to support the project was not only important to me in finan-

cial terms, but it also meant that many otherwise closed doors in the organ-isation were opened, to allow me to probe the production context of the programmes I was interested in investigating. The station's representatives were keen on me exploring poverty coverage on both its television and radio networks. However, after some deliberation and a two-month pilot study, I decided to concentrate on television news, current affairs, drama and Telethon programmes.

In doing so, I was interested in three basic though important questions. I wanted to establish whether or not there were dominant messages about Irish poverty across the range of factual, fictional and fund-raising television programmes, which I had selected for analysis. I also wanted to establish if RTÉ's poverty coverage differentiated between categories of deserving and undeserving poor. In addition, I wanted to explore the extent to which the organisational environment in which the poverty stories were made, shaped their actual content. In essence, I was concerned about the extent to which RTÉ's coverage of poverty could be considered to be ideological.

In using the term ideology in this study I am following closely on the work of Thompson who in revising the term, argued that ideology meant 'mean-ing in the service of power' (1990:6). Thompson's definition of ideology is concerned with explaining how ideas contribute to the maintenance of a social order based upon inherent inequality. O'Shaughnessy similarly explained ideology and hegemony by asserting that:

> Both of these concepts [ideology and hegemony] are used as a way of understanding how the dominant groups of any society maintain and retain their power over subordinate groups [women, ethnic minorities, the working class and so on]. Whereas earlier Marxist theories stressed the economic and material conditions of life as crucial determining factors, these concepts stress the importance of the way people think and feel – their common-sense consciousness or ideology – for maintaining the power and hegemony of the dominant groups and obtaining the consent of the people in their own subordination. This con-sciousness can be understood as the ways in which we 'make sense' of the world, giving some kind of coherence to the society around us. (1990:89)

According to Gitlin (1980) the media can be viewed as important forms of cultural reproduction which function to both disseminate ideology (usu-ally though not exclusively of the ruling classes) and allow the continua-tion of the existing social order. Ideology can also be hegemonic in that it allows the ruling classes to remain powerful through the moulding of pop-ular consent. An examination of media portrayal of poverty is, as this book demonstrates, an important test of the media's ideological role. It allows us to see whether the media contribute to the reproduction of a social order where poverty and unemployment are seen as endemic, or whether it chal-lenges the status quo, even in a limited way.

3

The deserving and undeserving poor

The approach taken in this book owes a debt to four previous studies of media representation of poverty in both the developed and Third World. These studies have adopted critical/Marxist, semiotic, discourse and frame analysis approaches in attempting to gain a more critical understanding of the media's role in explaining poverty. Broadly speaking, they concur with the assertions made in this book that poverty coverage (or the lack of it) should be considered primarily in terms of its ideological importance. Of interest also in these studies is how the media manage to construct categories of deserving and undeserving poor, as well as its ability to fashion special heroic roles for the comfortable. By limiting the scope of coverage of poverty in this way, the media play a significant role in reproducing relations of power which are unequal.

Golding and Middleton's *Making Claims: News Media and the Welfare State* (1979) examined how the media construct poverty stories in some detail. During their six-month study, Golding and Middleton found that welfare issues as such did not make the news. Significantly, welfare was only considered worthy of coverage when it was connected with other areas such as crime, fraud or sex. A central theme of media coverage of welfare abuse was that of the deserving and undeserving poor. Golding and Middleton argued that within this there are two further sub themes, namely:

> The fear that the welfare umbrella has been extended over too wide a range of clients, at greater social and economic cost, and related to this is the notion that we no longer can adequately sustain the distinction between, on the one hand, those groups whose poverty is due either to membership of a deprived group, the old or sick, or blameless individual's inadequacy, physical or mental handicap for example, and on the other hand those whose poverty is the result of individual anti-social behaviour; laziness, profligacy, irresponsible family planning and so on. The deserving poor are no longer held to manageable limits. (1979:12)

Golding and Middleton continued with this theme in their work *Images of Welfare* (1982). The study traced the persistence of bipolar attitudes to poverty in 19th and 20th Century Britain. Despite social and political changes, and more particularly in the context of the rise and decline of the welfare state, the belief that the poor may be divided into the categories of 'deserving' and 'undeserving' or as Golding and Middleton put it, into 'God's poor' and the 'Devil's poor' has persisted.

The authors contended that the media has played no small part in reproducing hegemonic explanations of poverty. Through engaging in a series of moral panics about welfare issues, the media succeeded in victimising certain portions of the poor. In the final analysis, this kind of media activity allowed for an even greater reduction in state welfare activities.

In his study *Media Discourse on Famine in the Horn of Africa*, Sorenson (1991) adopted a discourse analysis approach. In examining both the activities of media organisations and the stories they produced about the Third World, Sorenson argued, that taken collectively, these discourses could be read as ideological texts. Sorenson noted that despite the availability of film footage and details of famine, there was no take up of offers by the media to give the story airtime. He quoted an unnamed journalist as saying 'the Third World isn't news and starving Africans in particular are not news.' (1991:224) Sorenson argued that during the 1980s African famine, the story was largely kept off the agenda as it had a low entertainment value. Coverage was only given when a crisis point was reached in the famine. A key process, he argued '... in the discursive construction of famine in the Horn (of Africa) is that of aestheticisation, the packaging of famine as a shocking and dramatic crisis'. (1991:225)

Thus famine, itself a relatively permanent feature of many African countries, was not in itself deemed to be newsworthy and might only be covered through a discourse of impending or actual crisis.

Another key element of the media's discourse on African famine was the emphasis on Ethiopia as opposed to other stricken areas (owing perhaps in no small measure to the presence of the world media – albeit belatedly – in Ethiopia in 1984). The 'naturalisation' dimension to the coverage was also stressed – coverage tended to stress the notion that famine was as a result of natural causes as opposed to man-made causes. Sorenson's main assertion was that famine coverage by the media represented an ideological parable:

> Analysis reveals imposition of a narrative structure through the use of standard rhetorical techniques to construct famine as an ideological parable. This parable demonstrates the abuse of Western charity by treacherous Third World regimes allied with the Soviet Union. Media reports are related to other discursive constructions of Africa which offer a similar narrative structure. (1991:223)

Sorenson drew upon an analysis of *Newsweek* dated 26 November 1984 to illustrate this point. He argued that the discourse of this edition 'reveals a mythologizing of famine and the imposition of a narrative structure which serves to emphasise the culpability of Africans'. (1991:227) Africans were portrayed as being either incompetent or greedy with the West being portrayed as a kind and generous benefactor. Drawing on the work of Barthes (1973), Sorenson saw this media activity as a form of inoculation. In engaging in this kind of practice the media admitted the occurrence of 'accidental evil' (poverty and famine) and yet functioned to conceal the wider structural inequalities which have caused Third World poverty and famine. Thus the locus of blame rested with the Africans, especially the peasant farmers who were portrayed as being backward and incompetent. This coverage was in turn loaded with assumptions about the 'primitivism' of our African opposites or 'others'.

Benthall's *Disasters, Relief and The Media* (1992) examined media images of disaster and disaster relief. Relief agencies as well as the print and broadcast media used and abused children as a potent source of imagery.

Benthall divided his analysis of the symbolism of disaster relief into the pre and post 1980s. He argued that in the pre 1980 period, the imagery tended to be of a patronising sort 'Virtually all appeals for charity until the 1980s tended to picture helpless passive victims and heroic saviours'. (1992:177)

These campaigns involved using both realistic photographic styles and the flagrant abuse of starving children. In the post 1980s period, Benthall stated that his semiotic reading of the dominant imagery revealed that 'we' portray colonised peoples in the same way as men portray women. This portrayal exhibited an anxiety about our expendibility and the fear of forces which are beyond our control. Thus the West views Third World poverty as a threat because of the perceived implications that it may have for British and American society in terms of mass migration. Benthall's semiotic analysis also revealed that we in the West both exaggerate and misunderstand Third World poverty. He found that essential questions in the equation such as colonialism and capitalism were absent from how we explain the Third World at a visual and symbolic level.

This important study went further by drawing on the work of Propp (1928) in attempting to see these images collectively as a form of folk narrative. Thus images and stories about the Third World were seen to function as part of a total narrative convention. Stories and images had heroes (from the First World, usually white and middle class, often already well known in another role as actress, politician or popstar); villains (often portrayed as greedy dictators, or tyrannical Marxists); donors (who were given magical powers); and false heroes (such as fund-raisers who made off with the proceeds of a collection for the poor or starving).

But the practice of framing stories about the poor which serve the interests of the status quo through individualising their stories is not restricted to media coverage of the Third World. Drawing on the work of Gamson and Modligani (1987), Iyengar (1991) in his work *Is Anyone Responsible? How Television Frames Political Issues* subjected US media coverage of domestic poverty to a frame analysis. The study involved carrying out a series of experiments into how network television framed issues about poverty, unemployment and racial inequality. Iyengar's results demonstrated that framing took place in terms of attributions of responsibility for poverty and inequality. He analysed network news to see did it frame poverty, unemployment and racial inequality in terms of either 'thematic' or 'episodic' frames.[1]

1 According to Iyengar (1991) *episodic* news frames take the form of a case study or event-oriented report and portray public issues in terms of concrete instances. *Thematic* news frames place public issues such as poverty in a more general or abstract context which is aimed at more general outcomes or conditions.

In general, he found that US network news was not too concerned about poverty or racial inequality as news stories. Of the coverage of poverty and racial inequality that did take place, 66 per cent of stories were deemed to be episodic. Iyengar concluded that audiences were twice as likely to encounter a story that was episodic than they were to encounter one which was thematic. Unemployment coverage was predominantly thematic. He attributed these findings to the fact that while unemployment was recorded on a monthly basis and regularly the subject of government announcements, poverty received much less attention because governments measure and report on it infrequently.

Iyengar proceeded to carry out a number of experiments using five news reports which used either episodic or thematic frames. His study groups were asked upon viewing the reports to talk about whether poverty was as a result of societal or individual responsibility. The study found that news stories from network television were significant in terms of people's attribution of responsibility for poverty or racial inequality. Framing of an episodic nature increased the chances of audiences locating the responsibility in the hands of the individual, while thematic framing increased the likelihood of audiences viewing the responsibility for the problems in societal terms.

An overview of the study

The remainder of this study is organised as follows. Chapter Two argues for the retention of an approach which is concerned with examining the ideological make-up of media messages about poverty. Chapters Three to Six provide the reader with an analysis of Telethon, television drama, current affairs and news programmes. They take as case material coverage of poverty on RTÉ's *People in Need Telethon*, the *Tuesday File* current affairs series, *Six-One News* and the station's rural soap opera *Glenroe*. Each of these four chapters consider the respective programmes in terms of their history, production context, the content of their poverty coverage, as well as a consideration of the ideology of that coverage.

The study's final chapter deliberates on the ideologies in evidence within RTÉ's television coverage of poverty. In the light of the study's main findings, Chapter Seven also considers their implications in terms of the wider theoretical debate about the continued usefulness of the concept of ideology within media and communication studies. The book's main appendix describes the methodological model used in this study. It is unashamedly qualitative, drawing upon a critical content analysis and a series of ethnographic accounts of the production of the four selected programme areas. The approach taken in this study views the combination of production research and critical content analysis as an essential prerequisite to any future work which might want to explore the views of audience members in terms of media coverage of poverty.

2

Ideology and dominant ideology

Introduction

In this chapter I look more closely at the concept of ideology. First, I briefly trace the history of the concept noting its key turns within the Marxist tradition. Secondly, while acknowledging that the concept of ideology is not without its difficulties, I call for its retention, and, following Thompson (1990) I opt to use a definition of ideology which is concerned with how ideas are used to sustain relations of power and domination. Thirdly, I examine the arguments both against and for the continued use of the concept and I comment specifically on the applicability of the concept towards analysing the media.

The career of a concept

The term ideology has had a long and chequered career ranging from its initial conception as a science of ideas, to being a central concept within classical and contemporary Marxist social theory.[1] Notwithstanding the recent attacks on the concept from post-structuralism and specifically the doubts raised by some researchers engaged in reception analysis, this sometimes ambiguous term has been used variously to connote a science of ideas, a pejorative term of abuse, or as a system of ideas which facilitates domination. In some of its guises it has also been taken to imply a type of false consciousness. In using the term ideology I take it to mean the ideas which legitimise the power of a dominant social group or class.

The classic and essentially undeveloped materialist conception of ideology argued that the ruling classes in capitalist society controlled not only the means of material production but also controlled the production of ideas. Domination and control over the working class was achieved through not

1 See Eagleton (1991: 1-2) who listed 16 different aspects to this multifaceted concept as well as offering 6 definitions of the term ideology.

only a specific type of ownership and control of wage labour but was also facilitated by ideas which either masked the true exploitative nature of capitalism or presented these kinds of economic relationships as being natural and inevitable. Later versions of Marxism allowed for the relative autonomy of the media and the existence of a dominant as well as other types of ideology.

The Frankfurt School, Althusser and Gramsci

The concept was developed further by the Frankfurt School, Althusser and Gramsci. The Frankfurt School retained much of the overly deterministic conception of ideology which was to be found within traditional Marxism. In attempting to explain how, in their eyes, history had somehow gone wrong – capitalism had persisted and two world wars had brought about massive destruction of human life – the Frankfurt School turned their attention on the ever growing 'mass' media. They argued that capitalist control of the media was the main reason why capitalism had survived and flourished in the post-war period. Marcuse (1964) asserted that the media had helped to '… indoctrinate and manipulate, they promote a false consciousness which is immune against its falsehood'. (cited in Dutton 1986: 35)

The Frankfurt School largely replicated the deterministic conception of ideology which had been a feature of Marx's thinking. Both saw a direct relationship between the economic base and dominant ideas of capitalist society. For obvious historical reasons the Frankfurt School's conception of ideology was far more mediacentric than the earlier account of ideology as outlined by Marx. Both Marx and the Frankfurt School used an essentially negative conception of ideology which implied that those on the receiving end of capitalist ideology passively accepted the ideas presented to them.

The later projects undertaken by Althusser and Gramsci represented a fundamental shift in thinking within the Marxist tradition about ideology. Althusser wished to explain how the media gave its audience ideological meaning. He asked how the media assisted in the production of an 'imaginary picture' of the 'real conditions of capitalist production for the subject – ie the audience, thus concealing the reality of exploitation'. (cited in Dutton 1986:35)

In doing so Althusser introduced the notion of *Ideological State Apparatus*. According to Althusser, institutions such as the educational system, church or the media reproduced ideology in such a way as to represent capitalism as being natural, inevitable and indeed desirable. At an extreme level we can think of how American television presented the state socialism of the former USSR as being backward and incompetent during the Cold War in contrast to the successes of individualism and capitalism in American society. But in other less obvious ways if we follow Althusser's reasoning, we can see how the media present particular lifestyles as being more legitimate than others thus contributing to the reproduction of a particular ideology.

Built into Althusser's conceptualisation of ideological reproduction was the notion of relative autonomy. To facilitate domination on an ongoing basis he argued that the media must be seen by the audience to be relatively autonomous from the direct control of the ruling class in capitalist society. In practical terms this might best be exemplified by the notion of journalistic neutrality or the requirements within current affairs broadcasting to present two sides of an argument. Thus, in the case of current affairs television for example, a programme manages to appear neutral by questioning both those in power and those in opposition, while at the same time legitimising the customs and practices (and ultimately the ideology) of liberal democracies. Althusser's concept of relative autonomy allowed space for occasional dissenting views to be heard, but the dominant ideas which facilitated the continuation of the capitalist order, according to his thinking, held sway.

Gramsci's key contribution to the debate about ideology was in his development of the concept of hegemony. According to Gramsci ideological domination in capitalist society was achieved through the moulding of popular consent. The capitalist system managed to continue through the use of ideologies which facilitated the creation of a consensus between exploiters and exploited. In Gramsci's view the media reproduced a 'common-sense' view of the world which represented capitalism as natural and inevitable. This common-sense viewpoint was essentially an ideological perspective which functioned to maintain an asymmetrical relationship of domination between the powerful and powerless. According to Boggs, in Gramsci's theory of ideological hegemony, the media were the mechanisms that the ruling class used to 'perpetuate their power wealth and status [by popularising] their own philosophy, culture and morality'. (1977: 276)

Gramsci however accepted the idea that the media appeared relatively autonomous *vis-à-vis* the owners of capital, yet, they nevertheless were heavily involved in the production and reproduction of ideology which functioned to maintain capitalism.' Gramsci saw the production and reproduction of ideology as being ongoing. He held that the dominant class in capitalist society could not be sure of hegemonic order. Hegemony had to be constantly negotiated and renegotiated within the capitalist system to ensure its continuation.

Lull (1995) noted that Gramsci's theory of hegemony connected ideological representation to culture. Hegemony required that ideology translated into 'obvious' cultural assumptions. In Williams' words, hegemony necessitated the dominated to accept the dominant ideology as 'normal reality or common-sense … in active forms of experience and consciousness'. (1976: 145)

In the light of these theoretical developments within the Marxist tradition an attempt was made by researchers most notably at the *Centre For Contemporary Cultural Studies* and by the *Glasgow University Media Group* to operationalise these neo-Marxist understandings of ideology. Taken

11

collectively, their work found that the media reproduced a world view which was profoundly ideological. It argued that media representation managed to mask the social structure. Both research groups accepted the Althusserian notion of relative autonomy but believed that a careful content analysis of media messages could reveal clear ideological patterns.

The work acknowledged that oppositional views could occasionally be heard in the media. But while alternative ideologies existed, they were given less media attention or indeed framed in such a way as to ensure that audiences would not take them seriously. Thus, somebody advocating an alternative vision of society might be portrayed as a crank or as an eccentric. Ideas which were found to be supportive of the status quo were amplified and emphasised. Hegemony was achieved through constructing preferred meanings for the audience.

This research work represented an important move towards a concern with the concept of a dominant ideology as opposed to ideology *per se*. As Dutton (1986) pointed out, this shift meant that the use of the term dominant ideology allowed for the acknowledgement of alternative ideologies such as feminism or socialism and indeed allowed for media content which was opposed to the dominant ideology. The notion of relative autonomy from the ruling class interest in capitalist society also threw a question mark over the extent to which the media slavishly reproduced the dominant social order.

Dominant ideology

In the face of theoretical developments most notably within the field of poststructuralism and in the more general context of the key changes – such as the collapse of communism – which took place on the world's political stage during the 1980s and 1990s, the concept of ideology began to lose favour with many. However many thinkers leapt to its defence. (See Dahlgren, 1987, 1992; Eagleton, 1991; Giddens, 1979; Zizek 1994)

Thompson's important work *Ideology and Modern Culture* (1990) represented a stout rebuttal of those who were keen to rid the world of theory and politics of the concept of ideology. He was critical of the overly deterministic nature of earlier accounts of ideology as posited by Marx, Marcuse and Althusser. He acknowledged the problematic nature of the concept referring specifically to both its ambiguity and its pejorative uses. In the face of these difficulties Thompson argued that there have been two kinds of responses by theorists to the concept of ideology. In the context of the alleged decline of Marxism many thinkers have hastily dispensed with the concept altogether.[2] Others have preferred to, as Thompson put it, 'to try and tame the concept' by using a neutralised definition of ideology where ideology simply refers to a system of ideas or thought. (See for example Lull, 1995: 6-11)

2 See for example Frazer's (1992) study 'Teenage Girls Reading *Jackie*' who rejected the concept of ideology owing to its determinism and its implied false consciousness.

In surveying the career of the concept Thompson argued that there were essentially two types of conception of ideology which he characterised as neutral and critical. For Thompson neutral conceptions of ideology:

> ... are those which purport to characterise phenomena as ideology or ideological without implying that these phenomena are necessarily misleading, illusory or aligned with the interests of any particular group. Ideology, according to the neutral conceptions, is one aspect of social life (or form of social inquiry) among others, and is not more nor any less attractive than any other. (1990:53)

Conversely, critical conceptions of ideology:

> ... are those which convey a negative, critical or pejorative sense. Unlike neutral conceptions, critical conceptions imply that the phenomena characterised as ideology or ideological are misleading, illusory or one-sided; and the very characterisation of phenomena as ideology carries with it an implicit criticism of them. (1990: 54)

Thompson called for the retention of the term ideology and more specifically that it should be used in its negative or critical sense. He argued that our thinking about ideology should be refocused on the interrelations of meaning and power and more specifically on how meaning serves to maintain relations of domination. According to Thompson:

> ... the concept of ideology can be used to refer to the ways in which meaning serves, in particular circumstances, to establish and sustain relations of power which are systematically asymmetrical – what I shall call 'relations of domination'. Ideology, broadly speaking, is *meaning in the service of power*. Hence the study of ideology requires us to investigate the ways in which meaning is constructed and conveyed by symbolic forms of various kinds, from everyday linguistic utterances to complex images and texts; it requires us to investigate the social contexts within which symbolic forms are employed and deployed; it calls upon us to ask whether, and if so how, the meaning constructed and conveyed by symbolic forms serves, in specific contexts, to establish and sustain relations of domination. (1990:6-7)

Thompson's defence of the concept of ideology was an important one in that it reasserted the relevance of the concept in the examination of how meaning functions to support relations of domination. The interpretation and use of the concept in this sense meant that we should analyse the meaning of symbolic phenomena in a socio-historical context and more specifically in terms of how they function to sustain relations of domination.

Thompson's version of ideology with its particular focus on dominant ideology carried with it three important inferences which are worth noting.

The first is that by implication ideologies other than dominant ideologies exist. There are in existence at any one time oppositional ideologies which are critical of the status quo, feminism and Marxism being just two examples within contemporary capitalist society. Equally, alternative ideologies exist in what remain of the state socialist societies.

Secondly, Thompson's definition of ideology maintained that not all symbolic phenomena could be adjudged to be ideological. They are only ideological in the sense that they contribute to the maintenance of domination by one class group over another. Thus, if I place an advert selling my dog in a local newspaper it is simply an advert. If, on the other hand, my local newspaper reports in an affirmative way on the Princess Royal's visit to the homeless in my city it can be adjudged to be engaging in the production of ideology. The unequal positions of the princess and the homeless are reaffirmed, and the belief that charity is the appropriate response and not radical social change is underscored.

Thirdly, in the face of the debate over whether ideology represented a form of false consciousness or as Marx termed it a 'camera obscura' – Thompson argued that it was not a prerequisite that ideology should somehow falsify the nature of social relations.[3] He argued:

> It is not essential for symbolic forms to be erroneous or illusory in order for them to be ideological. They *may* be erroneous or illusory, indeed in some cases ideology *may* operate by concealing or masking social relations, by obscuring or misrepresenting situations; but these are contingent possibilities, not necessary characteristics of ideology as such. (1990: 56)

Thompson's useful corrective measure in redefining ideology in this sense removed the necessity of proving that ideological phenomena when characterised as ideological should also be as a matter of course be shown to be false or illusory. It did not however rule out the possibility that falsification took place. Such an activity was deemed to be secondary to the main task in hand which was to show how symbolic forms managed to establish and maintain relations of domination.

Thompson's definition of ideology was derived from Marx's latent conception of the term. He has attempted in his work to offer a revised definition of ideology which maintained one important link with earlier critical or negative accounts of ideology in that it was focused on how relations of domination were established and sustained.

3 See Eagleton (1991) for an alternative view. He asserted that the concept of ideology has followed two paths, the first stressed the question of truth versus falsity where ideology was seen to distort and mystify social relations, the second has adopted a more neutral stance by focusing on the role of ideas in social life rather than their respective truth or falsity. Eagleton maintained that the Marxist tradition has followed both routes and both approaches remain relevant in the analysis of ideology.

The operation of ideology — *Thompson*

In attempting to operationalise his revised definition of ideology Thompson asserted that there were five general ways in which it could function. These he characterised as legitimation, dissimulation, unification, fragmentation and reification.

Following Weber, Thompson believed that asymmetrical relations of domination could be created and maintained through being represented as legitimate. A hierarchical social structure might be presented as being just and worthy of support. He suggested that one way in which legitimation took place was through the process of universalisation. Through universalisation, a social structure based on inherent inequality of a class kind, was to Thompson's thinking, represented as meeting the interests of everybody and in principle the benefits which might accrue from rising through the ranks of the social structure through social mobility were open to all. A capitalist society like Ireland therefore may reproduce itself through ensuring that its citizens believe that the social and economic system, despite its evident inequalities, is legitimate, is in the interests of all concerned and indeed is open to anybody (assuming ability and interest) who wishes to succeed.

Relations of domination could also be established and sustained through what Thompson termed dissimulation. By this he meant that relations of domination were hidden, denied or obscured. Alternatively dissimulation could take place through forms of representation which either deflected attention away from relations of inequality or simply glossed over these processes. Through the process of dissimulation the issues of power and inequality are masked. Thus, asymmetrical class relations may be presented in a news report about charity as being simply human relations between the wealthy and the poor. Poverty might for example be explained by reference to the individual failings of the poor without any reference to the structural context in which that poverty is taking place or indeed go without any mention at all.

According to Thompson a further way in which relations of domination could be achieved was through unification. He argued that asymmetrical relations could be established and sustained through creating at a symbolic level a unifying ideology which welded individuals together into a collective identity. Such an identity could be used to supersede any individual or class differences that might exist in the collectivity. Perhaps nationalism is the best example of this. A ruling class might mobilise nationalist fervour in order to achieve a specific aim such as 'reclaiming' the Falkland Islands, bombing Russia, defeating the IRA, or engaging in attacks on the Sandinistas. This in turn may unify the various class groups involved and also function to detract attention away from the unequal nature of the relationship between the rulers and ruled.

Conversely, fragmentation may also be used to support a system which is based upon relations of domination. Thompson held that in certain cir-

cumstances asymmetrical relations could be maintained through dividing individuals and groups who might challenge the status quo. Additionally, the powerful may retain their power through redirecting the energies of those who might otherwise challenge the status quo at a real or imaginary enemy. Ideological domination could be achieved and maintained by a colonial power for example by promoting divisiveness amongst different ethnic groups who make up the colonised. Equally, it might be generated by an imperial power at home who foster feelings of enmity between the underclass and immigrants often around questions of work, housing or social welfare. Dominant ideology itself may be of a fragmented nature with various powerful interest groups vying with each other for overall supremacy and thus in turn its composite nature may give rise to the view that because of competing interests that there is in fact no dominant ideology.

Thompson's final *modus operandi* of ideology was the concept of reification. He argued that relations of domination could be created and sustained through representing these relations as if they were ahistorical and uninfluenced by time and space. The social structure and particular modes of production were portrayed as being 'natural'. He asserted:

> Ideology *qua* reification thus involves the elimination or obfuscation of the social and historical character of social-historical phenomena – or, to borrow a suggestive phrase from Claude Lefort, it involves the re-establishment of the dimension of society 'without history' at the very heart of society. (1990: 65)

Thompson suggested that reification could operate in two principle ways. Through a process of naturalisation a social or historical phenomenon such as the class structure was viewed as a natural event or as the inevitable outcome of natural characteristics. In addition, through the process of eternalisation, social-historical phenomena were defined as being ahistorical and portrayed as permanent features of human experience.

Thus, the social structure of capitalist societies is constructed as being a natural occurrence. The essential reason for its existence namely specific modes of production with a definite history are either conveniently ignored or presented as natural events. Other notions underpin this reification such as the idea that man is naturally competitive or that there always have been winners and losers in human society. Various ideas are mobilised to present an unequal system as being inevitable and natural. Parallels are struck with the hierarchies evident in the animal kingdom, stories are told about the 'fact' that societies based on a more egalitarian or collectivist ethos simply do not work because it is unnatural for them to do so. The idea that 'It has always been so' is stressed in the face of those who dare to suggest alternative possibilities.

Thompson's attempt to show how ideology functions to secure asymmetrical social relations represented an important development within the

contemporary debate about ideology. Prior to dealing with some of the more salient issues which have arisen in terms of the relative usefulness of the concept I wish to make one further remark about his account of ideology.

If we accept Thompson's corrective measures in explaining ideology then we accept that the production and reproduction of ideology is an active process in which both the ruling class and their subordinates participate. It is not, as earlier and more simplistic accounts of ideology would have it, a one way process whereby ideology just percolates downwards from the ruling class via their media and other state apparatuses. Both the dominant social class and their subordinates participate in the production and reproduction of ideology. It is not only the ruling class who engage in perpetuating the myth of society's classnessness. Consider the level of interest amongst the working class in the real life soap opera which is the British Royal Family. Political parties of a conservative nature are re-elected by those who benefit least from their re-election. The dominant ideology which welds an unequal society together may be evident in the beliefs of the subordinated – such as, 'if you work hard you get on' – and indeed their acceptance and reproduction of those beliefs may play an important part in the circulation of dominant ideology and the ultimate continuance of an unequal social order. That is not to say that the subordinated do not have the capacity to reject particular ideologies or indeed construct alternative ones.

Defending a contested concept

The concept of ideology has been under attack from several fronts. As noted earlier, theoretical and political developments fuelled speculation that the end of ideology was nigh. The findings emerging from communications research which focused on audience reception of messages also began to raise doubts about the usefulness of the concept. Ironically, at a time of the resurgence of the right, increasing privatisation and in the re-emergence of fundamentalism – both Islamic and Christian – there were those who argued that ideology was a concept bedevilled by many problems and who argued against its continued use. Despite the difficulties which may have dogged ideology in the past, it remains an important concept within social theory and within media analysis specifically.

At a theoretical level the concept of ideology has been under siege for a long time. (See Thompson, 1978) Critics of the term argued that typically it was applied in a pejorative way by followers of Marx who were blind to their own ideological position. Ideology, like beauty, according to this viewpoint was in the eye of the beholder. Fortunately, this argument may also be turned around against those who have condemned the concept of ideology to redundancy. It has been accused by some as being an ideological statement in itself which may be shown to assist in the maintenance of a dominant social order. (see Giddens, 1979) Just because it may be argued

that earlier theorists adopted a simplistic or short-sighted definition of ideology is no reason to reject the concept outright.

Opponents of the concept have also pointed to what they saw as the ambiguity of ideology arguing that because of its ambiguity and elusiveness that the term should be rejected. The charge that ideology is an ambiguous term or that it has in itself ambiguous qualities should not detract from its importance. Indeed, its ambiguity may in fact be a strengthening feature which helps ensure that it can go undetected. According to Zizek critics of the concept held that the 'critique of ideology involve a privileged place, somehow exempted from the turmoils of social life, which enables the subject-agent to perceive the very hidden mechanism that regulates social visibility and non-visibility'. (1994:3)

Frazer (1992) put it perhaps more baldly in accusing media theorists of committing the fallacy of simplistically inferring the ideological meaning of media texts and by implication their effect on audiences but not on themselves!

In response to recent criticism of the term ideology Thompson has accused those who are opposed to the continued use of the concept as being short-sighted. He argued that the critics of ideology had failed to examine closely whether or not there was, despite many problems, anything worth salvaging in the concept. He stated that the typical response of those who were opposed to the concept of ideology was:

> ... to abandon, or more commonly refuse to begin the search. Rather than asking whether the tradition of reflection associated with the concept of ideology has highlighted a range of problems with misleading and untenable assumptions, this response chooses to drop the question or, more frequently, presumes an answer while avoiding the intellectual labour in trying to determine it. (1990:6)

Eagleton (1991) summarised the grounds upon which the dominant ideology thesis could be questioned. In the first instance opponents of the concept of ideology argued that there was in existence no coherent dominant ideology. What existed were many competing ideologies. A second position held that even if a dominant ideology were shown to exist, that it was not as effective in moulding people's thinking and experience as was thought by proponents of the concept. A third strand in this line of thought argued that in late or advanced capitalism, society's members were kept in place more through economic pressures such as the threat of unemployment or poverty than through ideology. It suggested that the capitalist system maintained itself '... less through the imposition of meaning than through destroying meaning altogether; and what meanings the masses *do* entertain can be at odds with those of their rulers without any serious disruption ensuing'. (1991: 41)

A fifth and final criticism of the concept of ideology according to Eagleton (1991) was that even if a dominant ideology could be shown to exist, it may

be that the masses are in fact aware of it and are not foolish enough to be deluded by it. These arguments relegated the importance of ideas in late capitalist society to either the sidelines or indeed questioned their potency in securing hegemony.

Eagleton (1991) however expressed dissatisfaction with those who sought to argue that we were witnessing the end of ideology. Neither post-structuralism nor post-Marxism had, according to his viewpoint, provided us with an alternative concept which could satisfactorily explain the world. At its best, the body of work which opposed the continued use of the concept could be seen as a corrective measure to overcome some of the admittedly simplistic assumptions made about ideology previously. At its worst, this position could be interpreted as being ideological in itself because it functioned to assist in the maintenance of the dominant social order by arguing against the very idea that there might be a dominant ideology. It has to be noted that much of what was being written against ideology in the late 1980s and early 1990s was being written in a world in which capitalism was being viewed by some as a permanent feature, and where Marxism was seen as being in retreat. It was no accident that the views of the powerful came to be incorporated by some theorists into their thinking and indeed their arguments against ideology only add weight to the classical Marxist position that the ideas of any age are those of the ruling classes.

Media and ideology

A second set of criticisms of the concept of ideology emerged from empirical research work undertaken by researchers largely using a reception analysis model. Corner (1995) noted that while ideological analysis of media texts had some success in terms of examining form and content, the dissatisfaction which many had with the ideological model of analysis was exemplified in the shift towards analyses of reception and use of media texts. This resulted in a move away from ideological analysis which had attempted to show connections between television form and social structure, towards a concentration on the various contexts in which media messages were received. Nevertheless, there remained an important body of work within the reception analysis tradition which continued to make use of the concept of ideology.

Dahlgren (1992) although supportive of the concept of ideology, argued that earlier ideological analysis suffered from overly simplistic interpretation on the part of researchers in terms of how texts functioned ideologically. He saw the crux of this problem as being one of reconciling the polysemic openness of a text with the required narrow parameters of a text which would allow for a preferred meaning to be read. Drawing upon Thompson's (1990) conceptualisation of ideology, Dahlgren (1992) argued that the very openness of the text could assist in the reproduction of ideology through dissimulation. His analysis of viewer discourses on

19

television news led him to conclude that the openness of a text irrespective of whether it contained contradictions or not, helped in obfuscation and the circulation of ideology. Television news was found to present a range of possible meanings none of which assisted the viewer locate herself politically or socially. Thus, in masking the social structure through using open texts Dahlgren (1992) argued that television news contributed to the production and reproduction of a dominant ideology.

Fiske's (1987) study was an attempt to bring together the polysemic nature of television texts with the fact that they were being read by a variety of class and subcultural groupings. He examined the relationship between the ideological meanings of media texts and how diverse audiences interpreted and possibly resisted these meanings. Although he acknowledged that television texts were essentially dialogic in nature, he maintained that texts had to be understood in the context of the question of ideology. Fiske argued that 'Texts are the site of conflict between their forces of production and modes of reception … A text is the site of struggles for meaning that reproduce the conflicts of interest between the producers and consumers of the cultural commodity.' (1987:14)

Fiske's contention was that television programmes were produced by the culture industry which structured programmes around a set of meanings which did not challenge the status quo. However, as programmes became texts which were read by the television audience, there emerged a range of readings and interpretations that varied according to one's position in the social structure. This allowed for the possible subversion of the preferred meaning of the text. Fiske saw the polysemic nature of television texts in essentially political terms. He argued that:

> The structure of the text typically tries to limit its meanings to ones that promote the dominant ideology, but polysemy sets up forces that oppose this control. The hegemony of the text is never total, but always has to struggle to impose itself against the diversity of meanings that the diversity of readers will produce. (1987:93)

In a commentary on Fiske's project, Tester (1994) took issue with his arguments. Arguing for an ideological model of media analysis, Tester suggested that Fiske confused the fact that simply because something could happen, it automatically meant that it did actually happen. Tester asserted that it may very well be that media audiences can subvert the preferred meanings of media texts but that this did not necessarily prove the contention that they undertake such activities.

It should be remembered however that Fiske was not rejecting the notion that a dominant ideology existed in a media text and that it could be examined as such through careful research and analysis. As Lull (1995) has cogently argued, even where members of the audience either subvert or reject ideas offered to them by the media they engage in such activity only after being introduced to and contemplating the messages as dominant

ideologies. Gay men who have appropriated the term 'queer' have done so only after the dominant homophobic ideology defined them as such. Members of Militant Labour in rejecting Tory policy as evidenced in a party political broadcast do so in the full knowledge that such ideas are part of the raft of dominant ideology favouring the British ruling class.

It is also clear however that audiences *do* pick up on the preferred meanings of media texts. The task of infiltrating human consciousness and influencing consumer behaviour is at the core of the advertising industry. Those in the marketplace are clearly convinced of the power of the media to influence and change thinking patterns. Audiences can and do read preferred ideological meanings in media texts in terms of the intentions of their senders. (See for example Philo, 1993b; Kitzinger 1993)

The concepts of ideology and hegemony are of central importance in terms of analysing the media's role in contemporary society. Thompson (1990) argued that with some notable exceptions, such as Horkheimer and Adorno, sufficient attention had not yet been paid to what he termed the mediazation of modern culture in terms of the question of ideology. Others such as Lull (1995) and Corner (1995) have asserted that the media and especially television are well suited to the dissemination of ideology. Corner (1995) argued that 'Television represents the world through visual and aural conventions which work to invoke realist credibility rather than critical engagement ... It thus becomes well suited to ideological communication, forms of representation in which there is a mystification of power relationships.' (1995:44)

Gitlin has examined this process in greater detail. Following Gramsci (1971) Gitlin defined hegemony as the way in which the ruling class maintained their dominant position through the moulding of popular consent. He held that the media have become core systems for the distribution of ideology, whereby '... everyday, directly or indirectly, by statement and omission, in pictures and words, in entertainment and news and advertisement, the mass media produce fields of definition and association, symbol and rhetoric, through which ideology becomes manifest and concrete'. (1980:2) This, he argued, functioned to allow the continuation of the established social order. Ideologies, it was suggested, are reproduced through the use of media frames. Gitlin asserted that media frames may be seen as 'persistent patterns of cognition, interpretation and presentation, of selection, emphasis and exclusion, by which symbol handlers routinely organise discourse, whether visual or verbal'. (1980:7) Media frames not only help journalists to turn events into stories, but also allow for audiences to interpret the world beyond their direct experience. Frames are rarely referred to or acknowledged and function to present the existing social order as natural and inevitable.

Television, dominant ideology and poverty

Poverty and inequality in the developed world are as a direct result of the asymmetrical power relations which exist in late capitalist societies. So

what specific ideological role does television play in upholding or chal-
lenging such inequalities? I want to suggest that in terms of how ideologies
are circulated within media texts, that television plays an almost unique
role in reproducing the social order. Given the dominance of television as
a form of media in everyday life and the broader shifts that are taking place
within the medium itself - such as increasing privatisation and the rise of
infotainment within television programming - television remains the
medium where audiences are most likely to encounter the views of the
powerful. The powerful in society are only too well aware of the ideologi-
cal importance of television and there is abundant evidence available to
demonstrate how the powerful attempt to set the agendas of television
programming.

It is the case then that television is a potent source of dominant ideology.
Such a proposition is quite a traditional one. It recognises that ideologies
other than dominant ideologies exist in television texts. Equally, it accepts
that in other media settings counter-hegemonic ideologies exist in such
locations as the alternative press, community radio and in specific music
genres such as punk rock or rap. Dominant ideology however is more at
home within a medium which is mainstream and subject to closer scrutiny
by the powerful. While television does not slavishly reproduce dominant
ideology all of the time, there exist 'critical junctures' where it clearly sides
with the ideas of the powerful. television coverage of poverty stands out as
one of these critical junctures. When television comes to cover such issues
as poverty or inequality there exists the *possibility* of rupturing the hege-
mony of the ruling class. In practice this rarely happens however.

The revised conception of ideology as 'dominant ideology' remains an
important theoretical tool in the analysis of television's role in the repro-
duction of ideology. A modified conceptualisation of ideology as 'meaning
in the service of power' is still important for those interested in analysing
the social and political importance of television in modern society. Post-
structuralists and Post-modernists may have taught us a thing or two
about the functioning of texts, but they have failed miserably to address
how the media still play an important role in reproducing dominant
ideology and in contributing more specifically towards a more critical
understanding of the asymmetrical relationships of power which persist in
late capitalist society. Such theoretical developments are also noticeably
silent on the ideological struggles which take place within media organi-
sations over the content of texts which may be threatening to the *status quo.*

The key questions for those interested in analysing how such asymmetri-
cal relationships are sustained and legitimised within the realm of cultural
production are as follows: how is poverty explained by television? What
are the limitations to the discourse? Is the status quo threatened in any
way? What roles does television coverage of poverty allocate to both the
powerful and the poor respectively? How do those who work within tele-
vision contribute to or deviate from the production of ideas which are in

agreement with the dominant ideology? In order to answer these questions it is necessary to adopt an approach which combines an analysis of both the production context and content of a range of texts which deal with poverty. Without wishing to discount the importance of how television audiences read such texts in terms of their ideological content, the starting point for such analyses should remain with combining an understanding of cultural production with a critical content analysis of television texts. Before any examination of the reception of television texts can be undertaken one must have an understanding of the organisational forces which have shaped their content as well as an in-depth understanding of the text in question.

3

Good causes and God's poor

Telethon television and the coverage of poverty

Introduction

This chapter considers media coverage of poverty on a hybrid form of programme – the Telethon. Viewed perhaps more accurately as a media event, rather than a programme in the strictest sense, the subject of this chapter – the 1992 *People in Need* Telethon – was produced by the Variety Department within RTÉ. The discussion begins with an account of the history of Telethon TV in general and the emergence of this new form of broadcasting in Ireland in particular. The analysis of the 1992 Telethon is threefold. The production context of the programme is examined, noting the conflict which took place amongst the programme team over the Telethon's content. The way in which the Telethon's form and structure frames the way in which discourse about need takes place is also investigated, and finally, using qualitative analysis techniques, the contents of some of the appeal films used to raise money from donors are considered.

The emergence of charity television in Ireland

Although particular examples of charitable activities by RTÉ television and radio may be found if we sift through the annals of its history,[1] there have been radical changes in the activities of RTÉ and other media organisations since the mid 1980s. The emergence of fund-raising or Telethon television

1 RTE's pop music channel *2FM*, for example, organises the collection of non perishable goods at Christmas time for the 'poor and needy' in conjunction with *The Lion's Club of Ireland*. Gay Byrne's radio programme has also had a long history of locating and donating household items such as fridges and washing machines to the less well off. Appeals on behalf of the blind and other groups have long been a feature of RTE's radio schedule, whilst sponsored television appeals are used to raise funds for organisations like the St. Vincent de Paul Society.

represents a significant shift for RTÉ, not only in terms of a change in programming style, but also in terms of its perceived role and function. It is perhaps no accident that Telethon television emerged at a time when the Irish state was retreating from its provider role and adopting a strict monetarist stance in relation to spending. For our more immediate purposes however the Telethon is a new television genre to which RTÉ gives over a great deal of its time and resources[2] on a bi-annual basis, and in doing so, is forced to acknowledge repeatedly over a period of usually 12 to 14 hours that inequality and poverty exist in Irish society.

The Telethon is different from other television genres in a number of respects:

1 It marks the entry of contemporary television into a fund-raising role.

2 It involves the suspension of normal television programming.

3 It is particularly lengthy, usually taking on a 'marathon' format.

4 It involves the participation of well-known personalities from the worlds of entertainment and sport.

5 It relies upon the corporate sector – both native and multinational – to donate goods, services and money to the programme.

6 It has a significant amount of audience participation both in terms of the audience as fund-raisers and as subscribers.

7 It offers the opportunity (theoretically at any rate) to gain a greater insight into the world of the poor through the use of filmed segments and interviews.

8 It does not attempt to challenge the status quo, and proffers the notion that charitable solutions are an answer to social problems such as poverty and unemployment.

9 It places great emphasis on the (heroic and sometimes unusual) activities of individuals, groups and communities who have raised money for 'good causes'.

The history of Telethon television

We can trace the development of Telethon television back to the early 1980s. *The Jerry Lewis Telethon* which raises money for muscular dystrophy has long been a feature of American TV and is broadcast annually on Labour Day. Rapping (1983) noted that in excess of sixty television stations around the US, had, by 1983, devoted some of their prime time slots to *Job A Thons*.[3] In Britain, the first ever Telethon was organised by Thames Television in 1981 and raised £1.25m for a number of charitable causes.

2 The 1992 *People in Need Telethon* cost RTÉ £250,000 to stage. Source: correspondence between the author and the programme's executive producer.

3 The emergence of the *Job A Thon* concept is discussed in *Channels* (1983).

The 1985 *Live Aid*[4] fund-raising concert, however, represented a major shift in the media's role and relationship towards poverty and inequality. Seen world-wide by millions of viewers, this spectacular televised rock concert raised millions of pounds for the starving and destitute of the Third World. For a very brief period of time it focused the Developed World's attention on African poverty and inequality, although its critics[5] were quick to point out the contradictory images of millionaire conscience-stricken rock stars telling their audience to give to the African poor, of whom we were given only occasional glimpses, throughout the event. The dominant messages of *Live Aid* were:

1 Existing political structures both in the Developed and Third Worlds have failed the starving and poor of Africa.

2 Charity represents a (short-term) solution to these problems.

3 The communications industry, whether it be through the record or music business or through television, radio and newspapers, has a role to play in attempting to alleviate poverty and inequality through fund-raising.

The format adopted by *Live Aid* was to be used as a mechanism by RTÉ and other media organisations for the new fund-raising role in which they found themselves. In Britain, ITV's *Telethon*, and BBC's *Comic Relief* and *Children in Need* emerged as annual features on television. Even satellite television in the form of SKY TV had entered the Telethon business by 1995 with its *Gold Heart Day*. Leaving aside whatever philanthrophy and good-will which some broadcasters may possess, the spectre of inter station competition looms large in the background in the race for ratings and the moral high ground.

These programmes have managed to raise relatively large amounts of money in the short-term, but since the early 1990s they have been the subject of a growing amount of criticism from a number of quarters and from disabled rights activists in particular.[6]

The future of this type of media activity in Britain, was brought into question in 1993 when ITV decided to abandon its Telethon programme owing to a fall off in donations by the public. (See Thomas (1993)) ITV's *Telethon* had raised £24m in 1990 but had fallen to £15m in 1992.

4 Cubitt (1993:101) noted that the *Live Aid* concert used a 'combination of direct address ('Give us your money now') and statistical information on the amounts collected' to encourage audience identification with a common cause and the commonality of television. For an account of the importance of *Live Aid* from a development education perspective see Regan (1986). For a critique of the *Band Aid* model see Burnell (1991).

5 The Band Aid record which was the forerunner to the *Live Aid* concert was described by *Black Voice* as being the most racist event of the decade (See Simpson (1985)). Cairns (1985) noted that '... the motto of these videos could well be that guilt delivers the cash and so the message actually becomes 'give and save your own life soul'.

6 *The Block Telethon Group* protested at ITV in 1992 and *The Rights Not Charity Group* picketed the BBC's headquarters in 1993. For an account of these protests see, for example, Chalmers (1993).

In Ireland, *Live Aid* was to be followed up by three home-based Telethons; *Self-Aid* in 1986 which was directed at solving unemployment; *A Light in the Dark* in 1992 to raise funds for the starving of Somalia, and *People in Need* which had a broader focus on disadvantaged groups in 1989, 1990, 1992, 1994 and 1996.

As in Britain, the Telethon idea has not been without its critics. During the broadcast of the programme upon which this chapter is based, a group of unemployed people picketed the gates of RTÉ protesting against the idea that charitable solutions were the answers to serious social problems such as unemployment and poverty.[7] They carried placards, parodying the extra large cheques which corporate sponsors use when donating money to the Telethon, which claimed to pay one of the better known directors of the project 'an easy conscience'.

There were further criticisms of the event from a disabled rights activist. In an interview with RTÉ presenter Joe Duffy during the 1992 Telethon programme, the activist criticised this type of television. Liking the Telethon to Christmas, he said that '… the people who give most at Christmas…are the people who need most. People with disabilities aren't terribly happy with the notion of fund-raising as a mechanism of solving what are political issues …' and added that we should realise that the Telethon '… is not going to solve the poverty issue in this country'.

Similarly, in the aftermath of a national radio debate between the author and the chief executive of People in Need, about Telethon television, a caller to the programme who worked with the homeless, claimed that in her experience the homeless found this type of television to be patronising.[8]

RTÉ's experience in terms of fund-raising television to date has largely followed the path of its international counterparts. It supported the Live Aid Telethon of 1985 and proceeded to broadcast a series of Telethons which have focused on unemployment, famine and social need. As with the British experience, there has been some criticism of this kind of media activity, although given the population size of the country (3.5m) the Irish response to these appeals has surpassed that of any other Developed country[9] and the success in financial terms of the 1994 *People in Need* Telethon[10] seems to suggest that there is a high level of support amongst some of the public, ironically at a time of record unemployment and poverty.

7 See examples of print media coverage of this event in O'Shea (1992) and McDonnell (1992).

8 Caller to the *Soundbyte* comment line. RTÉ Radio 1, 31 May 1994.

9 In terms of the high level of Irish contributions to *Live Aid* in particular, the phenomenon was explained within popular discourse as resulting from the Irish nation's 'Famine Memory'. Historically, of course, there has been a long tradition of Irish activity in the developing world and this has largely been dependent on voluntary contributions to mainly religious organisations who have acted both as missionaries and developers.

10 It raised over £3m representing an increase of 45 per cent on 1992's totals.

People in Need Trust

The *People in Need* Telethon is organised by RTÉ in conjunction with The People in Need Trust which was established in 1988. According to its chairman Dr. P. J. Moriarty, the trust has the objective of raising money on a national scale for the smaller and lesser known charitable organisations which, for one reason or another, are unable to raise sufficient funds for themselves. (*People in Need Grant Allocations Report*, 1992:1)

Between 1989 and 1994 it raised in excess of £11m for voluntary organisations alleviating need. According to one source, the organisation modelled itself closely on the British Children in Need Trust, and the similarity in their titles and activities seems to bear this out.

Initially, the driving force behind the organisation was Margaret Heffernan (a director/trustee of the supermarket chain Dunnes Stores) who along with the then Lord Mayor of Dublin, Carmencita Hederman, decided in 1988 to form the People in Need Trust. In that year they raised £200,000 for forty organisations working with the homeless, and based most of their fund-raising activities on gala dinners and film premieres. Many of its directors and trustees are some of the most powerful and wealthiest members of Irish society and have previously been involved with other charities.[11] The trust shifted its attention to organising its first Telethon in 1989[12] and widened its focus in terms what it defined as social need. Interestingly, the trust's spokesperson rejects the idea that People in Need has anything to do with attempting to resolve poverty and insists instead that the trust is there to help voluntary groups working in the area of what it terms 'social need'[13]. To this end, the trust has never used the terms poverty or the poor in any of its literature or activities.

An examination, however, of where the money goes would seem to refute this argument. In 1992 much of the money raised went to organisations who work with those who are the most visibly poor[14] – the homeless, Travellers, the elderly, the long-term unemployed as well as to other groups who help those who are less visibly poor but at the same time both materially deprived and socially excluded. In addition to this, the 1992 Telethon's promotional literature uses a black and white photograph of a

11 The most recent list includes Dermot Desmond of NCB Stockbrokers, Norman Kilroy of the Grafton Group PLC and Margaret Heffernan, Managing Director of Dunnes Stores. In 1997 Heffernan's personal wealth was estimated by *The Sunday Times* to be £174m, making her the eight richest person in Ireland. See *The Sunday Times* Rich List supplement, 6 April 1997.

12 Anecdotal evidence suggests that RTÉ broadcaster Gay Byrne informed Margaret Heffernan about the Jerry Lewis Telethon which he had seen during his working visit to the USA in 1989.

13 Interview with the author 1 November 1993 and debate with the author on *Soundbyte* RTÉ Radio 1 24 May 1994.

14 Travellers groups (18) received £56,000, groups working with the homeless (24) received £137,000 and unemployed groups (14) received £45,000. Figures derived from data contained within *People in Need Grant Allocations*, 1992.

young Traveller girl whose clothes are shabby and who is begging by playing the harmonica on the street. Thus the People in Need organisation itself draws upon images of the absolute poor to promote its activities. The trust seems to be adopting a stance which views Irish poverty in absolute terms and emphasises the importance of encouraging voluntarism as a solution to what it insists on terming social need. The fact that a large number of those groups it assists are working with the very obviously poor is glossed over by its spokespersons.

Producing the Telethon: A view from behind the scoreboards

The 1992 *People in Need* Telethon was a joint venture between RTÉ and the People in Need Trust. Costing RTÉ £250,000 to stage, it was produced by the Variety Department of the television station. In the words of its executive producer its objective 'was to entertain, but to raise money at the same time' and was intended to catch as wide an audience as possible. Unlike previous RTÉ Telethons, the 1992 programme drew upon the talents of two independent film producers to make the appeal segments used by the programme to raise funds for those in need.

Planning the programme

The Telethon was to be a 12-hour programme built around a single anchor presenter (Gay Byrne) and in some respects would be modelled on elements of RTÉ's *Late Late Show*. Given both the length of the programme and the fact that it would also involve the use of seven outside broadcast units as well as a large number of studio based celebrity participants, the programme required a large amount of preparation. Planning for the programme came about through a series of discussions between the executive producer, other RTÉ personnel, the independent film producers and the People in Need Trust. The trust informed RTÉ about the events that would be taking place to raise money, the companies which would be sponsoring the programme and also made suggestions about which groups might be filmed for the purposes of making the appeal segments. In the end, the final decision as to which groups were to be filmed was to rest with the film producers, who divided the filming of groups according to geographical region and whether or not they had been included in the previous Telethon.

However, unlike other years in which well-known personalities did the voice-overs for the appeals, the executive producer decided, that where possible, those filmed should be allowed to speak for themselves. The films were to be made by two filmakers who were not employees of RTÉ, and in the view of one of these producers, the reason for this was that the executive producer wished for the film inserts to be made by someone with independent editorial control. The planning and creation of the Telethon was not, however, without its problems.

Conflict

My interviews and conversations with those involved in making the programme suggest that there is clear evidence of conflict in the making of the 1992 Telethon. This conflict may be seen to emerge from:

1 The executive producer's own unease with the concept of charity television.

2 Debate between the executive producer and the *People in Need Trust* as to how much profile corporate sponsors should be given.

3 Friction over the content of one of the appeal films between the executive producer and its maker.

The executive producer of the Telethon had a number of personal reservations with the politics of charity television. In response to my questions about the contradictions involved in this type of media activity she argued that, as a producer, she had inherited the programme and therefore a certain amount of the structure of the Telethon had already been set. Perhaps more fundamentally, she held the view that the programme had been agreed upon corporately, by RTÉ and the People in Need Trust and therefore she was limited in terms of what she could change.

She did, however, adopt an interesting strategy in terms of articulating her own reservations about the programme. In making the Telethon she was approached by a disabled rights activist with whom she was on friendly terms. He outlined his problem with the idea of the Telethon and asked to be given some airtime to vent his views. She considered his viewpoint and agreed to allow him to be interviewed by one of the programme's presenters. Thus, what appears in the Telethon as an off the cuff interview was in fact a deliberate attempt by the producer to allow a dissenting voice to be heard. In some respects we can see this strategy as an effort on behalf of the executive producer to overcome the difficulties she was experiencing in the face of the disagreements she was having with the People in Need organisation.

There were further conflicts between the executive producer and the People in Need Trust as to the amount of airtime which should be given to corporate sponsors. She held the view that companies who donated cheques should simply hand them over and not be given airtime. This concern appears to have been both ideological and practical. She observed that from a producer's point of view there was a great difficulty '… in balancing people's corporate profile against the amount of money they are giving, and that is hell on wheels'.

Her difficulty with corporate sponsorship and her protests to the trust seem to have been countered by the precedents set by previous Telethons. Thus, as was mentioned above, she was, despite her own reservations, bound by both precedent and the agreement made corporately by RTÉ with the trust.

There were also tensions between the executive producer and one of the filmakers she chose to make the appeal segments. In using these appeals she acknowledged that there was a danger of using 'set images' of those who were in need. One of the film segments dealing with homeless boys in Cork used a series of reconstructions of these boys sniffing glue, breaking into cars and drinking spirits. The executive producer admitted that she had some difficulty with the use of reconstruction in the piece – although she did allow it to be broadcast. Indeed the other filmaker was even more critical of this appeal segment. He stated:

> In any kind of dramatisation stuff, you reduce people to a pat formula, you reduce it to the kind of pat totally wrong images. We had images of young kids sniffing glue, and I think you'd be better having a kid talking about it so then you could connect with it … it seemed unreal and at a remove from the people.

This discussion indicates a number of important factors which influenced the making of the 1992 programme. While both the executive producer and at least one of her film producers expressed reservations about this type of media activity, both were pragmatic in terms of overcoming their difficulties. It was also the case that the final product – a large scale media event – was the subject of some negotiation and debate between programme personnel and outside agencies. This discussion also indicates the importance of the organisational environment in terms of influencing how programmes are shaped.

Filming the appeal segments: styles and symbols

The two film producers were asked to make a total of nine appeal segments. These nine films were selected by the producers out of a total of forty ideas suggested to the programme's executive producer by the People in Need Trust. Both producers agreed that they were given complete editorial freedom in the making of these inserts, although some discussion did take place about the use of reconstruction in one of the films.

Film Producer A

Film Producer A maintained that he was chosen to make the segments because of his reputation for his making films that were both 'aggressive and hard-hitting'. He also asserted that the reason that he and the other producer were selected was because, given the executive producer's awareness of the contradictions involved in Telethon TV she wanted, in his words, to '… bring a bit of grit to it … she wanted the films to touch base with reality in a way the rest of the thing [the Telethon] doesn't'.

He agreed that there were obvious discrepancies between the contents of the film segments and the Telethon programme as a whole. This, however, was a deliberate ploy by the executive producer to 'put a bit of reality into the day …' reminding the audience of what the programme was about. Producer A claimed that he was himself aware of the contradictory

elements of the programme but he felt that it was 'better to be involved than not involved'.

Thus, like the executive producer, he saw himself as being somewhat critical of the programme as a whole but adopted a pragmatic stance in terms of his involvement. Interestingly, he suggested that the audience is also aware of the contradictions of a programme like *People in Need* and interpret the images and messages in a variety of ways.

In terms of a filmaking style Producer A claimed that his approach was 'totally instinctive and the stories wrote themselves'. He did not work to a script and instead he chatted to the participants. Typically, he met the potential participants and spoke to them over coffee, asking general questions. He then met the participants again and filmed a series of interviews with them. There followed a selection process in terms of writing the final piece. In the case of the Dundalk unemployment film, he viewed the many hours of tape shot and decided that the unemployed man who eventually featured in the piece seemed to personify the 'thwarted energy of the unemployed'.

Thus, he structured the 90-second piece around his story. Added to his assertion that his filming was based on instinct were his suggestions that the other techniques employed in making these films were also based on instinct. Producer A claimed that his choice of background music for his films were chosen instinctively, but with the very clear intention of adding a further layer of meaning to the films. Dolores Keane's *Aragan Mill* told of the impact of de-industrialisation, while The Stunning's *Brewing Up A Storm* alerted the viewer/listener to the harsher side of life.

Despite his and the executive producer's intention that the subjects of the segments be allowed speak for themselves, he admitted having some difficulties in shooting the inner city piece and noted that 'The kids were remarkably inarticulate'.

Notwithstanding the problems of communication just noted, Producer A argued that he did not apply different standards in filming people who were either rich or poor. In terms of the ethics of filmaking, he viewed the process as being one of a reciprocal relationship between the filmaker and the filmed, stating that all that really mattered at the end of the day was how the film subjects themselves felt.

Producer A saw his filmaking in very personal terms, claiming that any work he has produced, was as much about himself as the subjects of his films. In choosing images for his work he saw this process as being a kind of emotional selection. He claimed to see a poignancy and something positive in what many might view as a negative image.

Producer A's Dundalk unemployment appeal film drew upon the images of a post-industrial landscape. He chose this location as he drove to the film shoot. Describing it as being like a gaping sore on the open landscape, he stated that it had: '... all these beautiful colours, and there was all this very strange light coming through it, and it was quite emotional'.

The disused factory represented for him the emotional terrain that the local people had once worked in and were now not working in. He was conscious of the problems that he had as a filmmaker about making a statement about unemployment. The broken down factory was for him a potent symbol of what he wanted to say about de-industrialisation. He was struck by the many colours which were daubed on the factory walls and for him:

> ... the colours of the paint and stuff seemed to represent that once upon a time there were people working there, perhaps were happy working there ... and the ruined building seemed to represent the emotional terrain, the emotional field that all these people were working in.

In this and in the other pieces that he filmed, he tended to use slow motion as a production device. From his perspective, he adopted this technique to focus in on particular images and to capture important moments in time.

Film Producer B

This producer/director opted for a docu-drama approach in making his appeal segments. His belief was that he should keep these 90 second films documentary in style, but also incorporate elements of drama as well. True to his realism, he felt that there were certain things which needed to be shown, and in the case of the Cork homeless boys piece, there was a necessity to act out certain otherwise unseen activities. In filming in Cork he spoke to the centre's founder about what he wanted to do. He maintained that the centre's founder realised that if he wanted to find young boys glue sniffing or drinking spirits he could easily do so out on the streets, so instead he filmed some boys from the centre in a reconstruction of these activities. He maintained that it was essential for the audience to fully understand the implications for these young boys of allowing such a lifestyle to persist. He shot the piece of film in the backyard of the centre using some of its clients – all of whom agreed to appear in the piece.

In describing the film segment he said:

> I did it as a straight documentary, but dramatising one element. Why? Because I could talk about it ... they sniff ... and people would say we don't really believe that. So you show it. Then I had to make up my mind about creating it ... If I had to go out and find it, it might take me a week ... So I created it. I didn't put a caption up saying 'This is a reconstruction' because that again enters into the realm of disbelief on the part of the viewer.

In the context of the earlier reference to the unease felt by both the executive producer and the other producer about this reconstruction, Producer B asserted his 'moral right' not to explain his filmaking processes to the others in the production team, as he claimed that the reconstruction was simply a creation within a documentary form. His intention in making the piece of film was to create a connection between the message at the end of

the film 'Our young people must not be allowed to die from drugs ...' and the images of solvent and alcohol abuse contained within the mini-dramatisation at the beginning. He maintained that what the audience was therefore being given was a certain degree of drama in two forms incorporating both the fictional and the factual documentary styles.

Producer B also admitted to the deliberate use of symbols in his filmaking. One of his appeal segments dealt with the work of the hospice movement and showed images of two women – one middle class, the other a Traveller – both of whom were waiting to die. In filming the Traveller woman's story, Producer B selected a well-known symbol of Traveller culture – the trailer or caravan. He filmed it from a distance showing it to be on its own at the end of a road. He viewed this as a way of illustrating the fact that this Traveller was not only dying of cancer, but also that she was in poverty, living at the side of the road. He very deliberately chose to articulate his messages about the Travellers at this symbolic level rather than using any stated verbal message. What is interesting is that in researching this piece of film, he learnt from the nurse who was caring for the woman, that when she died, true to Traveller culture there was every possibility that the caravan and the woman's bed would be burnt in a funeral pyre.

Producer B intentionally omitted this element of the story because he felt whether it was true or not, it would feed, as he would see it, the distorted views of Traveller culture which many middle class viewers might hold. Thus he consciously used a symbol to give the audience a particular message about the Travelling community (ie they are poor) while at the same time avoiding the possibility of invoking a negative reaction towards those who are invariably written off by many as the Devil's poor, by excluding any reference to how their culture might be misinterpreted and blamed for causing some of their hardships.

C'mon Everybody ? People in Need 1992: form and structure

The 1992 *People in Need* Telethon was broadcast by RTÉ 1 and Network 2 on May 8th. Lasting over twelve hours it raised £2 million, which was distributed to 644 organisations in the Republic of Ireland, including those providing services for the handicapped, the homeless, the elderly and deprived children. For several weeks beforehand, the programme's advertising campaign was heavily featured in RTE's advertising schedules. Having adopted Eddie Cochrane's rock and roll classic *C'mon Everybody* as its anthem, the campaign encouraged 'everybody' to get involved in no matter how small a way in the Telethon's events.

The advertising campaign featured familiar faces from RTE's radio and television networks and suggested to the viewers to organise fund-raising events in their localities, workplaces or schools. The Telethon was promoted, therefore, by an advertising strategy which gave the impression of

being inclusive. The notion of involving 'everybody' is patently at odds with the very reason why the Telethon might be deemed to be necessary in the first place, namely that there are groups of people who are poor by being both materially deprived and socially excluded.

Intertextuality

The Telethon was intertextual in form and as such represented a type of hybrid television. Part one of the Telethon was broadcast live from an open air setting in Cork. Here, the programme was fronted by presenters and characters (puppets) from young people's television. This part of the programme was shaped around a free rock concert and a wide range of games and competitions in which personalities and locals competed. The 'fun' or 'craic' element was stressed repeatedly by the presenters as being the most important part of the day. This section of the programme drew upon programme styles such as the competitive *It's A Knockout* and the humorous *The Den* with which viewers of young people's television would be readily familiar. The programme therefore knitted together parts of familiar television programmes to build a much bigger media event. The presenters had a set of simple messages for their audience 'We want to see more money! Send us your money now!'

Part two of the programme was modelled around the familiar *Late Late Show* format. But it too incorporated components of other types of television and radio programme. There were quizzes, competitions, games and music as well as star personalities doing strange things. News presenters sang for a bet, and an Irish language current affairs presenter modelled an expensive dress. In addition to this, there was an almost constant stream of information broadcast across the bottom of the viewer's screens to inform them of the unusual things people had done in order to raise money for charity[15] as well as encouraging audience members to get involved. Given that the programme was framed upon the basic plan of the *Late Late Show*, the anchor presenter Gay Byrne adopted some of his familiar ploys as a commentator, such as making fun of the studio audience and adopting his direct style of address to the viewers in his persona as 'Uncle Gaybo'.

As well as Byrne, the programme's second in command was Joe Duffy – familiar to viewers as Byrne's sparring partner from his morning radio programme. This two-hand act was replicated in the presentation style of the Telethon. Part two of the Telethon also borrowed from other programme styles such as *Treasure Hunt*. In the case of the Telethon, RTÉ presenter Gerry Ryan flew around the country in a helicopter, while some celebrity guests decoded the clues he found. Unlike the programme upon which this part of the Telethon was based, this treasure hunt was sponsored by a large corporation.

'We must beat the £2m target!'

In both parts of the Telethon there were strong dramatic components

which centred on whether or not the £2m target would be reached. Given the fund-raising function of the programme, there was perhaps understandably a great deal of attention paid to how much money had in fact been pledged by the viewers. Thus the programme was interspersed with accounts of how much the latest tally amounted to, reaching a crescendo when £2 million pounds had finally been reached.[16] The focus on the ever rising tally has parallels with the presentation style of the *National Lottery* which as well as promising individual wealth also claims to assist charities.

As in the advertising strategy used to promote the Telethon, the mode of address used by presenters in speaking to viewers treated them as an homogenous mass who were all expected to participate 'Keep sending us the fivers! We need your money now! The £2m must be reached!' As in the first part of the Telethon, there was a concentration on the fund-raising activities of the audience which stressed their inventiveness in coming up with fund-raising ideas and their basic generosity. The programme's main presenter told his audience 'We know you're going to be very kind and very generous and as decent as you possibly can on the situation tonight'.

This theme was further developed through his pleas that the Telethon was for a good cause. The reasons for this cause or the possible crises that might arise for the beneficiaries of the fund if the money was not forthcoming were not alluded to.

Structure

In terms of the structure of the programme itself, the 1992 *People in Need* Telethon had three distinct features. A major part of the programme was based in the main RTÉ television studio, where audience members could ring in to a group of celebrity telephonists[17] and pledge money for the Telethon's fund. The programme had a series of links with other celebrities at various locations throughout the country who told of the fund-raising activities in the region from which they were reporting. The programme also featured a number of filmed segments of people who were in need of our charity.

The studio-based part of the Telethon featured an auction of otherwise expensive household goods for which viewers could pledge money.

15 During my participant observation at the Telethon I worked as a runner for the team who decided which pieces of information should go on air. There was a strong emphasis on the exotic and unusual such as schoolchildren paying their teachers to keep quiet for a whole day.

16 Leat (1990), in a critique of British Telethon television, has noted 'Rolling scoreboards emblazoned in lights, cheers at every further thousand pounds, do little to foster public awareness that the amount of money raised is merely a means to and not the end of the exercise'.

17 The Telethon offers its viewers a chance to get in contact with stars and personalities in return for making a donation to the fund. In the 1992 Telethon, one of the programme's presenters tells the audience: 'Keep phoning, you can be straight through to the stars!'

Sponsorship by native and multinational companies played a central role in the make up of the programme, thus offering us the message that the business sector were doing their bit for charity. Throughout the programme we were reminded of three things. We [the Irish] are a great nation of givers 'I am always amazed at the decency and generosity of the Irish.' The money pledged was going to 'good causes' 'Remember now, the money is going to charity!', or in other words only to those who deserve our assistance or charity. The donations made were guaranteed to be given to groups at work in the area/region in which the donors live.

The links to the Telethon studio from the outside broadcast units throughout the country again underpinned this notion that the Irish are 'great' when it comes to giving to deserving causes. There was a strong accent here on the responses of children to raising money for the Telethon. The use of children, both in the appeal films as objects of our charity and as donors may be seen as a ploy on behalf of the Telethon to maximise donations from the public. Within the appeal films it was mainly children who were used as subject-matter while there was also a tendency to concentrate on the relatively small donations of schoolchildren in contrast to the contributions from companies or organisations. Thus, there was a sense in which children were used as examples of need to which the public couldn't refuse and added to this, the concentration on children as donors emphasised the notion that if children were giving up their savings of £5, then we must all make sacrifices and give to the appeal.

The outside broadcast links featured individuals and communities involved in spectacular, heroic and sometimes unusual events. Schoolchildren raised money by paying to be allowed to come to school in casual clothes. In another instance a man bungi jumped from the sky on a bicycle. Invariably, when companies sponsored a particular event or were simply making a donation to the Telethon fund, they would present the programme reporter with a cheque (usually £1,000), exaggerated in its physical size, emblazoned with the company logo and thus availing of cheap advertising on the national airwaves. Where the donation or sponsorship was particularly large (ranging from £7,000 to £12,000) the company received more airtime in terms of both their donation and company profile. One company – Golden Vale – presented a cheque for £7,000, half of which had been raised by its workforce. In presenting the cheque the viewers saw a company representative as well as a model dressed up as an olive tree. She was advertising the company's new dairyspread product for three minutes on screen.

The Flora/McDonnell Group sponsored children £1,000 per level of a pyramid built of their margarine product. The children wearing *Flora* t-shirts built 12 levels of the pyramid and thus the company donated £12,000. Other companies such as Lyons Tea and Lever Brothers also received airtime for their sponsorship or donations. Within the structure of the Telethon it was agreed that companies could buy up slots of time reserved

for corporate donors. Typically, companies received advertising through an interview/feature/presentation of cheque often in total lasting as long as four minutes. Other companies adopted a different strategy in getting public recognition (and advertising) in return for their donations. One Dublin based company promised to pay £1,000 if Gay Byrne mentioned their name on air. He did, and in fact repeated the company's name and its owner in return for the donation.

The third, and for our purposes most interesting, feature of the form and structure of the Telethon was the fact that the programme featured nine filmed segments of groups and individuals who needed our help. Given the marathon length of the Telethon, the segments themselves, taken together, lasted a mere eleven minutes and four seconds, and even allowing for the fact that a number of them were repeated twice during the Telethon, it is clear that the programme's primary function was to focus on the activities of the helpers of the 'deserving' and not on the 'deserving' themselves. Just who the programme makers chose as examples of people in need and how their story was told is perhaps of more fundamental importance.

It is the deserving poor who get most attention in these segments and even where groups who might otherwise be demonised – such as the young homeless, the young unemployed and the long-term unemployed – are given coverage, they are portrayed as the deserving poor because the examples used are those of the homeless and unemployed who are doing something about their situation with the help of the subscribers to People in Need.

Those segments fitting neatly into the 'deserving' poor category were ones which dealt with a child abuse intervention programme (1 minute: 57 seconds); the mentally handicapped (1:57); the physically handicapped (1:28); autism (1:30); and the elderly (1:28). In the remaining four segments which dealt with a youth unemployment project (1:25); the personal experience of unemployment (1:27); cancer care (featuring Travellers) (1:30) and a centre for homeless boys with drug addiction problems (1:57), the stories dealt with groups and individuals who are often rejected as the undeserving poor. Yet in three of the four cases the segments featured those who were doing something about their situation and thus deserving of our help.

In all but one of the nine appeals shown throughout the Telethon, the filmed segments featured what I have referred to earlier on in this study as the agents of the poor. Despite the executive producer's suggestion that the people filmed should be allowed to speak for themselves, a great deal of time was given over to those who are working either on a professional or voluntary basis for the poor or needy. Given the specific fund-raising function of these pieces of film, an identifiable set of production techniques were used by the programme makers, ranging from 'appropriate' background music and songs with relevant lyrics, to different styles of filming. Those who are the agents of the poor are shot speaking to camera in real

time, while the poor themselves are shot in real time, in silhouette, and in the particular case of those suffering from a mental or physical handicap in slow motion.

Good boys and slaves: Four appeal films considered
case (1) *The Centre for Homeless Boys*

This piece of film, lasting one minute fifty-seven seconds, was an appeal on behalf of a centre in Cork City which works with homeless boys, many of whom have addiction problems or have been imprisoned. In terms of production style, the segment used slow mournful music to emphasis the desperation of their lives. The visual imagery was composed of shots of a hooded male breaking into a car, a male youth sleeping rough, another with empty spirits bottles sleeping rough on a park bench. Later, we were to see a male youth sniffing glue and another shot of a homeless boy sleeping rough. These images were in stark contrast to others used in the film which featured the centre itself, those working with the youths, shots of these youths engaged in activities in carpentry and metal workshops, a bakery and in a residential treatment centre. Other images were of a young man speaking to camera in silhouette of his drug addiction and of the centre's director appealing for funds. The verbal messages of this piece of film are also interesting; mixing as they do the philosophy of the centre, the experiences of these youths in relation to drugs and drug abuse and the appeal for funds. The dominant verbal messages of this piece stressed the Christian ethos of the centre:

> We don't regard them as good or bad, because there is no such thing as a good or a bad boy. We are all brothers and sisters of Christ. He will probably never be a professor, but he will be a tradesman. [The centre's founder]

The dangers of drugs 'There was a fellah up in The Glen, he was sniffin' out of a barrel and he fell asleep like and his friends ran away and he never woke up.' [Young boy speaking to camera] The need for funds We're desperate for money. We have a very simple vision. Young people should not die because of alcohol and drug addiction. [Centre's director]

This piece of film is of interest in that it shows examples of activities (albeit set up for the purposes of filming) not normally seen on television such as glue sniffing, car stealing, and youths sleeping rough. It is also of interest in that it contains images of those who might be considered to be the 'Devil's poor' engaging in 'deviant' or 'anti-social' activity. They are, however, later rescued from such a categorisation by being seen to have reformed from problems such as drug abuse and by being busy and industrious in the centre's workshops and bakery. Thus by the end of this short film the 'Devil's poor' have become transformed into 'God's poor' deserving of our charity and sympathy. However, in promising the viewers that these boys have a future care is taken in noting that the status quo will be

preserved in the suggestion that while a trade may be possible for these boys anything higher on the social scale is unrealisable. The poor will stay in their place.

Case (2) *The Personal Experience of Unemployment*

This piece of film was one of two which dealt with the experiences of the unemployed. Lasting just one minute twenty-seven seconds, the segment told the story of the personal experience of one unemployed man who was involved with a resource centre for the unemployed.

The segment used a song by folk singer Dolores Keane *Arragan Mill* which is about the impact of de-industrialisation in a small town. Visually, the film consisted of images of dereliction in a post-industrial landscape, showing a disused railway line, broken down factory buildings. They also featured the unemployed man upon whose experience the piece was based, showing him at the unemployment resource centre, looking into shop windows at items he cannot afford to buy. This was in stark contrast to the auction for expensive household and luxury items which was taking place within the main body of the Telethon. These images were supplemented by others showing the activities of the unemployment resource centre shot in slow motion.

Visually then, the messages of this film segment were those of dereliction as a result of the decline of industry, the exclusion of the poor from being able to participate in a consumer society, but also of the deserving poor who were actively doing something about their plight through self-help activities.

Verbally, the messages of this segment emphasise the notion of the 'dignity of labour', the willingness of this man to engage in 'workfare', the broader threat of unemployment to others and the important work being done by resource centres such as that featured in the film. The man featured in this piece states at the outset that unemployment is an unhealthy situation to be in and goes on to say that 'It's not about money ... with me. I'm willing to work, even for the money I collect on the dole.' It is, he tells us '... unhealthy for me not to be working. I'm a healthier happier person when I'm working.'

The exclusion which the unemployed experience not being able to fully participate in a consumer based society is also stressed 'Even when I walk down the street, I don't look into shop windows, there is no point. I'm never going to be able to purchase what's in the window.'

The important self-help work of this and other centres is also emphasised. These centres help build self-esteem and self-worth in contrast to the dole which takes self-respect away from you.

This filmed segment has, as well as its fund-raising function, a number of other important messages. It uses a clear example of a member of the deserving poor to articulate a story about the experience of unemployment. It stresses the dignity of labour as well as making it very certain that

41

this man is not workshy or scrounging from the system. The fund-raising appeal function of this piece of film is structured around the activities of the unemployed who are seen to be doing something about their situation by attending classes and developing their skills. Thus like the deserving poor of the homeless youths film discussed above, these people are deserving of our charity and help.

Case (3) *Youth Unemployment Project*

The film sequence, which featured this Dublin-based training project for the young unemployed, was one minute twenty-five seconds in length. In attempting to get a set of messages across to the Telethon audience, it used a soundtrack which featured the music of Galway rock band The Stunning singing *Brewing Up A Storm*. The song's lyrics replete with social realism – 'Honey if the truth hurts, don't look away, it's easy to pretend that life is a rosy bouquet' – were used to underpin the messages of this film segment. Visually, the film contained scenes of dereliction, boarded up flats, graffitied doors and walls suggesting perhaps that this community has been both abandoned by some of its own members and by the state. The images, however, quickly shift to show the viewers, unemployed youths who are busy and productive in a workshop setting. These shots then lead to some action footage where a hovercraft and a windsurfer built by these youths are being driven along a beach at high speed. The final image is of a young boy appealing to the audience for funds for their project.

Verbally, the segment sends out three messages, the need for funding, the lack of resources in communities, where there is a high dependency on social welfare and the importance of projects like the one featured in the face of problems such as drug addiction and despair. The project's organiser alerts us to these issues in his interview. He says:

> ... in an area like this, where there is nearly 80 per cent unemployment ... the bulk of families live on social welfare as their main source of income. The kind of resources wouldn't be available in the community to allow the kids to experience these kinds of things. Young people drift into the drugs scene through a sense of hopelessness, and again, projects like this can offer some chance that life isn't just a drab.

This piece exemplifies the tendency to depend on the agents of the poor rather than the poor themselves in making these appeals. While it is conceded that it may not always be possible to hear the voices of those who are in need (because of a handicap for example) the appeal films tend to mediate the experience of those who are poor through the voices of those who are working with and for them.

Case (4) *A Centre for Autism*

This film segment lasting one minute thirty seconds was one of three segments which dealt with mental and physical handicap. All three invoked

similar production techniques and images, using appropriate music, show-ing those with mental and physical handicap in heroic poses, but always shot in slow motion while their agents were filmed in 'real time', explain-ing their work and appealing for money.

The appeal used a soundtrack consisting of Mary Black's song *No Frontiers*, suggesting perhaps the unlimited possibilities for these young autistics if funding (charity?) was made available. Visually, the piece consisted of a series of images of the centre's director explaining autism to a collection of images of the centre's clients. All of the ten shots of the autistic youths were shot in slow motion showing them in a variety of poses from working in the centre's garden, to feeding animals, and active in the centre's work-shops.

The technique of using slow motion shots in this segment as well as the other segments which dealt with the physically and mentally handicapped is an attempt at creating a sense of pathos, appealing to the audience on an emotional level. In line with the arguments made earlier about the por-trayal of the unemployed and homeless youths as 'doers', deserving of our charity and sympathy, a similar set of techniques were adopted in portray-ing the autistic youths shown in this film. The audience were therefore offered images of these youths engaged in a variety of activities against all the odds stacked against them.

Verbally, the piece contained a more hard hitting series of messages. The centre's director in speaking to camera asserted that '... the more handi-capped people in Ireland are, the more deprived they are of rights ...' adding that:

> ... young people with autism are the slaves of the twentieth cen-tury – they are forced to comply, they have no rights of their own. They are stripped of their dignity. They have no funds of their own. They are disenfranchised, and unless we start giving them that dignity back, we are doing nothing for our people.

Discussion

The 1992 *People in Need* Telethon may be judged to have been successful in terms of both the amount of money it raised (£2m) and in its audience rat-ings.[18] But just what does this type of media activity tell us about the issue of poverty in Irish society?

In some respects, this type of television can be viewed as a form of specta-tor sport, where the focus is on society's elite figures, who act vicariously on behalf of the audience. Credit card donations are made with the great-est of ease, while even where ordinary donors raise money through fun-

18 *The People in Need Telethon* was fourth in the *TAM Top 20* ratings during the week it was broadcast. It scored a maximum 16 per cent of all viewers (520,000). It is interesting to note that on the evening of its broadcast RTE's *Winning Streak* lottery programme attracted 27 per cent of all viewers.

filled events the focus is on the novelty of those events, rather than the ends to which these events are organised. At best, there are veiled ambiguous references to 'good causes' and charity. But even where audience members participate in the programme as either donors or participants in fund-raising events, their activities are removed from the ultimate beneficiaries of their donations. Thus, we can say that the Telethon allows for a form of passive detached giving whereby the donor (corporate or individual) is absolved from any questioning as to why need and poverty exists.

As a media activity, we can also regard the Telethon as a drama, whereby the issue of whether or not the programme can raise the targeted amount is played out for fourteen hours. The programme is driven by a crisis which needs to be resolved on or before its completion. The underlying reasons for the potential and real crises are never referred to. Within this drama those involved both directly and indirectly engage in a form of self-congratulation about their activities and this form of television suggests that society is able to contain problems of a social and economic nature through the generosity of some of its members. There are further elements of drama within the appeal films, such as the Cork homeless boys piece. Here, the producer used the device of ending the film with a 'cliff-hanger' statement, familiar within television drama, to emphasise that young homeless boys were dying from drug abuse.

Telethon television is a hybrid form of programming, which is intertextual in make up combining as it does many different types of television programme, such as the game show, quiz, and popular music programme. The location of this type of media activity within the entertainment's division of television serves to ensure that the focus of Telethon TV is of a light-weight nature and thus the possibility of examining, even in passing, the causes of such problems is not allowed.

From a semiotician's point of view there exists a wide range of often contradictory symbols and messages about those who are poor and in need. Taken as a whole, the particular programme which I have discussed here is replete with contrary images and messages. Poverty and need are juxtaposed against the glamour of the elite star personalities and the consumer goods which many people will never be able to afford. We see images of de-industrialisation and the retreat of capital, mixed with images of companies offering cheques to alleviate need. We witness the stars and personalities – many of whom are rich and comfortable – doing their bit for the largely invisible recipients of this charity. The focus therefore is on those who are helping the needy either as helpers/representatives or as donors to the collection.

To vary somewhat Golding and Middleton's (1982) delineation between God's and the Devil's poor – what in practice we see are the angels, who help those who are deemed to be needy and very little of the Devil's or undeserving poor. Even those who might in the mind of the general pub-

lic be a 'threat' undergo a quick catharsis and become examples of those who are worthy of our charity. Added to this is the editorialising which takes place as to the content of the appeal segments. The homeless boys become 'good boys', no reference is made to crucial aspects of Traveller culture so as to placate the perceived viewpoint of the middle-class members of the audience.

Those who consider themselves to be pragmatists or those of a consensus oriented political persuasion might suggest that I have read too much into the meaning of Telethon television. They might argue for instance that: (a) The Telethon is after all better than nothing. (b) The filmed segments only serve to convince the audience to put their hands into their pockets to give to people who are deserving of our assistance. I do not doubt the good will of (most) audience members for a second, but I believe firmly that there are a number of serious issues to be addressed in relation to this form of television programming. First of all there is the question of the entry of a public service television station into the field of fund-raising and charitable activities. One might question the appropriateness of the media mopping up the poverty mess which the failure of other state agencies has caused. One might also ask whose interests this kind of activity serves – the public in general including poor people or does it serve more particularly the interests of the status quo? Would it not be better for television to spend an equivalent amount of time in looking at the real causes of such poverty problems? The answers to the latter part of the first question and to the second question are of course resounding yeses.

Telethon television may be seen as contributing to the media's hegemonic process in a twofold way. It offers the powerful a role to play as benign figures who help those who are relatively powerless. This serves to ensure that the status's of those who help out are reaffirmed and not questioned in any way. It in turn re-emphasises the ideology of voluntarism which views the responsibility of solving problems such as poverty and need as being within the bailiwick of individuals, organisations or communities. The politically powerful, the comfortable and the rich are vindicated in terms of their responsibilities. The seriousness of social problems and their implications for people's lives are in turn trivialised by framing the media's response to such problems within the realms of entertainment events which occur on a biannual basis. There is of course the more insidious (and admittedly harder to quantify) problem of this type of television programme creating the illusion that something is being done about poverty and need, when in reality the amounts of money raised are relatively tiny.

At best, Telethon television offers a mere twelve to fourteen hours of attention on an annual or bi-annual basis to only some poor people. In another context Katz (1980) wrote of the sense of occasion during media coverage of events. This is particularly true of the Telethon where audience members are encouraged to participate directly in the making of the pro-

gramme. But while 'everybody', as the programme's slogan suggests, is encouraged to be involved, the reality is that those who can't afford to give are excluded.

There are also specific ideological issues to be addressed. In this chapter I argue that there are dominant sets of messages emanating from the Telethon. These are:

1 Television has a role to play in helping to solve social problems. The causes of such problems, such as the nature of the economic system or class inequalities, are, however, ignored.

2 Voluntarism and charity are seen as desirable and feasible in terms of the solution of poverty problems.

3 Capitalism is okay and individual companies and multi-national corporations have a role to play in either offering sponsorship or donations. No reference is made to poor pay, working conditions or tax avoidance for example, all of which either directly or indirectly can be responsible for inequality and poverty.

4 As a rule we only ever see God's or the deserving poor – in only one instance out of nine do we observe the Devil's or undeserving poor. But as I have argued above, these poor people whom we might otherwise dismiss become quickly transformed into those deserving of our help and charity.

This form of television therefore perpetuates the notion that there are two types of poor. The audience are served the myth that charity is the correct answer to poverty and that the deserving poor are the ones to whom we should direct our attention. The opposite is also true in that by defining who the 'real needy' are the remaining poor are not only ignored but also further demonised and excluded. These myths, therefore, serve to underpin the status quo and are comforting for both the social and political systems and some audience members.

In a brief, but very useful critique, of the emergence of Telethon television in a British context, Golding noted the paradox which is involved in this type of television programming:

> The paradox for the government is that in unleashing the charitable tiger it has barely held on to its tail. The land is alight with stark and forceful images of homelessness, child abuse, the old, the sick and the lonely as the iconographers of plenty have been let loose on the underside of Thatcherite Britain. (1991:51)

Paradoxically, Golding noted that, despite all the coverage given to the poor on these television spectaculars, the actual amount which the public are giving to charity has in fact decreased from £1.97 per month in 1990 to £1.28 per month in 1991.

With the exception of Ruddle and O'Connor's (1993) study, there is very little in fact known about charity trends in Ireland.[19] A pertinent question

for future research to ask might be whether existing charities have been affected by new fund-raising of the Telethon kind. There is, however, some evidence to suggest that the rise of large scale entertainment based fund-raising such as Telethon television has contributed to charity fatigue amongst potential subscribers. In 1992 for example the St. Vincent de Paul Society received a special once off payment of £1m from the Irish government because they were in competition with other charities such as Telethons which were raising money for the poor at home and abroad. By far the most disturbing dimension to this form of television is the collective sense of denial that both the audience and the programme presenters, reporters and participants enter into by holding onto the comforting notion that charity is the answer to poverty.

Writing in an American context, Rapping (1983) has correctly described this type of television as a form of black comedy, where despite the seriousness of the problems lurking 'out there' in the real worlds of poverty and unemployment, broadcasters and audience members collude with each other to believe that charitable solutions are both feasible and desirable.

Finally, what are the moral implications of Telethon television? This question has already been explored by Tester (1994) and Ignatieff (1985). Although Tester's (1994) text *Media, Culture and Morality* is essentially an attack on the Cultural Studies paradigm, the book contains an interesting set of arguments about Telethon television which I wish to consider.

Tester argues that the media, and especially television, are an important source of moral knowledge, yet they also function to inculcate audience passivity in the face of serious moral problems. The media can alert us to the horrors of famine, war and poverty, but to what end? Audiences may be stirred into action having witnessed the awfulness of images of famine and poverty or conversely these very images may be viewed by audiences in a voyeuristic way and result in little or no response.

Tester sides with the view that, in general, media coverage of problems like African poverty and famine result in audience passivity rather than stirring them into action. He tells us 'Although I feel very moved and upset by the television pictures of naked and shivering children in Ethiopia, actually I do nothing - or at least very little - about it. Certainly, I do not do *enough* about it.' (1994:94)

Live Aid stands out for Tester as being the exception to the rule. He argues that in this case the media functioned both to identify moral problems and to suggest appropriate responses to those problems. He asserts that the importance of *Live Aid* was not however simply in the amounts of money it raised for Third World famine relief, but also in the fact that it underlined the notion that the medium was as (if not more) important than the mes-

19 Ruddle and O'Connor (1993) suggest that the mode amount given per month to charity in Ireland is £2.

sage itself. *Live Aid* functioned to remind its viewers and participants that the Global Village made possible through technological innovation was in fact a divided village, requiring an immediate response from those in the developed world. Tester's arguments are in general agreement with the findings of this chapter. Yet he does not adequately explain why Telethon television is the exception to the rule. The persistence of the phenomenon of Telethon television since *Live Aid* seems to indicate that in the short to medium term, audiences are interested in, and willing to respond to, these media events albeit in a way which does not challenge their own relatively comfortable positions. A clue as to why audiences may react positively to Telethon television and not to news and current affairs coverage may lie in the fact that in Telethon television, the images we see of poverty and need are sanitised and relatively invisible in the wider context of a programme which emphasises entertainment and fund-raising. In many respects, as in the case presented in this chapter, the Telethon is often more about portions of the audience themselves as opposed to their objects of charity.

The indifference which Tester attributes to the television audience of the 1990s may be as a result of either over exposure to certain images which have ceased to be shocking, or perhaps indicative of an audience who have come to accept the view that there is little or nothing which one can do about inequality and poverty. Indeed, the rise and continuance of Telethon television itself may partially answer why audiences do not generally respond to moral crises which the mainstream media report on. Audiences have learnt to respond to moral problems on a cyclical and seasonal basis. Moral problems such as poverty, inequality or famine must wait for the annual Telethon in order for the audience to be motivated.

4

Unseating the audience
Current affairs television and the coverage of poverty

Introduction

Using the ethnographic approach, some secondary sources and a qualitative analysis of an edition of RTÉ's *Tuesday File* series, this chapter is concerned with both the production processes and message systems involved in the current affairs documentary *Are You Sitting Comfortably?*

This particular documentary was subjected to a detailed analysis for a number of reasons. Firstly, it was the only programme within the 1992–1993 series which had Irish poverty and inequality as its sole focus. Secondly, it was the stated intention of the programme's creator to make a personal essay-style programme in which one man would offer the audience his views on Irish poverty. This discussion, based on in-depth interviewing and observation at RTÉ, is intended to give the reader some insight into how programmes are shaped by the environment from which they emerge. The production of documentaries which have the expressed intention of being 'dangerous' to some of their potential audience can often fall foul of those wishing to preserve the status quo. In taking *Are You Sitting Comfortably?* as a case study, my initial concern is with how the programme was conceived, researched and developed by its producer. I describe how the programme idea came about; how and why it was selected by the programme team and how it was filmed and edited. A further concern here is with the ethical considerations involved in filming people who are poor. The penultimate section of this chapter is a detailed qualitative analysis of the content of *Are You Sitting Comfortably?* This account is followed by a discussion of the form and structure of the programme with a particular focus on the use of symbols in articulating a set of obvious and hidden messages about poverty. Of specific interest here is the extent to which the documentary deviates from the dominant Irish current affairs paradigm, as described by Kelly (1984b).

Tuesday File: Background and history

The origins of the *Tuesday File* series, which began its life in 1992, lie in the break-up of RTÉ's flagship current affairs programme, *Today Tonight*.[1] The birth of *Tuesday File* in controversial circumstances must be appreciated prior to addressing the question of how it has presented the issue of poverty.

In 1992 RTÉ decided, for reasons touched on below, to reorganise its current affairs output into five separate segments. The intention was that these would deal with social, economic and political issues through an audience-based discussion programme (*Questions and Answers*); single issue documentaries (*Tuesday File*); commerce (*Marketplace*); political issues (*Prime Time*) and a largely one-to-one interview-based programme (*Farrell*). The official RTÉ position was that *Today Tonight* had run its course; it had by 1992, in the words of one manager, become 'a jaded programme'.

Matters were not helped by the fact that the *Six-One News* programme had been lengthened, and had begun to feature in-depth interviews with senior politicians. Thus, what was traditionally viewed as the sole concern of current affairs television had come under threat from developments within the news division. Technical developments, in the form of an improved Dáil (Irish parliament) studio and the use of video instead of film, facilitated these changes. More than anything, however, declining audience ratings sealed the fate of *Today Tonight*.

Divide and rule?

This restructuring of current affairs television was viewed by many people, within and outside the organisation, as an attempt to muzzle the investigative powers of RTÉ's current affairs department. For a number of years there had been suggestions by political parties, Fianna Fáil in particular, about the supposed left-wing ideological hue of some of the reports produced by *Today Tonight*. A major case in point was *Today Tonight*'s detailed and sustained coverage of the Fianna Fáil government's health spending cuts in 1989, a factor which many in the Fianna Fáil camp say cost them the 1989 general election. Rumours of infiltration of RTÉ current affairs television by Workers' Party activists abounded. Whatever the merits of these allegations (and they certainly should be questioned) *Today Tonight* did produce some hard-hitting investigative reports on the illegal activities of moneylenders, rural poverty, drug dealing and property speculation.[2] In the final years of the Haughey era, programme makers began to experience increasing difficulties in getting government spokespersons to participate

1 See for example, Dawson (1992). For a more detailed account of the dismantling of *Today Tonight* and the decision of one of its former presenters to resign from RTÉ in protest at the new format of current affairs television, see Foley (1994).

2 See, for example, Raftery's (1991) account of the background to RTÉ's attempts to uncover the illegal activities of Patrick Gallagher.

in such programmes as *Questions and Answers* and *Today Tonight*.[3] RTÉ responded to these difficulties by reorganising its coverage into five stand-alone programmes.

In practice, the breaking up of the long-standing and more flexible *Today Tonight* format meant that programmes were now in competition with each other for both stories and resources. In adopting their strategy, RTÉ's management was taking the view that current affairs could be neatly carved up, and that the social, political and economic spheres could be investigated separately. A poverty story, for example, would now run the risk of being relegated to the social end of the spectrum without addressing the economic or political dimensions of the problem. There was the further obstacle that from now on only two of the five weekly programmes coming from the current affairs stable would have up-to-the-minute reports on events as these unfolded. The problems with the new structure were perhaps best exemplified in 1994 when the Downing Street Declaration – announced on a Wednesday – had to be covered by *Marketplace*, the business current affairs programme. This subdivision of current affairs has been criticised by some programme personnel who have described the new format of programming as 'limp'. One senior figure felt that the restructuring did not come about as a result of political interference, but the end result of a weaker set of programmes certainly helped to take the heat off the powerful in Irish society.

In an internally circulated document of March 1994, programme makers criticised the compartmentalisation of current affairs and questioned the judgement of some of their editorial colleagues. Added to this was a concern about the introduction of programmes (for *Tuesday File* in particular) which had been made by independent production companies. Some felt that such bought-in material ran the risk of being compromised by private sector interests (see Kerr (1994a; 1994b)).

The splitting up of the *Today Tonight* programme served to generate some fear and disquiet among those staff members committed to placing critical current affairs stories onto the agenda. According to one senior journalist within current affairs, the key issue was that of dividing up resources, which would in turn weaken the programmes' efficacy as an investigative medium. This individual said:

> At a time when this country still faces serious issues of poverty, inequality, fraud, business and political scandals, the public needs investigative current affairs programming with the same resources that existed in the 1980s. People's jobs are not on the line; this is motivated by journalistic standards and professional independence.

3 It has been suggested in some quarters that the refusal of the ruling party, Fianna Fáil, to co-operate with the makers of in the supply of ministers for the programme's panel was what led to it being rescheduled.

It was not so much the departure of the programme itself – most staff acknowledged that its time had run out – but rather the lack of space for serious investigative reporting that was (and is) viewed as the problem. So to what extent did *Tuesday File* address these concerns, and what implications did these changes have for the exploration of poverty and other social problem issues?

Constraints on poverty coverage

We can identify four main problems that conceivably might militate against the inclusion of poverty coverage in the *Tuesday File* programme. These are:

1 The compartmentalisation of the programme into separate issue types.

2 The need to bring in higher audience ratings than its predecessor, *Today Tonight*.

3 The limited amount of time allowed to produce documentaries.

4 The fact that some programmes are produced by the private sector.

As a component part of the new structure *Tuesday File* was to be a single issue investigative documentary series. Nineteen programmes were to be produced in the 1992–1993 series, ten of which were produced by RTÉ personnel and the remainder by the independent sector. The likelihood of poverty being considered as an issue for examination would therefore have to fit into the criteria of being 'interesting'. Even if it was covered as a story, it would almost certainly be excluded from consideration for the remainder of the series. There was the additional problem of reducing a multi-dimensional phenomenon like poverty to a single issue so as to make it fit within the constraints of the programme's structure.

Targeted primarily at a young urban audience,[4] the programme sought to maximise overall audience ratings. The fact that the programme was to be ratings-driven (and relatively successful in this regard) and that many programme-makers felt that poverty stories would not be the most popular with viewers placed a further constraint on the likelihood of coverage of poverty as a current affairs story.

4 An internal document, prepared by RTÉ's Audience Research Department in April 1993, revealed that in terms of audience interest in the programme, the adult series average viewership was quite high at 22 per cent (696,000 persons). Audience appreciation scores are available for 17 of the 19 programmes broadcast in the 1992–1993 series, and they indicate a high level of satisfaction with Tuesday File, averaging a positive 87, with the range running from 80 to 90. The programme had more rural than urban viewers. The average rural figure stood at 30 per cent, which is 12 per cent greater than the urban viewing rates of 18 per cent. In terms of social class, there were similar ratings for upper/middle (ABC1) classes (19 per cent) and working/other classes (C2DE) (21 per cent). The one worrying finding for the programme team was the relative lack of interest among those younger viewers at whom the programme was specifically aimed. Audience figures for 1992–1993 suggest that those in the 35 years+ category were more likely to watch the programme; in fact, a peak of 40 per cent was achieved in the 65 years+ age group. There seems to be less of an interest amongst 25–34 and 15–24 age categories, both turning in just 17 per cent and 9 per cent respectively.

The new format of programme making was to allow six weeks for the making of each programme – two weeks each for research, filming and editing. This time frame was criticised by some programme makers as being far too short to create incisive and critical documentaries about potentially controversial social issues. In the view of one senior producer, the most critical and influential documentaries often take many months (even years) to make. Programmes which might examine the fraudulent activities of the wealthy or the survival strategies of the homeless, if they were to be made properly, would require considerable time and resources.

A further problem with the new *Tuesday File* format was that some programmes were to be sourced outside of RTÉ. Thus it was contended by some insiders that given that these programmes were coming from the independent and private sectors, there was a danger that potentially controversial social issues would be ignored. In practice, these fears seem to have been realised with the majority of the more critically acclaimed programmes coming from within RTÉ.

Getting stories on to the *Tuesday File* agenda

We can divide those involved in current affairs television into proposers and gatekeepers. At the base of the hierarchy are a range of people who attempt to get their ideas accepted as possible programmes. These may be motivated by personal professional/career reasons, by an interest in the subject itself or by empathy with the cause, individual or group which becomes the basis of the programme. In the middle of the hierarchical structure, the series editor may be seen to act as both proposer and gatekeeper. He/she will suggest possible programme ideas to producers, researchers or reporters and expect them to develop these ideas as potential programmes. But he/she also acts as a gatekeeper, in that standing in the middle of this pyramidal structure, he/she will often reject programme ideas on the grounds that they will not be acceptable to those further up in the hierarchy or, perhaps, to the powerful in the outside world.

At the higher level of the structure, the gatekeepers can block the making of potential programmes or indeed stop the broadcast of completed programmes. Those who control the final output of current affairs television may be said to be concerned with a number of issues in this regard. Their gatekeeping function may be seen to stem from:

1 Their desire to exercise due care with regard to the sensibilities of the powerful in society.

2 Their awareness of the statutory and legal constraints on broadcasting.

3 The parameters of the current affairs agenda as they perceive it.

The contention within which *Tuesday File*'s predecessor, *Today Tonight*, sometimes found itself, and its ultimate demise, reminds us of the pressures which can be and are brought to bear on the media by sources outside the broadcasting environment. The gatekeepers are also conscious of

the statutory and legal constraints which frame the production of current affairs television (see Kelly (1984b)). As a public service broadcaster, RTÉ is bound by statutes which insist that programmes be 'balanced' and 'fair'. Top management is increasingly aware of the risk of litigation in the form of libel suits against RTÉ.

A further constraint takes the form of what the gatekeepers see as the appropriate concern of RTÉ's current affairs agenda. With the resignation of one of its senior presenters in 1994 in protest at the constraints of the new format of programming, at least one media commentator pointed out that RTÉ's current affairs division was being encouraged to produce lifestyle programmes. He added that 'It can make programmes about social problems, but there appears to be little appetite for material that will rock the boat or annoy the government.'

Awareness of poverty within current affairs television

The issue of how the poor are portrayed by RTÉ current affairs television has been the subject of some debate among programme personnel. From my observations at programme meetings, and from interviews and informal chats with producers, reporters and editors, there appears to be at least some awareness of the media–poverty question. In particular, a number of programme-makers worried about:

1 The under-representation and misrepresentation of poverty and poverty-related questions.
2 The damage that other current affairs, news programmes and print media had done in deprived areas in the past through the misrepresentation of issues, thus building up distrust between communities and RTÉ.
3 The possibility that programmes, emanating from a middle-class world removed from the realities of poor people's lives, could be patronising to the poor.
4 The possibility of audience lack of interest in stories about unemployment or deprivation.
5 The pressure which production constraints exert on the telling of realistic stories about the poor.

Is there anything new in it?

From speaking to and observing those involved in the production of current affairs television, one is struck by the extent to which programme personnel comprise a collection of individuals clearly aware of, and committed to, a wide range of political and social issues. At the beginning of my fieldwork I wondered why this did not translate into more coverage of poverty-related issues. The view which dominates current affairs thinking on this matter holds that the topic is covered now and again and cannot be given attention all of the time. The current affairs agenda, it is

suggested, is set by events beyond the control of programme makers; issues, such as elections or divorce legislation, must therefore be covered.

However, some production personnel believe that there is resistance to covering poverty as an issue, because it has been done before or there is nothing new in the 'story'. In the words of the programme editor:

> There is a resistance to going down and looking into someone's groceries and seeing what they have ... in looking at the every-day issues dealing with poverty, because there is a feeling that it has been done before. The motivation is to do something that has not been done before ... but this viewpoint is some way coun-tered by the ground rules which are to accurately reflect and investigate stories of current interest in Ireland and obviously poverty is one of those issues.

Current affairs television is similar to news television in that the value sys-tem which governs the selection of 'stories' about poverty distinguishes between the permanence of poverty on the one hand, and 'events' sur-rounding poverty which sometimes become newsworthy on the other. Another pertinent issue here is the self-consciousness within the organisa-tion of being part of a liberal, middle class Dublin 4 culture.[5] On many occasions, programme personnel mentioned this issue in either a serious or a humorous way. Most of those involved have had no direct experience of poverty or long-term unemployment. Consequently, in making current affairs television programmes, the issue of whether a feature on poverty or unemployment might seem patronising was a regular topic at meetings and during coffee breaks.

There was a discussion at one production meeting about the need for cur-rent affairs television to cover the issue of unemployment during *Jobs Week* in February 1994.[6] The way in which this topic was discussed and turned over by programme personnel yields some interesting insights into how poverty and the poor are viewed.

Many opinions were aired on the question. One producer argued that RTÉ had in fact not done enough in terms of critical coverage of unemployment. The view of another was that the proposed programme might attempt to dispel the myth that it is possible to do something about unemployment. A programme reporter responded to this suggestion by saying that the pro-gramme should not focus on unemployment as experienced by the unem-

5 The RTÉ campus is physically located in the postal district of Dublin 4, but the use of the term is meant to suggest that it belongs to a mindset which is urban, liberal and middle class. Fennell (1986, p.54), in one of his many critiques of RTÉ and liberalism, suggests that '... RTÉ functions, not as a forum and as an expression of our nation, serving our national interests, but as a propaganda agency of Dublin's Anglo-Americanised bour-geoisie, serving the interests of that class, and of the London–New York axis in Ireland.'

6 During this week a number of RTÉ programme slots were given over to the issue of unemployment. The programmes concerned used discussions, dramatisations, advice as well as current affairs coverage. Programme teams, it should be noted, were responding in all this to a directive from the station's management to cover the unemployment issue.

ployed. To do this might be perceived by unemployed viewers as 'another example of RTÉ's patronising attitude to the unemployed'.

It was added at this point that a conflict existed between the comfortable, middle class culture of RTÉ and the hinterlands of unemployment and poverty outside of the broadcasting organisation. Such a viewpoint was repeated to me regularly in interviews and conversations. That viewers are not interested in gloomy, depressing coverage of unemployment and deprivation was also stressed. If this planned programme was 'just another unemployment programme', a reporter imagined that many unemployed viewers would 'just switch off and go down to the video shop and take out *Lethal Weapon 4'*.

At the end of this discussion it was decided to:

1 Commission two video-diaries to be made by film makers from the independent sector, thus allowing the unemployed to speak for themselves and avoid using 'experts'.

2 Produce a drama documentary about unemployment.

3 Produce a programme which would challenge the myth of full employment.

4 Focus on the 'positive' side to unemployment by making a programme which would deal with local responses that took the form of community self-help action.

Ultimately, *Tuesday File* made a documentary entitled *Coming To Terms With Redundancy* (broadcast on 18 February, 1994), which examined the aftermath of the Digital factory closure in Galway. This programme focused on the 'human' story behind the 300,000 unemployed people in Ireland by exploring how six of the 780 people made redundant by the Digital Corporation were coping with becoming unemployed. This programme was set in a comfortable upper-middle class housing estate in Galway City and focused on examples of the 'new poor', a theme which also occurred within RTÉ's television news coverage of poverty at this time.

During the second season of *Tuesday File* (1993–4) the programme's editor suggested running a series of video-diaries that would permit individuals or communities to make their own features under their own editorial control. This suggestion, in his words, was an attempt to 'Get away from us spooning out our views on poverty when we have not got a clue what we are talking about'.

While in some ways welcome, a potential difficulty with this approach was that the use of video-diaries would further marginalise poverty and other social problems by pushing them out of mainstream coverage. These video-diaries did not in fact materialise, due to what was perceived as the poor standard of applications.

As well as a self-consciousness about patronising the poor, programme-makers are aware of the growing resistance to media misrepresentation of

deprivation in some communities. It is a current credo that good relations should be fostered between RTÉ and those it films. This has come about because of alleged abuse and misrepresentation of deprived areas in the past. In the words of one producer:

> It is the oldest story in the book, and every producer knows it, because we go into places and we pick up the debris from the last producer or journalist who was in there, or newspaper reporter who just came in, grabbed a story and ran it with a headline, and the people just feel appallingly used, so that they are very apprehensive and nervous and I recognise that, and I don't think that it is any of our business to use and abuse people like that, especially if they help you do the job that we have to do.

Perhaps the most tangible evidence of disquiet among some programme personnel is found in a report written by one programme reporter at the close of the first season of *Tuesday File*. In an internally circulated document entitled *An Informal Survey of Attitudes to RTÉ and Current Affairs Programming* (1993); the issues of how RTÉ was perceived generally, and of responses to current affairs programming in particular, were examined in four communities with 75–80 per cent unemployment levels and serious social problems.

This report notes that the question of RTÉ's credibility within some deprived areas had surfaced earlier following previous negatively perceived portrayals of poverty-related issues. The researcher, in fact, had encountered co-operation difficulties in one of the four areas because of the manner RTÉ had portrayed the community in the past. The researcher states 'In […] in particular, where RTÉ had done a special news report in March, I was told categorically that RTÉ would neither be welcome nor safe in the area at this time' (1993: 3). Nor was it just recent negative coverage which had caused problems; there is a passing reference to a 10-year old programme within the *Today Tonight* series which continued to attract a great deal of negative local reaction. The researcher in fact was told that 'The *Today Tonight* programme on […] is still talked about. People here don't trust RTÉ.' (1993: 9).

The survey's respondents were critical of RTÉ's coverage; they suggested that programmes were out of touch with the reality of their lives. Respondents were also critical of the negative imagery used by RTÉ in covering stories about poverty and unemployment. One unemployed respondent related how 'A recent news programme from Cork had seven minutes of negative feedback, showing deprivation and depression. I waited for *Home and Away* to come on instead and feel most unemployed people would do the same.' (1993: 5) By focusing solely on the social problems associated with those communities, the station is accused of helping to ghettoise these areas. Thus the report states 'Programmes which focus unremittingly on the negative aspects of unemployment, that feature poverty, social problems and crime in specific areas only add to the problems in those areas.' (1993: 12).

The report ends with some hard-hitting comments about RTÉ's current affairs coverage of districts experiencing high levels of unemployment and poverty. It concludes by suggesting that:

> The problem is with us. We either visited them in a patronising way and allowed the wrong spokespeople to speak for them (usually overused experts) or we've compounded the problem by highlighting only the bad in the community, thus making it even harder for them to keep positive initiatives going. (1993: 15)

More positively, the report argues for a series of programmes that would feature communities fighting back through collective self-help initiatives.

Although based on just a small set of opportunity samples of community activists the findings of this report, are nonetheless very revealing. Yet, the report was to elicit no formal response, either from RTÉ generally or from its current affairs division.

Are You Sitting Comfortably? Views from within current affairs television

From a broad consideration of how poverty issues are seen within current affairs television, I now examine the production of the documentary *Are You Sitting Comfortably?* According to the programme's producer, this documentary programme was '... designed to do something dangerous ... it was designed to make people uncomfortable'. Based on an image used by the programme's subject in which he sees Irish society as divided between the well-to-do and the deprived, the programme's title and contents were intended to make audience members sit up and think. In the words of the producer:

> The intention was to fling it at the audience and say 'You, there! Are you sitting comfortably? And if so, should you be thinking about what is going on around you, and why are you sitting comfortably when others aren't?'

The programme was targeted primarily at the politically and economically powerful, the well-to-do and the rich.

Selection

A practical consideration stood for much in the selection of this potentially controversial programme theme. *Tuesday File* was a new series, and at the early stages of its run, producers were under pressure to produce material with relative speed. The programme's producer had initially been working on a programme which would deal with teenage pregnancy. He changed his mind, however, believing that the issue would require more time if the programme was to be made properly. As an alternative, he suggested to the programme's editor that a full programme should be given over to Fr. Peter McVerry and his views about Irish society.

The need to meet a deadline and fill a programme slot was therefore to the

forefront of the editor's and producer's minds. At a programme planning meeting, the idea was presented and accepted. The programme editor was attracted to the idea because of the 'novel' way in which the documentary would deal with the issue of the poor and marginalised. A well-known man, champion of the cause of the poor, would be given free rein to air his views. As the editor told me:

> That was one of the attractions of the McVerry programme … I had not heard the idea before … It was a new way to cover it. Immediately once the producer had come in and said 'Here is what I would like to do', it was supported and it was 'go for it'!

The programme idea may have been acceptable to the programme's editor, but there were several other hurdles to be overcome before the programme was finally broadcast.

Balance and control?

The short-lived debate concerning the balance and content of *Are You Sitting Comfortably?* provides an interesting insight into the production context of this particular programme. The programme, it has been suggested in some quarters, ran into some early difficulties with RTÉ's management.[7] One source revealed to me that resistance was encountered for two reasons. Firstly, it was felt that the programme should not be broadcast because it was seen to be 'too down beat … too negative'. That this viewpoint held little sway, however, is clear from the facts that the programme was not stopped, and that the Director General of RTÉ did not request to view it prior to broadcast. It was also been hinted that the programme's subject (Fr. McVerry) was seen by certain people in RTÉ, and by the major political parties, as being an anti-establishment figure and that this was sufficient to kindle fears about the programme's message. According to one senior source – who was critical of print media coverage of this 'controversy' – what in fact happened was as follows. After being accepted at a programme planning meeting, the idea was placed in the advance plans for *Tuesday File*. At this point, a senior manager raised a number of questions concerning the issue of programme balance. Some consideration, he believed, should be given to the possible implications of allowing Fr. McVerry a whole programme to air his views. Would this mean that others should be allowed as much time within the same programme slot to air their opinions? He raised the possibility that the programme might be better off within a set of programmes that had personal statements as its focus.

Editorial discussions followed concerning the implications of making such a programme. It was agreed that the programme could be made and broadcast within the *Tuesday File* series. As well as the issue of balance, some further concern was expressed about the content of the programme,

7 See, for example, 'Affairs of the Nation' in *The Phoenix* (30 October 1992), and Joe Jackson's interview with the programme's former presenter, Emily O'Reilly, in *Hot Press* (2 December 1992).

which was felt to be intentionally controversial and in the words of one well-placed source, 'an eye would be kept on it' as it was being made.

The programme's producer did not engage in any rows with management about the content or message of the programme. Some discussions did take place between his line managers and management on the implications of making such a programme, but the concerns that had been raised quickly petered out. While the programme was in fact made and broadcast, we can see that management had laid down clear markers about their concerns.

Researching the programme

After receiving the go-ahead from the programme editor, the programme producer set about writing and researching the documentary. The decision to focus the documentary on Fr. McVerry was based on knowing him personally and empathising with his work with the homeless and dispossessed.[8] Fr. McVerry was approached and agreed to participate in the documentary.

Extensive interviews followed to ensure the producer understood Fr. McVerry views. Such an approach, the producer believed, would allow Fr. McVerry to set the agenda. Simultaneously, it would allow the producer to check the consistency of the views being expressed. From all this material, the producer had to decide what would be feasible from a production point of view. As he pointed out to me:

> Amongst the many things which agitated him, I had to make the decisions, to say we will do this and this. He [Fr. McVerry] set the broad agenda and then I vetted that. I was the one who had to make it into a television production.

Filming and editing

The filming of the programme began with a very long interview with Fr. McVerry. This was followed by shorter interviews with him at a number of locations. Shots of Fr. McVerry talking to people who worked with the poor and dispossessed were filmed. The producer felt that this was the best way to allow Fr. McVerry to tell his own story. Yet from a production point of view difficulties were soon to be experienced in trying, without using a reporter as intermediary, to build a programme around the subject's own words.

In the end only a fraction of the hour-and-a-half of filmed interview was used in the actual programme. The producer explained his predicament in the following terms:

> The decision was that McVerry would have the bones of half an hour ... the production would be slave to that ... it was my job to give that force and impact on a television screen ... the danger

8 For an autobiographical account of McVerry's life and work, see McVerry (1994).

always was that it would be an illustrated lecture … that was the challenge to me … it might just be a sermon from a priest … so I had to transform it or try to transform it into something more, something that worked on television … and it obviously was going to need all the production resources that it could possibly have … because a lecture for twenty-six and half minutes will not work … so that was one opposite and the other was an interesting and dramatic television programme and I had somehow to get the two together … and it was very hard work.

At least two segments of the programme were filmed only to be dropped by the producer. Fr. McVerry was filmed at an All-Ireland Hurling Final in Croke Park. The intention here was to show a deeply divided Ireland gathered together as spectators. Another segment filmed a district justice speaking about the lack of facilities for young offenders. Later, these sequences were judged by the producer not to have worked and were edited out of the final programme.

One way forward for the producer to create a more interesting programme was to use stylised production techniques, such as the use of stills photography by Derek Speirs. In some respects, the programme producer suggested that there '… was a conspiracy between McVerry and the programme makers …' in using these photographic images to convey a picture of a divided people. This emphasis on a deeply divided Ireland, which Fr. McVerry viewed as central, was one which the producer had no difficulty in accepting. Lists of facts documenting Irish poverty were juxtaposed with still shots of Fr. McVerry pronouncing on topics such as Ireland, politics, anger and inequality.

Ethical considerations in filming the poor

The possibility of the poor being misrepresented was something that preoccupied the programme producer. The documentary included shots of homeless men in hostels, as well as of recovering alcoholics and gamblers in a rural location. Everyone filmed was asked their permission; and anybody who declined was asked to leave the room where the filming was taking place. An interesting arrangement was made between the producer and local residents when examining community-based responses to unemployment and poverty. On account of an alleged joy-riding epidemic, the area in question had attracted considerable negative coverage in the national print media in the previous twelve months. Media misrepresentation was therefore a definite issue among community activists when *Are You Sitting Comfortably?* was being made. The producer told me:

We did not identify that area. It was virtually completely anonymous, okay a North Dublin suburb was said, but I made an arrangement with the residents who co-operated. They obviously were very apprehensive of being highlighted as an area that was likely to get into a conflagration, because of all the youth

disturbance and the absence of facilities, so the arrangement was that I wouldn't identify it. The deal was that they would not be identified by me, and they accepted that and I honoured that commitment.

The producer's position here stemmed from a belief that:

Programmes that are of any worth get very close to people's lives, and they are likely to have an impact on people's lives, otherwise they tend to be pretty forgettable. I have strayed into tending to give a lot of hostages to fortune, because of concern about people who are appearing in programmes, whose lives have to be lived after we've gone. I tend to regard it as a very high priority their satisfaction or acceptance of the programme, and so I offer them the chance to see in some form what is going to be broadcast.[9]

Ultimately, of course, all this sets up a tension for the producer between the need to produce powerful and controversial television and the need to respect the sensitivities of those who are filmed.

Unseating the audience: An analysis of the content of *Are You Sitting Comfortably?*

Even before the audience viewed the actual documentary about McVerry there were warning signals from both the station's continuity announcer and the programme's link-person Emily O'Reilly that a portion of the audience were about to be challenged. The continuity announcer stated '*Tuesday File* now examines the Ireland of Fr. Peter McVerry' and then in a much more dramatic tone 'Are *you* [her emphasis] sitting comfortably?'

There follows the usual *Tuesday File* theme replete with images taken from U2's *Zoo TV*, the Dáil in session, bishops walking after a conference, war imagery and a computer screen running rapidly through lists of names. On the desk holding the computer there is a government report with the familiar icon of Irish officialdom – the harp.

It is suggested in the programme's introduction that *Tuesday File* is concerned with a post-modern Ireland, mixing the old and the new and being full of tensions and contradictions. While it has become a technologically sophisticated society – as symbolised by the computer and modern office setting complete with executive toys – the office's television screen continues to pump images of war, politicians arguing and bishops considering, as well as the government report strategically placed on the desk, which intimates perhaps that there are still many problems which need to be resolved.

The documentary about McVerry's Ireland is prefaced by a brief introduction by the programme's link-person Emily O'Reilly. The post-modern

9 When this man produced a *Tuesday File* documentary which featured inner city drug pushers, *Victims of the Pushers* (broadcast on 9 November 1993), participants similarly were given the chance to view the rough edits.

theme from the programme's introduction is continued with the link-person standing in front of a giant television screen which shows the *Tuesday File* logo in black and red. O'Reilly's introduction serves to put tonight's programme in an immediate context as well as present the programme's subject Peter McVerry. She tells her audience that:

> For the last few weeks the airwaves have reverberated to the sound of middle-class panic. The currency crisis and the hike in interest rates have led to new levels of fear amongst the better off in Irish society. People who once gave to the St. Vincent de Paul are now looking to that organisation for help.

Her introduction however makes it very clear that her audience are not an homogenous entity. She continues:

> But all misery is relative. While some families consider selling the second car or foregoing the Christmas ski-trip, other people are watching this programme tonight from areas with 70 per cent unemployment, where their young people face death from drug use, where homelessness is an everyday reality.

We are then introduced to McVerry whom we are told is a turbulent priest, whose message tonight is designed to disturb as well as to challenge. O'Reilly's introduction also contains images which pre-empt ones which McVerry will himself use in the course of the documentary. We are told that McVerry is frightened by the divisions which he sees in Irish society and that 'Unless there is change, and fast, we will reap a terrible whirlwind'.

In the midst of the programme's post-modern setting we encounter images which are biblical in tone, foretelling an apocalyptic destiny for Irish society if we do not resolve the divisions between rich and poor, or as McVerry would term it, the comfortable and the struggling. The scene is now set for McVerry to tell his story.

Our first glimpse of McVerry is of him travelling alone past the tower blocks of Ballymun at twilight. Rising high into the night sky the tower blocks symbolise both the poverty of urban Ireland of the 1990s and the inadequate responses of the Irish state to a growing urban underclass.[10] These images are in contrast to the classical incidental music underpinning the sequence. The programme's theme is set by McVerry in a voice-over which states:

> I see our society as divided into the comfortable and the struggling. The challenge of the Gospel is to the comfortable. It is to say, you've got to become less comfortable, so that those who are struggling need struggle less.

The sequence then cuts to a still shot of McVerry against the black and red colours of the *Tuesday File* logo with the programme's subtitle *The Ireland of*

10 Ironically, the Ballymun tower blocks are named after the executed leaders of the 1916 Revolution. See Waters (1994).

Peter McVerry underneath and the programme's title *Are You Sitting Comfortably?* on the right-hand side of the screen.

McVerry then responds to questions which are not heard by the viewer about being Irish, anger, politicians and violence. He firstly tells us that 'A lot of the time I'm ashamed to be Irish'.

This statement is made by McVerry in his office. In the background there are black plastic bags containing clothes donated to his hostel for homeless youths. In contrast to the images of expensive clothes which we will see in the shopping centre scene later on in the film, the black plastic bags symbolise the dependence of the poor on the cast-offs which some of the more comfortable in society dispose of.

He then speaks of his anger 'A lot of the time I get very angry and indeed I always say that when I loose that anger I will be no use to anyone anymore.' This statement is made by McVerry while being filmed at the window of his office. We again see the tower blocks of Ballymun in the background. These are a physical manifestation of McVerry's reasons for anger. Next, McVerry tells the viewers that he despairs of politicians. This statement is made while we see a shot of the Minister for Finance, the Taoiseach and the Lord Mayor of Dublin sitting together in a spectators box at Croke Park for an All Ireland Final – symbolising both the powerful and the comfortable. The image of togetherness signified by the politicians and the ordinary spectators suggests that the 'nation' is both united and divided. McVerry also talks about violence warning the viewers that 'We are going down the road of the Toxteths, the no-go areas, the rioting is going to occur in our own cities'.

His warning is embellished by a short news clip of the Toxteth riots. The following sequence opens with a view of the government buildings at night. The shot is of the gates opening slowly. The suggestion is, that these gates are in fact closed to many, and that we are somehow entering a privileged world.

Through the use of a dramatisation, we now see shots of a middle-class dinner party. The camera zones in on a young woman who is finishing her meal. She is one of the comfortable, wearing expensive looking jewellery. The film now cuts back to a shot of the Oireachtas (parliament) buildings at Leinster House which can only be seen through the railings. There is again a suggestion of exclusion for many of the nation's citizens. We now see a series of black and white stills of some of the nation's poor. Unlike the colour of the buildings and parties of the rich and powerful these images are shown to us in monochrome. They show Travelling people living in squalor; a child begging on the pavement while a group of five people queue for their money from a cash dispensing machine; and two poor boys on the street.

In the next sequence we see that the last still photograph of the two poor boys on the street is in fact part of a photograph on the wall of the middle-class dining room. We are back again to the dinner party whose partici-

pants are oblivious to the photograph of the poor boys on their wall. They are engaged in a post dinner discussion, which we as audience members and as the poor do not hear, because we are excluded.

Ironically, the comfortable middle-classes have turned even images of the poor into items which are bought and sold at inflated prices. These photographs are therefore both symbols of contrast and symbols of the acquisitive society. This portion of film pre-empts another of the documentary's later messages which stresses the social distance between the rich and the poor.

The exclusion experienced by the poor is further emphasised by more footage of Leinster House which is shot through the Oireachtas's railings. We are again offered more still shots of some of the nation's poor through the use of black and white photographs. Here, we see a social welfare queue outside of a labour exchange; children waiting for their fathers in a labour exchange and a woman and child begging in the streets.

In the last shot we also see two adults and a child walking past the woman and child who are begging – both of the adults are ignoring the woman while their child has a concerned expression on her face. Both sets of stills photographs have queues in common. For the comfortable, queues symbolise their access to money and privilege while the poor must queue for social welfare payments in order to survive. During this sequence of shots the national anthem *Amhrán na BhFiann/A Soldier's Song* is being played as incidental music. It is clearly intended to be ironic as patriotism has been replaced by individualism and acquisitiveness.

McVerry's statements during this section of the programme warn us the viewers that we have created a society which is divided between the comfortable and the struggling and that by allowing this situation to continue we are sowing the seeds of destruction for both the struggling and the comfortable.

At times McVerry's tone is biblical. He tells us that 'We are sowing the seeds even of those who have got into the comfortable land'. The final shots of this section are of McVerry walking alone on a beach. These lone shots serve to underline what many of us already know about this man. He is a lone voice, a critic and regarded by many in power both in the Irish state and in the Catholic Church as a maverick. This completes the first part of the programme.

In the next section of the documentary we see examples of those who work with the struggling. This allows McVerry to show us examples of those who care in society as well as a number of examples of deprivation. This featured McVerry's own work with homeless youths; a hostel for the homeless in Limerick City; a residential treatment centre for alcoholism in County Limerick; and an elderly couple in North Dublin who have to cope with an adult mentally handicapped son. The focus here is very much on the helpers of the deprived although we do see evidence of those struggling in each piece of film.

In McVerry's own hostel – which in fact is a flat in the Ballymun tower blocks – we are shown how as many as 15 youths have to sleep and eat in sparse, inadequate and overcrowded conditions. McVerry notes that not a single politician has ever complained about the inadequacy of the hostel. We see a number of homeless youths in this segment although we do not hear them speak.

The report then shifts to a hostel for the homeless in Limerick City. McVerry interviews the hostel administrator about the absence of facilities for the young homeless in Limerick. We are told that when the hostel is full youths may often be given a blanket and sent to sleep in the adjacent graveyard or in the local railway station. Again we see but do not hear a number of homeless men in this piece of film. We see the men in the hostel's lounge area sitting around, reading, smoking and playing with a dog. There is also a shot a young man lying in bed in the daytime, smoking. There is the suggestion in these images that time hangs heavy for the homeless.

McVerry's next port of call is to a residential treatment centre for alcoholism in County Limerick. Here the audience is told about the work of Sr. Consilio and her team of helpers. For McVerry, she is a symbol of how Ireland should be, and is not. We see the centre itself which is run through voluntary contributions and begging and we are also shown examples of the centre's work in the form of a group therapy session. Unlike the previous segments, we hear briefly from some of the centre's residents. We the audience are eavesdropping into the group therapy session. It is clear that those participating are recovering and have learnt to care for both themselves and their families.

Extending the image of care, McVerry then brings us into the home of an elderly Dublin couple who have to look after a mentally handicapped son. In his interviewer mode McVerry talks to the young man's father about his fears for his son's future, given the lack of state back-up in the form of residential or community based care. The father describes his plight to McVerry in emotional tones and states that the help that his wife and himself have received has come not from the state but from their neighbours.

McVerry returns to the programme's earlier theme of anger and asks the man whether he is angry with the system to which the man tearfully replies '... no ... not angry ... disappointed'. We also see images of the young handicapped man sitting and talking to his elderly parents. The images are shown in real time unlike the slow motion images of disability which were an intrinsic part of the techniques used in the 1992 *People in Need Telethon*.

These pieces of film show us the work of carers whom McVerry admires as well as three different dimensions of poverty. There is an underlying suggestion in all four pieces of film that Irish society and in particular the state at both local and national level does not care for the struggling. McVerry's

makeshift hostel is inadequate, there is no hostel for youth homelessness in Limerick City, the Cuan Mhuire centre which epitomises care for McVerry is dependent on people's goodwill and charity and the failure to provide for the mentally handicapped is the source of great anguish for parents facing old age and death. The programme cuts back to McVerry as interviewee in his office and he states categorically that the 'people who make decisions in our society just don't care'.

That those who are in power do not care is emphasised further in the next film sequence. These segments are linked by means of a still shot which tells the audience that the government buildings on Merrion Street, Dublin have recently been refurbished at the cost of £17m. We see McVerry approach the entrance to the complex. He is walking around surveying the scene, the Irish tricolour fluttering in the background symbolising the gap between the patriotism and idealism of the state's founders and the rise of a new elite interested only in grandeur and power.

He comments on the renovation and restoration work that has taken place admitting that it is quite beautiful.[11] Yet he is scathing in his criticism of government thinking. The renovation work symbolises for him how we have distorted our priorities. He says:

> When I think of what £17m could have done. For £17m you would not have a sight or smell of a homeless kid in Ireland for the next five years and of battered women for £17m a lot of battered wives would have been able to take legal action to secure their lives.

He adds that he cannot see the justification 'for spending money on buildings like this when so much suffering goes unabated for lack of money'. The lack of care amongst those in power is manifest from McVerry's assertions. Their wisdom, however, is questioned further in the film shots that contrast McVerry's verbal messages with visual shots of the statues of wise philosophers and dead political leaders in the building's grounds. There may even be an intimation of the vanity of the current political elite situating themselves amongst the wise of earlier times.

McVerry's next tour of duty is to a shopping centre in the middle of Dublin City where the many of the city's comfortable do their buying. The incidental classical music used in the opening scenes of the documentary is again used to signify our entry into the world of 'high' culture. We follow McVerry as he window-shops. The prices are prohibitively expensive – £310 for a watch, a jacket at a reduced sale price of £50. The next shots are of McVerry reading the property pages of an Irish national newspaper. The choice of headlines that we see here add further weight to his thesis about a society divided between rich and poor – *Dalkey house sold for around £1m, Rich Dubliners go North for Holiday Homes* and *To the Manor Born*. McVerry's

11 These buildings were renovated during the Haughey era to coincide with Ireland's Presidency of the EC.

verbal message in the voice-over bring together the images of a divided society where the poor are excluded, and where the contact that the rich and comfortable have with the poor is often second-hand through media coverage. He says:

> If you live in Mount Merrion, and you have an office in Ballsbridge and you do your shopping in Grafton Street, you can live blissfully unaware of what is happening to the poor people and to deprived areas in our city. You read about them. You see them, but it could be the Lebanon that you are reading about and watching.

McVerry's critique of how Irish society is organised is not confined to an attack on the politically powerful or the affluent. He is also critical of the Irish Catholic Church, of which as a priest he is a member. He asks why the Church is not campaigning on behalf of prisoners, the homeless and against the poor conditions that exist in areas of high unemployment and deprivation. We see McVerry saying mass in the church in Ballymun where there are many empty seats. He tells the viewers that the Church has little or no interest in the poor and that the poor themselves do not see the Church as relevant to their lives. What interest in the poor there is appears to be confined to a minority of members of the Church's hierarchy. We see McVerry interviewing Fr. Eamon Walsh who is an auxiliary bishop in the Dublin diocese.

Walsh's perspective is more moderate than McVerry's. He believes that a general consciousness raising about the plight of the poor is the appropriate approach with room also for 'a full frontal attack' by McVerry and others on the system. Despite these differences in perspective and approach, it is clear from this segment that McVerry's message is that as a rule the Church is on the side of the rich and powerful who are in turn supportive of the political elite in society.

In the next sequence, McVerry, in perhaps a contradictory statement, tells us of the compassion of the Irish for the downtrodden. He argues that the population is frustrated by the system and therefore can do little or nothing to help. To illustrate the Irish population we are shown a general shot of feet walking. Ironically, this footage was shot on the very street that McVerry mentions in his assertions about the social distance between rich and poor in the shopping centre segment earlier on.

The contradictions in this statement are again evident in the next sequence. Switching again from commentator to interviewee, McVerry returns to a theme mentioned in the opening scenes of the documentary. He tells us of his shame and pain of being Irish in the light of how we treat our fellow human beings.

McVerry then adds further weight to his thesis that Ireland is divided between the rich and the poor by examining the workings of the taxation system. There are a clear set of messages spelt out in this piece. McVerry asserts that the rich and powerful have had a great deal of influence on the workings of the taxation system. Citing the fact that there is no wealth tax

in Ireland and that the Beef Tribunal had unearthed a myriad of tax avoidance schemes, McVerry refers to the 'scandal of tax evasion in Ireland'.

He differentiates here between the PAYE worker and those on low incomes and those who do not pay their fair share of tax – multinational corporations, the self-employed and large farmers. The piece also contains a warning to those who are tax avoiders. The civil servant to whom McVerry speaks makes it clear that the attention of the Revenue Commissioners has now switched towards their new audit programme which would allow them to catch an increasing number of tax evaders. He tells McVerry 'The temperature of the water in that pot is beginning to boil up and the evader is going to feel it.' As if to reinforce this point, we now see McVerry talking to another civil servant who is working at a computer telling us that it is now possible to get behind the statistical data and investigate any sector, company or individual who is not paying enough tax. The themes of both warning some sections of the audience and examining the track record of the Catholic Church in relation to poverty are examined in the next sequence. Here we see McVerry attend a conference on power organised by the Conference of Major Religious Superiors at Milltown Park, Dublin.[12] The priest addressing the conference is talking about Galbraith's (1992) book *The Culture of Contentment*. He is drawing a parallel between Ireland and the USA in terms of the conditions which gave rise to the Los Angeles riots. We see images of the rioting and looting as he is speaking. McVerry then interviews the speaker about the conditions prevailing in Irish communities where there is long-term unemployment and deprivation.

Like McVerry's use of the civil servants working in the Revenue Commissioners in the previous section, here he draws on the advice of an expert working in the field of social policy formation.

The use of expert opinion is again drawn upon in the documentaries penultimate section. The imminence of societal breakdown if the gap between rich and poor is not breached is again stressed. McVerry interviews a community development worker in an unnamed North Dublin suburb. The development worker speaks of the ghettoisation of the poor as well as the possibility of civil disturbances in the future. We see shots of people walking, mothers pushing prams, children playing in the vicinity of a shopping centre. But in order to warn of the dangers we are facing the camera focuses on an electric pylon which looms large over the houses. This pylon is both unsightly standing as it is between a group of houses, but also signifies danger for those who live there.

The supposed rising level of violence which is said by McVerry to exist in urban Ireland is given further attention as we now can see a newspaper article[13] which refers to Dublin as being one of the most dangerous capitals

12 The Conference of Major Religious Superiors has since changed its name to The Conference of Religious in Ireland.

13 Written originally for an Australian newspaper and reproduced in *The Irish Press* 4 September 1993.

in the world. We hear Gay Byrne read out the contents of the article on his morning radio show on RTÉ Radio 1.

In the programme's final section we see McVerry outline what the documentary refers to as 'An Immediate Six Point Plan'. These six points for the resolution of some of the problems referred to in the programme are presented to us in series of six stills. The stills are reminiscent of the billboards which are used by political parties in their election campaigns. They call for a:

1 Major increase in local authority house building.

2 Increases in social welfare payments.

3 New taxes on wealth.

4 More money for national schools.

5 New powerful Dáil committees.

6 An end to youth homelessness.

The programme finishes with the usual rolling credits which tell us about the personnel involved in making the documentary. But interspersed with these stock images are a repeat of the Derek Speirs photographs of some of the Irish poor. The usual *Tuesday File* dramatic theme music has been replaced by the national anthem. The last sounds we hear on this documentary are of the crowds cheering at an All Ireland Final in Croke Park.

We are left therefore with a final message about a society which despite its republican and egalitarian ideals is in fact increasingly divided. It may be symbolically divided on the playing field but the stark images which we have witnessed tell of deeper and more fundamental divisions, which will ultimately be the cause of its demise.

Symbolising exclusion: The codes and conventions of current affairs television

Across a wide number of dimensions – theme music, length, use of certain stylised techniques, reliance on 'expert' opinion and in its reliance on the same link-person (a well-known and trusted journalist) to introduce the programme – *Are You Sitting Comfortably?* compares with many other documentaries in the same series. But there the similarities end. The programme did not follow the current affairs convention of balancing one set of arguments against another; in fact, it set out with the deliberate intention of being one-sided. Although a link-person may have been used to introduce the documentary, there was a clear departure from RTÉ's usual style of using what Kelly (1984b) refers to as 'a team of trusted and credible presenters'. The programme's subject was placed in the role of presenter. *Are You Sitting Comfortably?* was also unusual in adopting a personal essay-type style to convey a picture of how *one* man sees the issues of Irish poverty and inequality. The structure of the programme was meant to convey Fr. McVerry's view that Irish society is increasingly divided between the well-to-do/rich and the poor.

The documentary proceeds by exploring Fr. McVerry's perspective on poverty, introduces us to the lives of people whom he admires, and suggests a solution to the problems he identifies. A set of contrasts is elaborated between those on the margins (the homeless, the alcoholic, the mentally handicapped, Travellers and the unemployed) and those who have political or economic power (politicians, the middle classes and owners of capital). Examples of people who obviously are either poor or well-to-do/rich are used to help make different points.

Fr. McVerry, as the main subject, plays a variety of roles. He is commentator, interviewer and interviewee as well as the activist on whom the programme focuses. By giving Fr. McVerry a variety of roles to play, the producer was able to overcome his initial worries that the programme could turn into a sermon on the ethics of poverty. As interviewee, commentator, and activist we hear Fr. McVerry's own views. The views of others, who add credence to his arguments or serve to moderate his opinions, come across in the interviews he conducts.

The use of still shots of Fr. McVerry, and photographs of the marginalised, are used to reinforce the points the priest makes about the extent of poverty and exclusion in Ireland. These stills serve both to break up the programme into sections as well as to provide a stark contrast to the images we see of the economically and politically powerful. Still shots are used again at the conclusion when Fr. McVerry outlines his six-point plan to alleviate Irish poverty.

Use is also made in the documentary of news footage, radio commentary, newspaper headlines and even dramatisation. The news footage serves to warn of social breakdown and disorder in the form of rioting. The radio broadcaster, Gay Byrne, warns of Ireland becoming an ever more violent place. These messages are juxtaposed with the headlines of a newspaper's property page that announces how some Dubliners are paying £1m for a house. The dramatisation of a middle-class dinner party is meant to convey the contentment of the economically powerful with their own lives.

In the only situation where we actually hear the marginalised speak for themselves – in Bruree, Co. Limerick – the viewers are briefly allowed to eavesdrop on a group therapy session. Otherwise, we hear either Fr. McVerry or those engaged in caring for the poor.

There is a clear sense in which the programme chose to personalise the issue of poverty by allowing a well-known priest to air his views. The documentary thus conforms to a tendency to narrate stories about poverty through the eyes of the agents of the poor, rather than through those of the poor themselves.[14] The other viewpoints introduced tend to be those of other agents of the poor who reinforce Fr. McVerry's interpretation of the condition of Irish society.

14 Harvey (1983), for instance, notes that media coverage of poverty tends to focus on the personalities involved rather than the poor themselves.

Symbolising exclusion

How was Fr. McVerry's view that Irish society is divided between the powerful and the poor articulated on a symbolic level? Two sets of messages are encoded in *Are You Sitting Comfortably?* There are the obvious messages embedded in words, music and visual images which are used to warn the audience of growing social polarisation in Ireland. Less obvious signifiers are also at work in the documentary. These are built on images of buildings, people, statues, flags, and consumer goods that symbolise either affluence or poverty, inclusion or exclusion.

The documentary, at one level, can be read as a parable. It is meant to warn those well placed in society that unless they change their ways the social order will break down and everyone will suffer. This basic message is repeated regularly throughout the programme and the nature of social polarisation is constantly adverted to. Images of those who care for the marginalised (Fr. McVerry, Sr. Consilio, The Brothers of Charity, an elderly couple, a bishop and a community worker) are set against images of those whom McVerry says do not care (local and national politicians, administrators, the wealthy and well-to-do).

Language such as 'whirlwind', 'seeds of destruction', 'the comfortable land' is used by the programme's link-person and presenter to hint at the inevitable apocalyptic fate of Irish society if the gap between rich and poor continues to grow. These warnings are accompanied by references to breakdown in other societies, such as Britain and the USA. Fr. McVerry and many of the experts he interviews allude to the possibility of riots in urban Ireland in the near future.

The programme's incidental music also works to send a set of messages to the audience. Chamber music is used in a way that symbolises 'high' culture and that provides a foil against which the prosaic images of Fr. McVerry's daily world are meant to stand out. The slow air, of course, also serves to capture the pathos of the priest's experience. The same piece of music is used to bring us back to the world of the rich and powerful when we accompany Fr. McVerry on a visit to an up-market shopping centre.

Use is made of the national anthem – *Amhrán na BhFiann/A Soldier's Song* – to symbolise the failure of the Irish State. On two occasions the idealism contained within its lyrics is juxtaposed with stark images of Irish poverty. The intent is both didactic and ironic. The words of the song tell of those who have fought for the glory of Ireland. Yet we know from the visual images and the verbal messages of this documentary that patriotism has been replaced by individualism and greed. Other messages address the lack of concern for the poor by the Irish Catholic Church, and the lack of interest of politicians in problems of poverty.

As well as its manifest warning message, a second layer of messages concerning poverty and exclusion is also encoded within the programme. Here a range of symbols is deployed to signify exclusion and poverty.

Buildings, people, sport, clothes, black plastic bags, food, jewellery, flags, queues, statues and electric pylons are all used to capture the dangers facing Ireland's divided society.

Buildings are a versatile signifier in *Are You Sitting Comfortably?* They can symbolise both poverty (as with the Ballymun tower blocks, the Limerick and Dublin hostels) and political, economic and social power (Government Buildings, St. Stephen's Green Shopping Centre, Ballymun Church, upper class homes and dining rooms). The theme of exclusion is developed by reference to the built environment. The poor are shut out from places of power and privilege. We see shots of Government Buildings through the railings; and even when the gates are opened slowly, we know that we are entering a place where the marginalised are not welcome. The spending of £17m on the renovation of these buildings symbolises for Fr. McVerry the Irish political elite's lack of social concern. On the other hand, the poor must queue outside social welfare offices and again queue up inside. That many seats of the Ballymun church are empty, because poor people do not see the Church as relevant to their lives, also makes a statement.

We also find the poor excluded from participating in many markets. In the up-market shopping centre, for instance, we are shown clothes that are prohibitively expensive for those with little or no purchasing power. Buildings may serve to provide the viewers with another set of messages. Thus the Revenue Commissioners Office at Dublin Castle is shown as a place where the State (in the form of vigilant civil servants) is busying itself with the tracking down of wealthy tax dodgers.

People can also be used as signifiers. Fr. McVerry and those persons he admires symbolise those who are fighting for a caring society. Three of our best-known politicians (shown watching a match) represent those who can sit back and enjoy their position of political power. Other images of people are used to symbolise the Irish general public (a wide shot of people walking in Grafton Street), the privileged set assembled at a dinner party scene or shopping in the St. Stephen's Green Centre and the poor (the unemployed, Travellers, children begging in the street).

Food, clothing, jewellery and sport can equally become symbols of exclusion and poverty. We see images of the cramped eating conditions in Fr. McVerry's hostel – in sharp contrast to the spacious room where a nouvelle cuisine meal is being consumed at a dinner party. The poor may live out of black plastic bags while the rich can shop for their clothes in exclusive establishments where the equivalent of a week's social welfare payment can easily be spent on a single purchase. Jewellery is a conspicuous signifier of wealth. At the dinner party a young woman is shown wearing expensive rings and earrings; at the shopping centre, we see a watch which is priced at £310.

Discussion

Are You Sitting Comfortably? presents a significant case study for a number of reasons. For one thing, it deviates somewhat from the dominant pattern of current affairs television. It also presents a notable example of how Irish television has mediated the issue of poverty through the eyes of a self-proclaimed agent of the poor rather than through the eyes of the poor themselves.[15]

Kelly's (1984b) account of RTÉ's current affairs television sees it as being supported by a central personality who articulates a middle ground view of the world. The personalities in question tend to appear regularly on television and can draw upon their positions and experience as academics or journalists to establish their credibility. Kelly sees Irish current affairs television as marked by an ability to question those in power from a middle ground position; to communicate effectively with the audience; to use experts; to be seen to be on the side of 'the people'; and to be driven by a value system which stands for democracy and honest government.

Are You Sitting Comfortably? departs from Kelly's (1984b) characterisation in terms of its ideological positioning. Conspicuously, the programme criticises and questions those in power from a left-wing perspective, albeit one that is somewhat tempered by an ultimate acceptance of reformist solutions. Otherwise, *Are You Sitting Comfortably?* conforms to the pattern of current affairs documentaries described by Kelly (1984b). It, too, confirms the existence of a problem by devoting most of its attention to it, solicits the opinions of experts and community leaders, before finally proposing a reformist-type solution. Explicitly siding with the dispossessed and marginalised, 'the people' are seen to be split into 'haves' and 'have nots'. The programme's aim, as its title suggests, is to prick the consciences of the economically and politically powerful.

Are You Sitting Comfortably? stands out as a programme which takes as its subject matter what some Irish people might regard as the 'undeserving' poor (what Golding and Middleton (1982) describe as the 'Devil's poor'). Its focus falls on the situation of the homeless, the unemployed, alcoholics and Travellers, as these are viewed by a well-known agent and champion of the poor.

Are You Sitting Comfortably? is noteworthy both for its content and for the manner in which it was made. The programme's subject was allowed to set the agenda for the documentary. A specific ethical code was adopted by the producer in reaching agreement with individuals and communities regarding filming.

One of the documentary's most interesting features is its use of symbolism

15 Other documentaries about homelessness have opted for a docu-drama approach that uses actors to tell a story. The most celebrated example of this genre is Jeremy Sandford's *Cathy Come Home*, broadcast by the BBC in 1966. For more details, see the interview with Sandford in Rosenthal (1971).

to articulate a set of messages about Irish poverty. We can view this in two ways. Symbols are used as explicit production devices to 'hook' the viewer. Certain images (relating to sport, buildings, queues, consumer goods) are heavily utilised to reinforce the basic message of a divided society. In addition, the programme's symbolic elements are used by the producer to offer to the viewer a preferred reading of the documentary. The programme, following Hall (1974) and Hall *et al* (1976), can therefore be said to possess a dominant code which seeks to get the viewers to interpret its messages in a definite way. As, however, the programme was intended to challenge both the viewer and the *status quo*, its dominant code may be seen to depart from the hegemonic codes which normally govern current affairs, and other types of television programming. That this is the case can be seen in the programme running into some difficulties with the station's hierarchy prior to its broadcast. It can also be gleaned from the producer's intention to make a programme that went against the grain of accepted beliefs about poverty and inequality in Ireland (see Davis *et al* (1984) and Mac Gréil (1977)).

A rare example of a programme which sought to challenge the *status quo*, *Are You Sitting Comfortably?* provides some support for Altheide's (1984) thesis that those who work in producing news and current affairs television cannot be assumed, as a matter of course, to support a society's dominant ideology. That the producer was allowed to make and broadcast such a programme also serves to question the validity of the media-hegemony perspective.

Fr. McVerry, as helper and agitator, qualifies as a television personality in Monaco's (1978) terms. Two types of television personality can be distinguished, those who appear regularly on television and those, such as Fr. McVerry '... who exist outside of television in their own right, but are recruited into television at various strategic junctures as resource material – politicians, celebrities, experts or 'ordinary people.' (Monaco 1978: 7; see also Langer (1981)).

Already familiar to many viewers for his work with the homeless and through infrequent media appearances, the central use made of Fr. McVerry in *Are You Sitting Comfortably?* departs from the pattern of what Kelly (1984b) and Kumar (1977) see as the deployment of credible and trusted presenters as a means of questioning those in power. It might be said, however, that while the rich and powerful are clearly blamed for mass poverty in Ireland, these same rich and powerful, safe in their anonymity, remain protected by the symbolic use of imagery of wealth and power.

5

No news is good news

Introduction

Poverty coverage in a current affairs setting is marked by its scarcity, and by its dependency on the heroic helper as its subject matter. So to what extent is this situation replicated in RTÉ news about poverty? Mindful of Gans (1979) statement that most news is about 'knowns', this chapter examines RTÉ television news coverage of Irish poverty. It argues that in terms of television news, poverty is by and large invisible on our television screens. As this chapter suggests, when coverage does take place it manages to fashion a special role for the comfortable and the powerful. The status quo is rarely threatened by such coverage and, as such, television news plays a powerful ideological role in reproducing unequal social relations. This analysis is undertaken in the realisation that television and indeed other media frequently tell stories about people who are poor but rarely refer to the fact of their poverty. Stories about lone parents, heroin addicts or juvenile delinquents are more often than not framed in such a way as to ignore either their subjects' class background or the unequal social structure which causes their poverty.

The chapter examines stories broadcast on *Six-One News* during the period 1 September 1992 to 31 December 1992.[1] It compares news reports transmitted by *Six-One News* which dealt with the new poor (the middle classes experiencing difficulties with mortgage repayments) those traditionally considered to be poor (homeless, needy, Travellers, unemployed), and those individuals and organisations who act on behalf of the poor, old and new. Following this exegesis I discuss the codes and conventions of television news about poverty stories. This is done by examining the background and production processes of three news stories and through a

1 This study period was selected for two main reasons. Firstly, I was interested in examining how the various themes, such as the 'crisis of homelessness' or the 'arrival of the new poor', as suggested by *Six-One News* developed over several news bulletins during the last quarter of 1992. Secondly, this period coincided with the first phase of my fieldwork at RTÉ and I succeeded in discussing the content of some of these reports with the journalists who were responsible for their creation.

wide-ranging discussion on the dominant images and messages about the Irish poor on RTÉ television.

The new poor

An interesting theme occurring on *Six-One News* in 1992 was the notion that there was now also a 'new poor' in Ireland. The rise of unemployment into the middle classes and the hike in mortgage interest rates in the autumn months served to ensure that new poverty would make news. Outside of the novelty considerations of newsmakers, the fact that many of the so called new poor were organised and articulate helped to guarantee the place of the new poor's stories on the news schedules of *Six-One News* (*SON*, 2 December 1992 and 21 December 1992).

It is interesting that the focus of reports on the new poor centre on the idea that they have become economically poor because of forces outside of their control, while much of the focus of the stories on the old poor such as Travellers, unemployed or homeless locate some of the responsibility at their own feet.

'These people have made a go of life ...'

In December, the programme reported on the problems facing mortgage holders in Galway City (*SON*, 2 December 1992). The story suggests that the crisis facing the middle classes of Galway 'will cause bigger problems than the activities of money lenders this Christmas' and according to local welfare and tenant organisations, the problems facing the new poor demand immediate political action. This new poverty is, we are told, different from the traditional poverty of the unemployed and underprivileged. The new poor are 'not the people on council lists ... these are people who have bought their own homes and thought they would be secure and its a very frightening and traumatic time for them.'

We are told by their agents that they are:

> the poor of the PAYE sector and they have no medical cards ... they have never had to go to the St. Vincent De Paul. These people have made a go of life and tried to keep it there ... [and interestingly] they are forced into being the new poor.

By virtue of their previous efforts, we are being told that 'immediate political action' in the form of full mortgage interest tax relief is necessary to help these examples of the new and deserving poor. It is also made quite clear to the audience that these people have fallen into poverty through no fault of their own.

The reporter invokes Dickensian imagery to begin his story. We are told that the increase in mortgage interest rates 'hangs like a ghost of Christmas yet to come' over many of the comfortable housing estates of Galway. The suffering and hardships experienced by the new poor, as well as the worries of their agents, are emphasised. There is also the suggestion from one

of the St. Vincent de Paul interviewees that the task in hand is to save the new poor from losing their houses and to 'try and keep their dignity together'.

At a visual level, we see an opening shot of a prosperous housing estate with large semi and detached houses. To extend the reporter's use of a Dickensian metaphor, we are viewing these houses from above and we see them bathed in a late evening fog. This helps to signify the bleak prospects for the inhabitants of these comfortable houses, but also functions as a means of masking the identity of this housing estate. Next, we see an interview with a representative of the St. Vincent de Paul, who is telling us of their work with the new poor. This interview is interspersed with shots of both the local St. Vincent de Paul conference at a meeting and a shot of a statue of the organisations founder. The activities of St. Vincent de Paul helpers have, however, changed from working with the destitute of Paris and elsewhere to also sorting out the problems of the Irish middle class. The remaining images are those of a representative of the Galway Combined Residents' Association, who is telling the reporter about the poverty crisis affecting the middle classes of Galway, while situated outside a large prosperous looking house.

Except for the vague housing estate footage at the beginning of the report, we do not see any representative examples of the new poor. We do, however, hear from their agents in the form of both the St. Vincent de Paul and the residents' association.

The old poor
The homeless

Homelessness as an example of extreme subsistence poverty is not deemed to be a newsworthy story *per se*. A cluster of stories about homelessness in December 1992 arose because something 'out of the ordinary' happened. Four homeless people died in quick succession from hypothermia. However, it was the activities of elite figures in responding to the 'crisis of homelessness' that ensured that the issue of homelessness would be on the news agendas of print and broadcast media for the month of December.

The first story entitled *On The Streets* was told as a *Six-One News* special report and it dealt with the funeral of one of the two homeless people who had been found dead from hypothermia on waste ground on December 2nd (*SON*, 8 December 1992). The programme's anchor-woman tells the audience that there are approximately 500 homeless people in Dublin and refers back to the deaths of Michael O'Meara and Pauline Leonard, which have taken place the week previously. The latter had been buried that day in the Alone plot for the poor in Glasnevin cemetery. The focus of this special report is on the funeral mass and burial of Pauline Leonard. It is told as a poignant story with references by the reporter to Leonard's 'lonely death' and the mood of the tea rooms where she often ate as being 'mellow

and sombre'. There are interviews with two homeless men about her death, one of whom is visibly upset.

The report is structured around the priest's homily and the reactions of both locals and her fellow homeless. The narratives of all three emphasise her saint-like qualities noting her gentleness with animals and birds, her warmth and friendliness and the certainty that she is in heaven. The reporter in turn talks about the fact that the dead woman used to take shelter in the doorway of the church where her funeral mass was being offered

The report draws upon a range of images to tell a story about this woman's death. We see the obvious images of her coffin, the funeral mass, bouquets of funeral flowers and the funeral hearse. Yet other images are used to signify the sadness and reality of her death. We see a shot of penny candles some of which are lighting, more of which are extinguished. This shot cuts to a portrait of the Blessed Virgin Mary, which has the logo *Mother of Perpetual Help*. We view this image when we are hearing the priest speak about the dead woman's caring qualities. Also on view are the rarely seen homeless on whose faces the camera focuses to pick up on their sadness and upset.

The issue of homelessness returned to *Six-One News* just four days after the report on the funeral of Pauline Leonard (*SON*, 12 December 1992). Another homeless person had died from hypothermia while sleeping rough at Grangegorman, Dublin. The focus of this report is on the details about the removal of the dead body but also on the calls by what the newsreader refers to as 'a leading campaigner' on the government to deal with the 'housing and homeless crisis.'

The reporter tells of the discovery of the young homeless man's body in a derelict building in the grounds of a Dublin hospital. She frames her story in the context of the deaths of three other homeless people in similar circumstances in the previous two weeks. Her report is structured around images from the scene of the death and an interview with an activist who campaigns on behalf of the homeless. We firstly see a policeman patrolling the derelict building and then a wider shot of the building. Next we see a shot of the interior of the building and a photographer is witnessed in the adjacent room taking pictures. Four men then take the stretcher holding the blanket wrapped body through a window frame. The corpse is then loaded into the bottom portion of the funeral hearse. The film now cuts back to the derelict interior again. Having shown the interview with the homeless activist, the final images are those of the policemen watching over the scene of the death and the undertakers closing the door of the hearse.

Two days after the Grangegorman report *Six-One News* returned again to the question of homelessness (*SON*, 14 December 1992). This time the programme reports on the fact that a special working party on homelessness is to be set up to investigate the issue in Dublin. The focus of this story is

on the response of elite figures to the question and although we see some evidence of the homeless in the film, the report conforms to the norm of not showing the faces of the homeless. We hear of the Lord Mayor's initiative in setting up the working party from the reporter and through interview.

The report's visual message system uses a mixture of old and new footage to tell the story. We firstly see a still shot of a destitute man with the caption 'Homeless' underneath. The first three parts of the report use footage from the Grangegorman report of 12th December. We again see the corpse of Patrick Feary being removed through the window frame and two shots of the derelict building in which he died. Next, we see the first meeting of the Mayor's task force on homelessness. Following an interview with the Lord Mayor about the work ahead of the group, we see some footage of a hostel for the homeless. We see a hostel sitting room shot, from a distance through a doorway. There are also two shots of individual homeless men both of whom are shot from behind and therefore faceless.

The approach taken in the making of this report was to be repeated as the story developed over the next few days. (*SON*, 16 December 1992) The Taoiseach announced that the Irish Army were being drafted in to help alleviate the problem and a temporary emergency shelter was to be opened. *Six-One News'* Religious and Social Affairs correspondent filed a report which focused on the preparations being made by the army and Civil Defence. Having begun with the fact that several activists and supporters of the rights of the homeless were currently engaged in a vigil outside the Dáil, the reporter notes that just yards away from the parliament building a homeless woman sleeps on the steps of a house in a cardboard box each night.

Through her interview with an army press office representative and her own narrative, the reporter chose the preparatory work being done at the hostel by the army and others as her main theme. This story is interspersed with images of the homeless. The report begins with the still image of the homeless man used earlier in the working party story. We also see the cardboard home of the woman who sleeps opposite the Dáil. All of the shots of the homeless men at the hostel are filmed from behind. We see the homeless men in a variety of situations (walking, talking, eating, sleeping), yet all are faceless.

The needy

The practice of doing a story on the 'needy' during December and more particularly on Christmas Day itself is a well-established convention within the RTÉ newsroom. In the context of the earlier coverage by the media on the question of homelessness in Dublin at this time, the Christmas story on the needy is perhaps an even more telling example than usual on how a poverty story of this kind is told in a sanitised way (*SON*, 25 December 1992).

The report concerns the annual Christmas lunch at the Dublin Mansion House which is prepared by the Knights of Colombanus for the 'less well off' and 'city's needy'. It was given as one half of a report on the events of Christmas day. The reporter tells his audience that 'They were dancing in the aisles of the Mansion House where over 850 of the city's needy received their annual Christmas lunch provided by the Knights of Colombanus.'

The focus of his introductory remarks are on the activities of the knights who have been engaged in this activity for 68 years and on the fact that the numbers of needy attending the lunch are increasing. These remarks about the scale of the problem, are, however, tempered by his suggestion that the atmosphere at the lunch was one of gaiety and celebration. The report then cuts to an interview with a needy man. Reinforcing the story's introduction, he tells the reporter:

> I had a big gang with me … a big load of people … and everyone one of them went away happy. There was a bit of a gift and all given to each and every one of us, it went off beautiful, really beautiful.

The reporter thanks the man and wishes him a merry Christmas, to which the man replies excitedly 'And the same to you and to everybody out there … Happy Christmas! and many more of them!'

Unlike other reports, where the tendency is to interview those who work with the poor rather than the poor themselves, this story is unusual in that it allows us to hear the voice of one of the poor and not his helper. This is because the knights are a secretive and powerful Catholic organisation, who are rarely, if ever, interviewed in public. But there is also a feeling in viewing this report, that the man was chosen for interview because he helped tell the story as a lightweight Christmas piece, comforting for both the powerful and many audience members.

A range of images are used to tell us this story of Christmas goodwill and cheer. Despite the suggestions in the reporter's introduction that 'They were dancing in the aisles' we in fact see a lone man dancing with his back to the camera. Next we see a wide shot of the tables and the guests which has been filmed from a distance. This then cuts to a 'chef', who is serving up food to the needy men. We then see a shot of the tops of the men's heads, filmed from overhead the tables.

The report concludes with an interview with a man whose face is visible to the camera and the audience. This story is an example of the custom and practice of telling a story about the needy on Christmas Day. We can point to two main reasons why a story of this kind will make the news on Christmas Day. Firstly, there is typically very little else happening news wise during the holiday season. Secondly, this type of story fits in with the culture of Christmas given the fact that the original Christmas story is itself a story about poverty and homelessness. But given the lightweight way in which our example of need on Christmas Day is told, there is also a sense

that the story is narrated in this fashion to reassure the more comfortable members of the audience that everything is okay 'out there'.

The Travelling community

The reports on the Travelling community present them in the main as a social problem group. In December the programme carried a report which dealt with the health problems of the Travelling community in the west of Ireland. (*SON*, 8 December 1992) The report is an interesting example of how the focus of poverty related stories is on those who represent the poor rather than on the poor themselves. This report features a socialist and former Minister for Health, one of the authors of a study on the needs of Travellers, as well as a Catholic bishop. It is also of further interest that the issue of intermarriage between first cousin Travellers is singled out as the main feature of the study. The study in question in fact covers a much wider range of issues about the needs of Irish Travellers dealing as it does with the health, education and social issues which affect this marginalised ethnic minority group. (See O'Nuallain and Forde, 1992)

The story is introduced by the news anchorwoman, who tells us that the former Minister for Health Dr Noel Browne[2] has made a strong plea for a greater understanding of the problems experienced by the Travelling community. We hear a section of Browne's speech, in which he notes the contradictions inherent in Irish public attitudes and responses to the issue of poverty. He tells us that 'There's widespread discrimination against Travellers. They're needlessly sick, they die young, they have suffered disability. Riddle me this, how is it that we last night raised £1m for Somalia?'[3]

The report then cuts to the correspondent, who outlines what he sees as the main features of the study being launched. Next, one of the study's authors speaks about the issue of intermarriage amongst the Travelling community and their subsequent high rates of genetic diseases. The theme of intermarriage is carried further with the reporter interviewing a local bishop about the problem. Thus the only voices we hear are those of the anchorwoman/reporter, the former minister, the author and the local bishop. The report is concerned with what the latter three have to say and how they say it. Browne makes 'a strong plea' and 'an impassioned plea', the author suggests a direct link between genetic disorders and consanguinity, the bishop promises to discourage inter-marriage between first cousins.

The absence of a Traveller voice in this report and their physical and cultural distance is further emphasised by many of the visual images used to tell the story. When the report is being introduced by the news anchor woman, we see a superimposed still shot of some Traveller children at play

2 The late Dr. Browne would be well known to most viewers as a radical socialist minister who pioneered the onslaught against TB in the late 1940s. Following the collapse of the Inter-Party Government Browne remained a marginal figure who championed the cause of the poor both at home and abroad.

3 In reference to RTE's *Light in the Dark Telethon* for Somalia held the previous evening.

behind her left shoulder on the screen. It is not a clear image, and the characters are not readily identifiable. As the report proper commences, we see a Traveller campsite from a distance. There are a group of Travellers outside the trailer but are again not identifiable. Next, we see a wide shot of some Traveller children playing amongst scrap and waste. There is a tap spilling water into the wind. In the next frame, we see a close up shot of a young Traveller child turning the tap off. The report cuts now to Browne who is shown in a tight close up shot as he is making his speech. The camera pulls back and shows Browne as well as five others who are sitting at a table behind him. They include two of the report's other interviewees. Next, we see a wide shot of the audience which is largely made up of Travellers. When the reporter tells us that 'Traveller children in County Galway are twenty times more likely to suffer from profound deafness and eight times more likely to suffer mental handicap than children of the settled community' the camera zooms in on a close up shot of three Travellers in the audience. This close up shot is an exception to the norm of showing groups like the Travellers or homeless in either vague or headless shots. It then cuts away to an interview with one of the study's authors – here a close-up head and shoulders shot of the speaker is used and then moves on to a wider shot of the bishop addressing the audience. As he is speaking, the reporter is telling us that the bishop will 'be doing his best to discourage marriages between first cousins in the future but he doesn't believe that a total ban will work.' The camera zooms in on the face of a young Traveller woman to gauge her reaction through her facial expression. It then quickly moves to a wider shot of the assembled audience and finally cuts to an interview using a close up head and shoulders shot with the bishop.

The accommodation problems experienced by Dublin Travellers was the feature of a news report in October (*SON*, 13 October 1992). The story was prompted by the launch of a study by the Dublin Travellers Education and Development Group entitled *No Place to Go* (1992).

This report was similar to the previous one in that it was prompted by an 'event' – the publication of a new study – but also because of the utterances of an elite figure, namely the Lord Mayor of Dublin. It was different from the former reports, however, in that it included a Traveller activist as one of three interviewees.

The report begins with the news anchorman telling the audience that the Lord Mayor of Dublin has suggested that a representative of the Travelling community be given observer status on Dublin City Council. Next, we hear the reporter tell us about the main findings of the study and he outlines the accommodation crisis which Travellers are experiencing. The report then features an interview with a Traveller and Travellers' rights activist about the issue of Traveller accommodation. Although he does concede that Travellers have to bear some of the responsibility for the problem, he sees the ultimate responsibility as resting with the local authorities given their

legal powers and financial resources. We hear from the PRO of Dublin Corporation. He acknowledges the dreadful living conditions of many Travellers, but stresses the problematic nature of dealing with the question. He notes that it is 'a problem with local communities and a problem with Travellers themselves.' The report now cuts back to the reporter who tells us that according to the Lord Mayor, the solution to the problem is to try and find a compromise between the Travellers and the settled community. He interviews the Lord Mayor about his views who, as well as suggesting Traveller representation on Dublin City Council, tells us that he 'doesn't expect the Travelling community to come half-way, because all the cards are in the hands of the settled community.'

The report ends with a statement from the reporter who tells his audience that Travellers are seeking immediate action on their accommodation crisis and quotes their report's demand for an end to the building of temporary accommodation.

The verbal messages of this report are interesting in that they not only acknowledge the existence of a problem, but attempt through interviews with a number of spokespersons to try and suggest some possible solutions to the issue. There appears to be some conflict of opinion between the Travellers' spokesperson and the Corporation official as to where the responsibility for the problem lies, yet the leading role of the piece is played by the Lord Mayor who is attempting to be conciliatory. The Lord Mayor is cast in an heroic light – he is portrayed as a man of action representing a half way position between the two other conflicting viewpoints we have heard.

Visually, a similar range of techniques is used as before. A superimposed still shot of a Travellers' halting site is used to signal the story. Here, we see Traveller trailers in poor surroundings replete with scrap metal and garbage. The report itself begins with this same footage, now shown in real time. Next we see two Traveller children walking past the scrap cars. They are filmed from behind. The report then cuts to a sequence of still shots showing the cover of *No Place to Go* in addition to some black and white photographs from the study.

There follows a series of interviews with both the Traveller activist and the Corporation official. Both are head and shoulder shots filmed outside the official residence of the Lord Mayor – the Mansion House. Next, in a close up shot, we see the Lord Mayor making his speech. This scene cuts to a wide shot of an assembled group of largely female Travellers and moves then to an interview with the Lord Mayor outside the Mansion House. The report ends with a series of shots of the Travellers and their living conditions. We again see some Traveller children walking through a halting site. The images of caravans and scrap are also repeated. The final image is that of a single tap spilling water into the wind. This single image facilitates the conveyancing of a message about the poverty and lack of resources which Travellers experience.

Travellers are portrayed by television news as a problem group. Their newsworthiness seems to hinge on both the occurrence of events such as the launch of new reports about them by their agents or else on the utterances of elite figures on their behalf. The dominant message coming from news stories about them is that of Travellers as a social problem. We can also say that the visual messages used are ones which emphasise the cultural and economic distance of the Travellers from the dominant culture of Irish society. The poverty of the Irish Travellers is largely mediated through the use of symbolic imagery and through the statements of people who are not Travellers (or poor) themselves.

Unemployment

Unemployment featured heavily as the subject of television news reports in 1992. Most of this coverage tended to be about unemployment and the responses of government and other powerful groups to the problem as opposed to coverage of the unemployed themselves.

In October, *Six-One News* carried a report that told the audience that the government's decision to set up a £50m fund to help employers to get through the currency crisis had been criticised, on a day when some of the unemployed had taken to the streets of Dublin as part of a European-wide march for jobs (*SON*, 6 October 1992). The story is framed around the criticisms made by the representative of the Irish National Organisation of the Unemployed (INOU) of government and big business. The arguments being put forward by the INOU are that the issues affecting unemployed people are being ignored and that many of the key players in Irish business are behaving immorally, owing to their speculation against the Irish pound. The INOU representative tells the reporter:

> Their [the unemployed] dole payments do not go up much per year, while the majority of speculators get very rich on it, you know, while some people can make 'x' amount on one swift property deal or one swift property market and while they get £57 or £56 per week.

The activists assertions about the behaviour of the wealthy, are, however, countered by both the reporter and his other interviewee, who defends the role of Irish business. The reporter tells his viewers:

> There is the feeling that so-called speculators are being made scapegoats. Many are in fact major Irish based companies employing thousands of Irish people and buying and selling their currencies on the financial markets, in an effort to protect their employees.

He goes on to interview a senator who argues the case on behalf of the business sector. He asserts that the 'young men in red braces' are not going out to speculate against the Irish pound; rather, all sorts of Irish companies, banks and charities are attempting to defend their position. Here the

reporter interjects 'For the good of companies to preserve jobs.' To which the senator replies 'For the good of companies which will preserve jobs.' These statements are then linked back to the original assertions of the unemployment activist, who again calls for government action to deal with the problem of unemployment. The assertions made initially in the piece have been challenged by the reporter and by his other interviewee. Thus, the dominant verbal message of the piece shifts from one of criticising the wealthy and big business to calling on the government for action on the problems of unemployment. Big business has been defended and the locus of the responsibility for the unemployment problem now rests with the government.

Visually, an interesting style emerges. We see the unemployed through the use of still shots of a dole queue, and black and white photographs of a previous unemployment march. There are shots of the INOU activists at work preparing for the march later that day. The images of women making sandwiches, for the marchers, are used when the reporter is referring to the 'bread and butter' issues that affect the unemployed. In contrast to this, those who are being blamed for speculating and endangering the Irish economy are faceless. With the exception of the interviewee who defends the role of Irish capital, we see the economic system symbolised by the stock exchange. Here we view some wide shots in which no one person is recognisable. We do see an example of one Irish company (Bord Bainne) which is held to exemplify those Irish companies who, we are told, are attempting to save themselves and their workers through taking risks at the marketplace. Unlike many of the reports being considered in our discussion, in this instance it is the powerful and not the poor who are faceless.

The second report deals with the issuing of a pastoral letter on unemployment (*SON*, 8 December 1992). The report tells of the Catholic bishops' latest warnings on the unemployment problem. Filed by the programme's religious and social affairs correspondent, the report attempts to put the bishops' pastoral letter in the context of their individual concerns (emigration, job creation) and the scale of the problem in both Cork and Galway. The bishops having made consultations on unemployment for almost three years have described the problem as a 'grave evil' in Irish society. We are told that the bishops hold the view that the responsibility for dealing with unemployment lies with ourselves – although they do not claim to have a blueprint for solving the problem. There is also a call by the bishops on the business sector to do something about the problem of unemployment.

Visually, we witness images of both the bishops and the unemployed. The business sector, which the bishops suggest could have an active role to play in sorting out the challenge of unemployment facing Irish society, is nowhere to be seen. We see a range of shots of the bishops which suggest that in face of this problem, they are – despite their lack of a blueprint – men of action. There are images of the bishops in conference, at work,

being interviewed and discussing the problem. Through the use of still shots, we see their action plan being outlined to us. The stills concentrate on their pronouncements of the 'grave evil', 'the inevitability of high unemployment' and 'job creation in Irish hands'. Their antidote to these problems lie in 'local initiatives', 'more decentralisation' and 'regional development schemes'.

In contrast to the image of the bishops as actively doing something about the issue of unemployment, we see the unemployed only in terms of their connection with dole queues. Unemployment is signified through the repeated use of images of dole queues, a faceless unemployed man who is walking alone and the Department of Social Welfare logo. The unemployed are yet again anonymous and portrayed as passive recipients of state handouts. This is in stark contrast to the images and messages used to tell the story of the 'new poor' who are portrayed as deservers of state and voluntary assistance, because of their efforts in less pressurised times.

The agents of the poor

Most stories about the poor are told through the words of those who work on their behalf. It is also the case that poverty as an issue often only becomes newsworthy as a result of the activities or statements by the agents of the poor. These reports focus on the doings of those who are in positions of relative power over those they are deemed to represent or support.

During the period September–December 1992, there was a great deal of coverage on both the activities of organisations like Combat Poverty, the St. Vincent de Paul Society and on the endeavours of President Mary Robinson to assist the poor at home and abroad.

Typically, these stories centre on the activities of the agents rather than on the cause of or solutions to such problems. Thus a story broadcast in September on how the Dublin Taxi Drivers' Association brought the 'Special Children' (the disabled and mentally handicapped) on a day trip concentrated not on the poverty and disadvantage associated with these children, but rather on the activities of the association and more fundamentally the support given by President Mary Robinson to the day (*SON*, 8 September 1992). The focus of the story is on the President, noting why she decided to lend her support and the fact that she spent a half an hour with the special children.

The most striking image in this report is of a blind child touching the President's face. She is cast in an heroic Christlike role, turning up to assist these children. In other stories during the month of October, we again see President Robinson on her mercy mission to Somalia to highlight the famine and poverty of that Third World country and thus the image of the President as a saviour is highlighted (*SON*, 2 October 1992 and 5 October 1992).

In September, *Six-One News* ran a report which told of Mary Robinson's speech given at a social policy conference on the disadvantages of being

poor (*SON*, 22 September 1992). The reporter told of the conference dele-
gates congratulation of the President for her 'courageous decision' to go to
Somalia. We are told of her speech about the needs of the unemployed and
disadvantaged groups and the necessity to include the socially excluded in
the decision making process. Added to the report on the President's speech
is an interview with a member of the Conference of Major Religious
Superiors, who again talks about the exclusion of the poor from the deci-
sion making processes. The piece ends with a statement from the reporter,
which says that what the President and the other speaker means is 'invit-
ing groups like the unemployed into programmes like the PESP'.

The visual messages focus in the main on the President. We see her arriv-
ing at the conference, heading for the podium, being applauded by the
crowd and addressing the audience. When the reporter is linking the
images of her speech together with her interview with the conference
organiser, we see some queues in an unemployment office. It is a wide shot
and no one person is distinguishable. The report then cuts to the interview
with the conference organiser and then concludes with another shot of the
unemployed waiting for the dole. It is ironic that given the President's
comments on the problems of exclusion faced by the poor, we yet again
only hear the voices of the powerful. The poor are again relegated to the
shadowy background of the anonymous dole queue dependent on the
voices of the concerned but comfortable to make their case.

The mortgage and unemployment crises of the winter months of 1992 put
those working in the voluntary sector under increasing pressure due to the
increase in the numbers of people seeking help. The Irish response in terms
of donations to Third World charities and for the Somalian crisis in partic-
ular, appears to have reduced the amounts of voluntary contributions to
indigenous groups working with the Irish poor.[4]

In December, *Six-One News* broadcast a number of reports about the fund-
ing difficulties being faced by the St. Vincent de Paul Society (*SON*, 12
December 1992 and 21 December 1992). The Irish Government had
decided to grant a special once off payment of £1m to the organisation to
help fund its activities. The focus of the report of 21st December is on the
both the organisations activities and on the Minister for Social Welfare. We
are told that the St. Vincent de Paul has helped 200,000 people, but that its
fund-raising has been hampered by the demands being made by other
'worthy causes'. The story emphasises the fact that their work is not only

4 The issue of Third World poverty and famine was a much debated one on *Six-One News*
 during this period. The coverage of the issue focused on the Somalian and Mozambique
 famines as crises. Told from an Irish perspective, the stories concentrated on the extent of
 Irish voluntary and governmental donations to the developing world (0.17 per cent of
 GNP in 1992), the mercy mission of President Mary Robinson to Somalia and to the UN,
 and the activities of agencies such as Goal and Trocaire. The crisis dimension to the
 famine is exemplified in the report 'A Race Against the Clock' (*SON*, 6 October 1992).
 Media interest in Somalia culminated in an RTÉ Telethon entitled 'A Light in the Dark' in
 December 1992.

with the 'old or traditional poor' but also with the 'new poor'. The society works with a wide range of poverty groups and problems; however, visually we are offered a set of images which focus on the homeless. The footage conforms to the style discussed previously, namely that we see a range of homeless men in a hostel. All are either filmed from behind or else are headless. The remainder of the report is concerned with interviewing both the president of the society and the Minister for Social Welfare.

The production of poverty stories on *Six-One News*: three case studies

Case (A): The Annual Report of the St. Vincent de Paul Society

Background

The reporter in question received advance notice from the St. Vincent de Paul Society that their annual report was to be launched. She held the view that reports of this kind were commonplace and therefore not automatically newsworthy. Her decision to do a story using the report's findings as her template were influenced by the fact that she could link the report to two other factors.

It was exactly one year since the deaths of four homeless people in Dublin and she had also discovered in her research that the temporary emergency hostel set up in December 1992 was to remain open. She therefore felt that she could combine three news angles into one story and be assured of success in selling the story to the programme's editor.

In deciding to do a story on the society's annual report, she did not wish to base the entire piece on an interview with one of their representatives, so she decided to structure the story around one of the society's hostels for the homeless in Dublin.

She chose the particular hostel for filming in because of two factors. Firstly, she had a good working relationship with the hostel, and the St. Vincent de Paul Society, in doing stories about homelessness in the past. She stressed that the society, unlike another unnamed organisation for the homeless, had proven themselves to be co-operative with her when she was doing stories on poverty and homelessness previously. Secondly, her choice of the particular hostel was influenced by the fact that she saw its population as being representative of the homeless in that half of the residents lived there permanently and the remainder were transients. The reporter gave the society and the hostel itself a guarantee that the film crew would not necessarily film any faces of the homeless and they would be guided by the hostels administrator in terms of where they would or would not film.

The reporter and her film crew went to the hostel early in the morning and spent about ninety minutes there. Although they only needed a small amount of footage for the story itself, they also used the opportunity

afforded to them in accessing the hostel to gather some library footage for future stories about homelessness.

Filming the homeless

The crew filmed the men as they got up and went to breakfast. In filming the bedrooms, washing area and breakfast scenes, the reporter stated that the crew were careful about the shots they took. The filming of the hostels residents was driven by a number of concerns. The reporter stated that her concern in filming homelessness, child-abuse or poverty would firstly be to ensure that one is not actually putting people's faces out there on television, who do not want to be there, and not to be seen to be exploiting the situation for the sake of better pictures. She said 'You always approach them [the homeless] from the basis that they will be anonymous shots, hence there is quite a lot of emphasis on hands, feet, all that type of cut-away stuff.'

Her work was also guided by the credo that you ask permission before filming those who are poor. In this case, the reporter asked the permission of the hostel's warden and of the homeless men themselves. The crew found some of the men to be co-operative, yet many were nervous of being filmed.[5] In some instances, it was felt that despite the men granting permission to be filmed, they might not fully understand what was going on, so it was decided not to shoot them at all.[6]

Images of the homeless

In filming the report, the reporter wanted a set of images that would tell a story about poverty without using what she termed 'head-on shots'. She wished to:

> ... indicate that in lots of ways, life for these people is the same as everybody else. They do the same things as everybody else like wash, shave, whatever, but at the same time you want to capture the pathos of the situation.

Thus the report focused on men eating, walking and shaving before breakfast. In the case of this reporter, she typically discusses the parameters of the story with her crew and suggests the type of shots she wants for the piece. Although she has the ultimate say in terms of what images go into her report, oftentimes and in the case of the above report, the cameraman will also make his contribution in terms of the best images to shoot and include.

This particular case is an interesting example of how a journalist turned a relatively common event (the publishing of a report) into a newsworthy story and therefore stood a greater chance in getting the story onto the

5 This was particularly obvious in watching the rough footage of the breakfast scene.

6 In viewing the rough footage shot at the hostel, it was possible to hear the camera man call out instructions to the homeless men being filmed and telling them that their faces would not appear on television.

news agenda. It is also of further interest in that it shows how, despite the lack of formal procedures in terms of filming the poor, individual journalists carve out their own personal criteria when it comes to filming those on the margins.

We can identify two types of agenda-setting in this case. In the first instance, the agent organisation tried to influence the news agenda by informing the reporter and by sending advance information to the newsroom diary. This information in its own right was adjudged by the reporter to be insufficient and she realised that a combination of related stories would stand a greater chance of being a contender to reach the news agenda.[7] Tuchman's (1991) thesis that 'The statement of an official source is an event' has therefore to be qualified in the case of poverty coverage. Many statements about poverty are made and do not make it onto news agendas. The agenda-setting which took place in this instance was influenced by the fact that the reporter had a good working relationship with the organisation in question. Ultimately it was the agreement of the editor or gatekeeper which allowed for the making and broadcasting of this report.

Case (B): The funeral of Pauline Leonard
Background

In December 1992, two homeless people were found dead on a plot of waste ground in Dublin City. They had died from hypothermia. The deaths were briefly mentioned in the news on radio and television, but it took six days for the events to be translated into a television news report.[8] The reporter suggested to his editor that he would do a story under the special features section of *Six-One News* on the funeral of one of the two homeless people who had died. He was motivated by a feeling that the news programme had a responsibility to cover the story out of a sense of social accountability.

There is also a sense, however, in his thinking that the story was somehow novel in that while some funerals are common to news agendas, the funeral of a homeless person had not been done before. He received the go ahead from his superiors and set about contacting the homeless organisation responsible for organising the funeral. His intention was to try and tell the story of Pauline Leonard's life through her death, as well as raise the possibility that more homeless people would die on the streets that winter.

7 The fact that potential stories about poverty reach the news diary does not necessarily mean that they will be translated into actual reports. During my fieldwork for example a launch of a fast for Third World famine was disallowed from the news agenda because it was judged by both editors and reporters as not being newsworthy enough.

8 This is in contrast to the print media. *The Irish Times* reported the deaths on the morning after the discovery of the two bodies. 'Two Bodies Found in Laneway' 3 December 1992 (p. 2) and they also reported the post-mortem results on 4 December 1992 (p. 2) in 'Woman, man died from cold' by Paul O'Neill.

The report in his words was 'designed to tug at the heartstrings' of the audience, to make them aware of the issue of homelessness in 1992.

Filming the funeral

The reporter and his crew were quite deliberate in their choice of images. Some discussion on what was to go into the report took place between the camera man and the reporter. He held the view, however, that, because of the constraints of working to a tight deadline for a television news programme, there is in fact very little time to consider the images used. Filming and the selection of images was attributed to instinct. Thus, for example, there was an attempt in this report to intertwine the story of Pauline Leonard with the story of the Blessed Virgin Mary as well as drawing upon other artefacts, such as candles associated with Catholic belief. The reporters view was that the use of candles – some lighting, some extinguished – was intended to be provocative, emotive and religious. Similarly, the use of images of the Blessed Virgin Mary were intended to mesh her suffering and humility with those of the dead woman.

He also decided to use the priest's homily about her kindness to animals and birds as a narrative which would sum up her life. Unusually, there are close up shots of the woman's homeless friends who have turned up to grieve. The reporter included these images in the final cut of his report because in his view:

> That [a homeless man crying] says everything to you. That's a sad down and out. They showed up. They knew her … they showed up at 10 o'clock in the morning.

His view was that those who are on the margins of society and normally excluded had made the effort to turn up to the funeral and therefore deserved to be included in the story. The reporter saw his narrative as a powerful human interest story and therefore felt justified in using frontal shots of the homeless. While there are no set groundrules about filming people who are poor, the reporter in question expressed the view that he took care in terms of not intruding on people's grief and being sensitive to people's sadness. This particular story provoked an amount of reaction from the viewers and the reporter in question argued that it was in some way responsible for forcing the national and local government to temporarily act on the matter.

Case B is illustrative of three types of agenda-setting. The idea for the story came from an individual journalist, who sought to get the story on air. He was successful in suggesting to the news editor that the story be included under the rubric of special features. As in Case A, the final decision as to whether or not the story be included in the programme rested with the editor. This case is also an example of what Breed (1955) termed inter-media agenda setting, as the report set in a train a series of other reports on the issue of homelessness in both the Irish print and broadcast media.

Case (C): Travellers on the Curragh firing range

Background

Prompted by a story printed in a provincial newspaper, the *Six-One News* Security Correspondent decided to do a report on the presence of some Travellers near the Irish Army's firing range in County Kildare. The suggested report was accepted immediately by the programme editor. The reporter considered the news worthiness of the story to stem from the fact that Travellers were alleged to be exercising their trotting ponies on the firing ranges of '... the people who are entrusted with the security of the state'. He discovered that there were three parties involved in the dispute: The Irish Army, The Department of Defence, and Travellers and that the matter was now the subject of a High Court injunction against the latter group.

He researched the story by getting in contact with both the defence forces and the Department of Defence. He did not contact either a Travellers representative group or indeed any of the Travellers who had taken up residence at the Curragh camp. He ran into a number of difficulties in producing his story, because of the refusal of the Department of Defence to provide a spokesperson and owing to later accusations by a department official that the film crew and reporter were actually trespassing on the lands in filming their report. Despite the refusals of co-operation at an official level, the reporter managed to gather enough information from unofficial sources to write his story. Initially, he wished to speak to all sides of the dispute when he was filming the report. Yet he was hampered by the fact that army officials would not speak to him on camera, the Department of Defence would not provide an interviewee and the possible legal problems in interviewing a Traveller over a matter that was sub-judice. He was particularly conscious of the possible legal difficulties that might arise if he began to ask the Travellers to explain their situation – a task which he held would be more appropriate for a High Court judge. In any event, he was saved from this difficulty on the day of filming because when he and the crew arrived at the firing range there were no Travellers to be seen as they were all attending a wedding elsewhere.

Filming the report and the use of images

The filming of this story was to be constrained by the lack of co-operation given to the reporter, the possibility of legal problems and his reluctance and inability to interview any of the three parties in the dispute. The reporter in question suggested that he was in control of the images filmed and used in the final report. Much of this control is owed to practical rather than ideological concerns. As a Security Correspondent, he was readily familiar with the location in question, and he argued that, given that you have the film crew for approximately one hour, you have to take some immediate decisions on what you wish to be filmed.

Case C is a further example of the necessity to please the gatekeepers who guard the news agenda and Breed's (1955) concept of inter-media agenda setting. In this instance *Six-One News* was influenced by the appearance of a report in the provincial print-media.

These three cases confirm the assertions by Ericson *et al* that:

> News is a product of transactions between journalists and their sources. The primary source of reality for news is not what happens in the real world. The reality of news is embedded in the nature and type of social and cultural relations that develop between journalists and their sources and in the politics of knowledge that emerges on each specific newsbeat. (1989:377)

Tuchman's (1991) argument on how the politics of knowledge affect news agendas is also confirmed. Journalists attempt (with varying degrees of success) to place stories on the news agenda in the knowledge of what news editors will accept or reject.

Poverty news as ideology

Following the work of Sorenson (1991), this study takes the view that news reports about poverty can be viewed as being ideological in make up. The findings of this chapter would suggest that there is an obvious tension between the permanency of poverty in Irish society and the ebb and flow of poverty news on television. The need of journalists to abridge what is a multi-faceted problem to a single 'story', which will be acceptable as 'news' by a programme editor serves to reduce the likelihood of poverty being explored in any detailed way. Poverty cannot of course be a news item all of the time, but qualitative examinations undertaken in this chapter would suggest that there are identifiable trends in how RTÉ news constructs its coverage of poverty.

Unlike the regular, but sometimes narrow, thematic coverage of the issue of unemployment, news about poverty is largely episodic in nature. These findings are in general agreement with Iyengar's (1991) analysis of the framing of poverty stories by American television. He found that poverty news is not a priority for American newsmakers. Of the poverty stories which do get on air, they are predominantly of an episodic nature – a trend which is confirmed in our analyses of RTÉ's stories. Unemployment news on both Irish and American television is largely of a thematic or abstract nature. Despite being covered on a regular basis, the coverage of unemployment is typically structured in such a way as to ignore the true causal factors of unemployment, namely as a result of the dysfunctions of late capitalism.

What is therefore a permanent in the real world comes and goes as a news story. The fact that a news programme treats poverty in this cyclical and seasonal way suggests that RTÉ news engages in an ideological exercise which firmly locates a consideration of poverty to one end of the news

year.

This can in some respects be explained by the complexity of poverty as a phenomenon, but there is also the more basic issue of the relative newsworthiness of poverty to be addressed. When poverty stories get past the news gatekeepers, they are marked by the following features:

1 Poverty stories feature elite individuals and groups.
2 They are often the result of the prior actions of other media organisations.
3 Poverty news is told in terms of a crisis.
4 Where actual members of the poor are featured, there is a tendency to focus on the problematic nature of the more exotic or 'deviant' subcultural poverty groups such as the Travelling community or the homeless.

Galtung and Ruge's (1965) and more recently Horgan's (1986, 1987) assertions about the proclivity of the media to focus on elite individuals in terms of the *dramatis personae* of news are confirmed in this chapter. In the main, poverty news is really news about how those who are in positions of power are responding to aspects of the problem of poverty. This news reaffirms their status and rarely questions their activities in any way. The emphasis on elite figures can in part be explained by their ability to influence the setting of news agendas. Other media organisations can also be shown to set the news agenda in terms of poverty coverage. The large number of reports on the activities of President Robinson in Somalia in 1992 and the crises of both homelessness and the new poor were in part influenced by the fact that the Irish print media had also taken an interest in these themes.

Poverty news is often told in terms of some real or imagined crisis which is about to affect an individual or a group. In terms of the analysis of news stories in this chapter, poverty stories, which were narrated as crisis stories, were ones concerning the new poor and the deaths of the homeless. The fact that poverty exists on a long-term basis for large numbers of people and that homelessness exists permanently in Irish society are in themselves not deemed to be newsworthy. In the few instances, where stories focus on actual members of the poor, RTÉ news was found to feature less powerful and more exotic groups. Many of these reports reaffirm what some members of the audience might regard as the problematic nature of groups such as the Travelling community. Thus, as Shoemaker *et al* (1987) pointed out, the deviant has considerable newsworthiness. Coverage of the deviant poor may arise out the sense of novelty or oddity in a story, but it in turn plays an important ideological function. The existence of the problem is confirmed, but the locus of responsibility for the problem is individualised and therefore absolves the news programme from viewing the issue in a structural way. Thus the status quo is confirmed and not threatened.

The way in which news stories about poverty are produced adds weight to the argument that they are ideological.[9] As Golding pointed out news may be seen to be ideological 'not by virtue of any intent to deceive or manipu-

late, but, because of the exigencies of routine production procedures in newsrooms and the beliefs and conventions which support them.' (1981:63) The three cases of how poverty stories were produced by RTÉ in 1992 show the constraints which journalists work under in getting stories onto the news agenda. The need to convince the editor/gatekeeper of the relevance of the 'story'; the limited amount of time available to film and edit the report; the dependency on what are viewed to be reliable spokespersons; and the use of particular reporting/filming styles all influence the final product which is the news story.

9 In choosing particular images or symbols to communicate their stories, reporters engage in an ideological act, which may determine the way in which audience members will interpret the message systems about the poor. For example, religious symbolism may be used to convey a sense of pathos about the lives of the poor, but this also functions to replace more hard hitting images about the reality of their lives.

6

Never mind the issues …
Where's the drama?

Introduction

This chapter examines the coverage of poverty issues on Irish fictional television. It asks whether television of a fictional nature provides more or less space for the coverage of social problems. The chapter considers the 1992–1993 series of *Glenroe*, beginning with a description of its history and a discussion of the features of the programme which might constrain its coverage of poverty stories. In addition to this, an ethnographic account details the background processes that frame the making of poverty stories in *Glenroe*. The third and main part of this chapter is an examination of how *Glenroe* explored some issues pertaining to the Travelling community and the unemployed. Our discussion concludes with a consideration of the limitations of fictional television in dealing with social problem issues.

Glenroe: Background and history

Glenroe is an RTÉ-produced weekly television drama serial. (See Sheehan, 1987 and 1993) First broadcast in 1983, the programme had just completed its tenth series of 34 episodes in May 1993, which forms the basis of the discussion in this chapter. The programme's lineage may be traced to the RTÉ mini-series *Bracken*, which bridged the gap between the long running serial *The Riordans* and *Glenroe*. Set in County Wicklow, supposedly about 30 miles from Dublin, the programme is concerned with the inhabitants of the village of Glenroe, in which a mixture of rural and urban people live.

All three programmes have had the same creator in Wesley Burrowes and both *The Riordans* and *Glenroe* have dealt with aspects of the problems

1 It is interesting to note that during his days as the creator of *The Riordans*, Wesley Burrowes held the view that 'The main reason for not providing solutions to problems is that really serious problems have no solutions. If the Itinerant question, or the problem of mixed marriages had a simple solution, they would still not be national problems. It is unfair to expect *The Riordans* to answer questions which the State and the Churches have not answered in sixty years.' (1977:91)

experienced by the Irish Travelling community.[1] The programme has been a phenomenal success in terms of its level of viewership. It regularly attracts 1.5 million viewers to its 8.30pm Sunday evening slot, and, for example, in its eight series, it pushed *The Late Late Show* into second place as the top rating programme on RTÉ. The average viewership of *Glenroe* during its 1992–1993 season was 1,234,000 (39 per cent) for the Sunday broadcast (8.30pm to 9.00pm).[2]

Given its positioning in RTÉ's programming schedule, and in terms of the types of issues explored in the series, the programme is clearly intended for what its makers describe as 'family' viewing. Controversial issues of a political nature such as Northern Ireland or even political corruption at local or national political level are never mentioned. Likewise, there is no debate on sexuality, even though there is a strong melodramatic emphasis in the series, which takes relationships between the (usually married) sexes as their theme.

Most of the action of the programme takes place in a number of communal locations such as the village pub, The Molly Malone, the local Roman Catholic church, the Byrne's farm, Stephen Brennan's golf-course, and in the homesteads of the Byrnes, Brennans, and Morans.[3] Other scenes are shot on the streets of Glenroe or in places of business such as Byrne's vegetable shop or Moran's auctioneers.

In common with other television drama serials,[4] the series is dominated by the rural middle class of farmers and professionals (farmers, shopkeepers, auctioneers, publicans, chemist) but the other ends of the social spectrum are also represented (the ascendancy and the Travelling community). Class divisions, however, are not seen as barriers to interaction between the characters. The programme places a strong emphasis on the possibility of good relations between different social groupings based on a shared membership of the Glenroe community. With the exception of Stephen Brennan and Mynah Timlin who are cast in the role of being anti-Traveller, Blackie Connors (the programme's main Traveller character) moves with ease between the programme's characters who respect Blackie for his wit and his involvement with community affairs.

At the other end of the social ladder, George Manning who is of ascendancy stock and lives in the village's Big House, is portrayed as a friendly eccentric with an interest in wildlife and gardening. He is regularly the butt of the other villager's jokes – the locals for example make great fun out of his annual stint as 'landlord' of The Molly Malone when he replaces Teasy who is on holidays, because of his inability to pull a proper pint of beer. Yet

2 The repeat of this programme on RTÉ's *Network 2* on Thursdays at 7.30 pm attracts an average viewership of 342,000 (11 per cent). (Source: RTÉ TAM Survey).

3 See Appendix Two for a list of relevant characters

4 For a discussion on the class composition of soap operas see for example Rose (1979). Rose argued that the soaps which she examined had an emphasis on professional and not family life. Blue Collar occupations were found to be virtually non-existent in the series considered.

despite his class position, wealth and membership of a different religious tradition he is liked by the inhabitants of Glenroe. The programme concentrates on the lives of two families, the Byrnes (Dinny, Miley and Biddy) and the Morans (Dick and Mary) with other families and individuals getting coverage as a result of their interactions with the Byrnes and Morans and in terms of storylines of less interest. In common with other television drama serials, there is a strong 'human interest' dimension to the programme with a great deal of emphasis on marital infidelity, failed love affairs and personal crises.

Critics of this television genre have dismissed the capability of television drama or soap opera to effectively deal with issues of either a social or personal nature. The depth to which problems are plumbed is held to be superficial. Indeed it might be argued that given the concentration of such programmes on the experiences of particular families and individuals it is hardly believable that so many things could happen to the characters portrayed in any one person's lifetime. Leaving aside the ability of the television drama audience to suspend its disbelief when viewing such programmes, there remains the issue of the extent to which problems are explored. Issues may be raised, touched upon and very quickly dropped again by the programme's producers. What we term the 'hot-potato effect' certainly has its bearing on how *Glenroe* raises issues in the social sphere. Questions such as the racism experienced by Travellers are raised and very quickly forgotten. Greater attention seems to be paid to the melodramatic events in the programme, which are, more often than not, stories written about the central characters. These are the politically safe issues of marital infidelity or personal crises. Stories about the break up or formation of new relationships are given more attention, more space to develop as stories and usually re-emerge after a particular time period has lapsed.

The formula of the programme is based on a series of contrasts, strong characterisation and humour. As Silj noted, drawing on O'Connor's research 'The plot and characters revolve around the axis of the traditional versus the modern, the rural versus the urban'. (1988:94) The mixed rural and urban population of the series allow for these contrasts to be explored and in many ways the storylines of the programme present an interesting cultural mirror, reflecting in dramatic form some of what is actually happening in a rapidly changing society like Ireland.

According to a study of audience response to *Glenroe*, the programme's strengths were seen to be its humour and characterisation. O'Connor found that 'This humour was regarded as peculiarly Irish and was distinguished from other kinds of humour in a number of ways. It was perceived as being both subtle and clever.' (1990:9) An example from previous episodes might be when Dinny decided to go into the free-range egg business. He in fact was buying the eggs secretly from a supermarket and covering them in chicken dung and fooling his buyers. Similarly, in the series considered in this chapter, George Manning who was having problems with supposed impotence got around his embarrassment by describing his

sperm as salmon swimming up the river towards their breeding ground. O'Connor's (1990) research indicated that the viewership of *Glenroe* also were attracted to the series because of its strong characterisation. Dinny, Miley and Biddy were the most popular figures with the audience and particular mention was given to the humorous exchanges between these characters. Other characters in this series were dismissed because of their lack of humour. As one of O'Connor's sample group told her 'Dick Moran and the rest you forget because they are too serious ... where you are only watching for ... the amusing parts ... you dismiss them really when they come in ... they are just the many people to keep it going.' (1990:10)

These findings are of importance in terms of our interest in how *Glenroe* either ignores or covers aspects of social problems. The audience research carried out by O'Connor suggested that *Glenroe*'s emphasis on humour was to the detriment of its coverage of social problems. She argued that:

> ... it is no coincidence that our audience research has shown that the age groups with which this serial is least popular are the younger ones. Young people criticise the stress on humour, feeling that in the end this produces a lightweight programme, inferior to British serials, particularly *Brookside*, which is regarded as far more attentive to social problems. (1988:103–104)

This is an interesting comment, in that two British serials, *Emmerdale* which is very similar in structure to *Glenroe*, and the urban based *Brookside*, have both dealt with contentious social problems. At the time of writing, in *Emmerdale* the local publican Alan Turner has developed a concern for the homeless. We see Turner not only fund-raising for the homeless but actually spending some time 'skippering out' with the homeless men and women of the area. The text of this programme has spent a great deal of time challenging notions of middle-class philanthrophy and has in turn allowed us to view a set of often unseen images of the poor. In *Brookside*, the programme has explored in some detail the problems of an illegal female Polish immigrant who, not being legally allowed to work, is facing destitution and ends up working as an escort girl. Neither *Brookside* nor *Emmerdale* are short on humour but still contain the capacity to deal with social problem stories.

Constraints

If we are to consider how *Glenroe* deals with the issues of unemployment and the problems of the Travelling community, it might be useful at this juncture to summarise what the constraints of the form and structure of the programme on this coverage might be. *Glenroe* is a popular television drama programme, its actual content and concerns are evidently popular with its audience. The programme's formula is driven by a strong emphasis on humour and characterisation. The programme's makers see their role as the production of good drama and not as the Irish society's troubleshooters. (As one of them recently remarked to the author 'Never mind the

issues ... Where's the drama?') Its focus is on a limited number of central characters, with coverage of other characters usually in the context of the experience of the central characters. The scarcity of social problems as the material for stories is influenced by the fact that, despite the existence of examples of an underclass and upper class in the series, the programme is taken up predominantly with the affairs of the rural middle class. There is a tendency to concentrate on 'human interest' stories, and if social issues are raised they are usually touched upon in only a superficial manner. There is evidently a 'hot-potato' strategy used in the coverage of certain issues. Aspects of potentially controversial issues are touched upon and then very quickly forgotten. There may be technical limitations, which place a brake on the extent to which a programme may look at issues real-istically and in depth. In *Glenroe*, for example, most of the action is shot around a limited number settings.

A view from inside *Glenroe*

From the perspective of those who are involved in the creation of *Glenroe*, the programme is seen as having the core function of entertaining its audi-ence. Character development is central to this process and social issues are included only if they have a dramatic potential. This point of view repre-sents an interesting shift in the making of RTÉ's television drama in that *Glenroe*'s parent programme *The Riordans* had a remit which was to educate the rural population in terms of modern agricultural techniques, but also more importantly, it was conceded to me by the creator of both *Glenroe* and *The Riordans* that the latter programme deliberately sought out social issues to investigate.

Thus the evident change of heart by the programme's creator has led to a significant alteration in the ways in which the role of television drama is seen within the *Glenroe* camp. The formula for *Glenroe* is seen as being character driven rather than story or issue centred. One senior member of the production team told me that as a rule the stories or social issues always come from the characters. If and when some social issue emerges from the character's development which the writer is attempting to create then it is dealt with, but only in terms of the character's development and not vice versa. According to another member of the production team, social issues only ever get on to the programme's agenda out of a story which is concerned with the interaction of the programme's characters. Indeed, the programme's creator held the view that those few characters who were evi-dently poor were to be defined by the programme's writers and producers as characters first who in turn happen to be Travellers or unemployed. In addition to this belief that characters and not issues come first is a clear antipathy towards being seen as a programme which is preaching to its audience. In the words of one of the programme's writers, *Glenroe* 'must not ever appear as if we are trying to preach a gospel that will reflect one or other situation'.

There is widespread agreement amongst the makers of *Glenroe* as to the programme's remit. The dominant view is that *Glenroe* is a realistic serialised drama and not a soap opera. Such an assertion is based on the programme's quality in terms of both its production values and the dramatic content of the series. However, the extent to which the programme reflects reality is constrained by the premise that the programme should primarily be entertaining and only reflect reality in the words of one scriptwriter 'at a safe distance.'

Another person involved in the making of the series saw their relationship with the audience as one of collusion in that the programme makers believed that they had to 'look after their audience' by entertaining them and not attempting to be didactic. There are two potential problem areas here in that *Glenroe*'s makers assume that (a) the audience is a monolith; and (b) they know what the audience wants.

The Theatre of Reassurance

Built into this set of assumptions about what 'the audience' want is the view that audience expectations centre on being entertained in a comforting way. Indeed in terms of those audience members who are poor, the programme's creator held the view that he did not have the right to pontificate to them. He added that:

> ... entertaining them [the poor] has its own value. To be able to escape into this world once a week where everything is predictable and controlled in the hands of a writer and a production team is important in its own right.

He saw the programme as being allowed to be as experimental or as socially conscientious as it liked, but it must never 'preach a gospel that will reflect one or other situation'.

This notion that the programme is free from having an ideological position is a stance which cannot be accepted as our analysis of the programme's content below shows. The certainty with which those involved in making the programme speak about the tastes of their audience must also be questioned. One of the programme's scriptwriters told me 'people don't expect it to be a gritty realistic programme – when we have done realistic stories, we wonder how far you can go with a story on a Sunday night?'

The location of the programme in what is seen as 'family' viewing time (8.30pm Sunday) is seen by its makers as being a constraint on the parameters of *Glenroe*. Added to this is the issue of programme ratings. There is an evident pressure on the makers of *Glenroe* to keep the programme at the top of the TAM ratings list. In the words of one of the production team the most important issue for the makers of *Glenroe* is 'getting re-elected'. Thus the dominant view is that given the programme's success (in ratings terms) to date there is no need to change what is already a tremendously successful programme.

Production processes

In terms of the making of *Glenroe*, my fieldwork revealed a number of interesting features. While formal procedures are observed there are also a number of informal practices which govern the production of the series. The formal production process is overseen by four meetings each year which review the development of the programme's characters. Some discussion takes place on the storylines which are about to be written, but attention is also given to the views of the audience panels who scrutinise programme content over a series. They may be asked to examine specific storylines to assess whether or not they are realistic or to evaluate the performance of a character recently introduced to the series.[5]

In addition to these considerations some thought is given to the various appeals which come from charities and voluntary organisations who want *Glenroe* to build in their particular cause into the programme's storylines. The groups which are successful will find either mention of their cause in the drama's dialogue or at the very least their poster situated on the wall of the local pub. In the 1996 series, the Third World charity Bóthar received several mentions by the programme's characters and one of the programme's storylines revolved around a charity concert in aid of their work.

It was admitted to me by one of *Glenroe*'s scriptwriters that arguments over the portrayal of particular characters took place at some of these meetings. The person in question wished to portray the Travelling community in, as he saw it, a more realistic light, but was disallowed from doing so because the majority of the programme team wanted the series to be comforting for its audience. The programme has in his view 'political correctness hanging around its neck' and therefore cannot explore issues in a realistic way. In the case of another storyline concerning the paternity of Carmel O'Hagan's son, the storyline was changed at one of these meetings because of a worry of antagonising the audience who hold Miley Byrne's character in high regard. Another storyline on the exclusion of both Travellers and the disabled again saw division amongst the production team over the inclusion of this story. The debate centred on whether this was just an issue based story or whether it would in fact help with the development of the two characters concerned. The programme's creator was opposed to covering this issue because in his words 'everything with me is the story and the relationship of the characters.' In his estimation there was nowhere you could bring the story afterwards and it contributed little, if anything, to character development. Although the issue was included in the programme, it in fact quickly disappeared from the programme's storyboards which allow us to conclude that the dissenting views of the programme's creator eventually held sway.

5 In 1993, for example, the audience panels indicated some disquiet about the absence of young people from the programme and the subsequent introduction of several younger characters in the 1994–1995 series would seem to indicate that their views held sway.

But it is the more informal practices which are perhaps of greater interest. One source told me that in the making of the series if ever there arose in scripts elements which were anti-Traveller or which were 'politically incorrect', the actors would change either the script or characterisation in a subtle way as they did not wish to be associated with the viewpoint being expressed. Despite the later objections which might arise from a scriptwriter, the producer would allow these changes to be made because of the pressures of production and the possible delays in shooting the next episode if a rewrite were required.

In terms of portrayal of the Travelling community a further informal practice has evolved. One of *Glenroe*'s secondary characters is in real life a member of the Travelling community and is to the forefront of a public campaign to establish the recognition of Travellers as an ethnic minority. In the making of *Glenroe* scripts which concern the Travellers are referred to the actor to check for their reliability in terms of both cultural practices and the language patterns which Travellers might use.

This practice of checking with this particular actor as to the authenticity of the script is in turn replicated by many of the other cast members. He has attempted (with limited success) to influence the programme's agenda in terms of Travellers issues. At the beginning of the 1992–1993 series, the actor got in contact with the writers and producers of *Glenroe* to see if they would include more Traveller issues. He wanted his character's child to die in order to demonstrate the alarming rates of infant mortality which affect Travellers. According to him this story was rejected by the programme's creator because 'He couldn't inflict it on the nation'. In this instance what is perceived by the programme makers as good entertainment and character development won the day.

In its portrayal of the Travelling community, *Glenroe* is constrained by a number of factors. The limitations faced by the programme in resource terms (and in its prioritisation of existing resources) meant that in the 1992–1993 series there was no set built to show Travellers in either a halting site or in permanent housing. Likewise the audience did not see where the unemployed couple Carmel and Damian live. Thus, in the opinion of one of the programme's actors both the Travelling community and the unemployed were being deliberately kept at a distance from the programme's audience.

The programme's makers, however, have to deal with other problems if they in fact attempt to be more realistic in their portrayal of the Travelling community. One senior person involved in the series told me:

> We ought to show Travellers as they are – warts and all. It is difficult to do so because of the instant reaction you get from them. But if you make them too cosy – the public say they are not like that at all.

That the programme is on the receiving end of scrutiny from Traveller activists was evidenced during my fieldwork at RTÉ. In the 1993–1994

series of the programme *Glenroe* had a mistaken identity storyline which saw Blackie Connors being wrongly accused of housebreaking in *Glenroe*. After much accusation by the other inhabitants of *Glenroe*, the question was solved with the arrest of another man who looked like Blackie. But as soon as the story began, Travellers' rights organisations complained to RTÉ about both the negative portrayal of Travellers and *Glenroe*'s choice of Blackie as the subject of a burglary storyline.

Losers and primitives

Despite these difficulties, it has to be said that the programme has a degree of commitment to covering some Travellers issues.[6] The perspective which the creator of the programme has on this and the issue of unemployment reveals an ideological viewpoint which is worth commenting upon. He admitted to me that the programme is interested '... in exposing the continuing social prejudices towards the Travellers. But the Travellers themselves we will try to show as an ordinary kind of working class people of an innocent primitive kind.' This is a position which sees the Travellers as having an exotic curiosity value and may partially explain why they are the only examples of the poor who have continually featured in the series. There is, however, a crux with this perspective in that all of the other characters in the programme (and presumably many audience members) whether middle or working class do not see the Travellers as being working class but rather as standing outside of the division of labour. They are closer to what Marx (1958) referred to as the lumpenproletariat.

The creator of *Glenroe* accepted that the programme has not sufficiently acknowledged the effects of unemployment on a community like *Glenroe*. This position was defended somewhat weakly by the assertion that *Glenroe* has been more concerned with character development rather than the effects of unemployment. A hint of where the programme's creator stands ideologically may be found in his viewpoint expressed to me that 'life's like that' and 'the innocent suffer' in terms of how the storylines about Carmel and Damian were written.

He saw *Glenroe*'s task in writing their story as allowing the programme team to comment on how the Irish public view those unemployed who are outsiders or 'blow-ins' to use a colloquial term. But in doing so *Glenroe* was not attempting to solve the issue but merely present it. The notion that the interaction of the programme's characters is more important than the issue itself was again put forward as the reason why the programme dealt with this question in a superficial way.

6 Ironically, during the filming of a previous series of *Glenroe* which dealt with the lack of facilities for Travellers to hold a wedding celebration, the programme team came face to face with the prejudices experienced by Travellers in the real world. After filming the programme at a County Wicklow hotel about the racist attitudes of many hoteliers, the programme's extras who were in fact members of the Travelling community were refused service in the hotel used by RTÉ in shooting the scenes for *Glenroe*. Life therefore does imitate fiction.

Outsiders and Travellers

Glenroe's treatment of the issues of unemployment and the Travelling community in its 1992–1993 season are now examined. I begin by summarising the background to the storylines and then in turn examine in detail the messages of this programme about the Travellers and the unemployed.

Outsiders: Carmel and Damian's story

In the first seven episodes of *Glenroe* the programme deals with the experiences of an unemployed couple named Carmel and Damian. They are familiar to viewers from the series *Bracken* in which there was a storyline which hinted at the notion that Miley Byrne was the father of Carmel's son. This was meant to have happened when Miley was in exile in London. It transpires that the child's father is in fact Carmel's husband Damian. Both were Irish emigrants and have now decided to return to Glenroe in search of work. Damian is portrayed as having a 'difficult' character while his wife Carmel is generally viewed with a mixture of distrust and sympathy. The couple's attempts to get work are thwarted by everybody in the village (with the exception of Miley). Both Carmel and Damian, however, persevere in their search for employment. Carmel temporarily replaces Biddy in the vegetable shop while Damian does a number of odd jobs in the village. When Damian eventually gets an evening's work in the local pub, it ends with him having an argument with the proprietor's son. He leaves the pub in anger and is later found dead, having being killed in a hit and run car accident. This leaves Carmel a widow and sets the scene for a storyline concerning alleged infidelity between Carmel and Miley in the later episodes of the series.

The Carmel and Damian story represents an interesting narrative about unemployment and the unemployed. They are outsiders in the community that is Glenroe and are treated with distrust by the locals. Their story is one of pain and hardship while other couples beset by hard times are saved by magic wand solutions. Carmel and Damian, however, are viewed with suspicion and hostility. Their right to assistance is questioned by many of the programme's characters and particular reference is made to the notion that they are 'sponging' off the state's social welfare system.[7]

From the first episode in the series Damian is treated with suspicion. His wife Carmel has asked the parish priest Fr. Devereux to help in finding Damian work but to no avail. She offers his electrical expertise to Michelle Haughey. When it turns out that the job undertaken by Damian was not a success the following exchange takes place between Michelle and her mother:

Michelle: I knew that fellah could not be trusted!

7 For an account of coverage so-called 'sponging' in the news media see Golding and Middleton (1979).

Mother: What fellah?

Michelle: Damian. I'll gut him when I see him, he was supposed to fix that fuse box, you know ... chancer ... he took 25 quid off us as well.

Mother: I wonder was that all he took?

Damian is viewed with distrust. When it transpires that a box of silver cutlery is missing he is immediately blamed. Michelle's own husband who is also unemployed, however, pawned the cutlery to pay for his gambling activities. Yet the community readily believes the story that it is Damian who is responsible for the act.

In episode three of *Glenroe* Damian is still looking for work. He asks Fr. Devereux for help in this regard. The priest who is organising a 'Clean Up Glenroe Campaign' passes Damian on to his housekeeper. She very quickly tells Damian that the work is of a voluntary nature and that he would get his reward in heaven. When Damian is helping out with the loading of a skip with rubbish, he is also selecting items which might be useful for himself or which might be sold. One of the locals, seeing Damian hiding some of the rubbish behind a tree, humorously refers to Damian as a 'squirrel'. There then emerges a conflict between the Traveller Blackie Connors and Damian. Blackie who deals in scrap, is likewise interested in the contents of the skip.

The ensuing scuffle is sorted out by Fr. Devereux, Kevin Haughey and Stephen Brennan. This is an interesting scenario in that it portrays the two most visible groups of poor in the village pitted against each other. Damian ironically casts himself as the protector of community property, working voluntarily for a community that has turned its back on him. The scene portrays both Damian and the Travellers as being in a parasitic relationship with the rest of the community and being in competition with each other. It also serves to confirm the suspicions which the locals have of Damian as unreliable and impetuous.

In episode four of *Glenroe*, Michelle Haughey and Teasy McDaid discuss Carmel and Damian. Michelle sees them as scroungers and undeserving of help. Teasy responds to Michelle's observations by stating that Carmel and Damian have had a rough time. The following conversation takes place:

Michelle: Teasy, we have all had a rough time, but we don't go sponging off the state.

Teasy: Who's sponging off the state?

Michelle: Well ... they come back here because they can't make it in England and they expect to be supported as though we owe them a living or something.

Teasy then hands the heavily pregnant Michelle her maternity leave form to which Michelle very quickly says 'and that's not sponging off the state ... I've earned every penny of that'. In Michelle's eyes Carmel and Damian are spongers undeserving of the help of either the state or the com-

munity. Michelle's husband Kevin is unemployed and she is about to go on maternity leave thus rendering her dependent on the state for a while but she sees herself as entitled to assistance believing she (unlike Carmel and Damian) has earned it. Thus she falls into the category of those deserving assistance. By episode five Damian has still not found work of a permanent or long-term nature. Miley suggests that Damian work in the vegetable shop replacing his wife Carmel who is about to start work in the fast food take away. Biddy rejects Miley's suggestions and again adds fuel to the notion that Damian ought not to be trusted. She states 'I'm not having that fellah working for us. I don't trust him. Imagine giving him a job and the pub just across the road.' Thus the distrust of Damian continues and is now added to by reference to the idea that he is fond of drinking.

In the following episode, Damian finds work (of a black economy sort) in the local pub. This, however, sees Damian getting drunk and engaging in a row with proprietor's son. Damian leaves the pub in an angry and excited state criticising the key figures of the community for their smugness. He is later found dead on the roadside, having being the victim of a hit and run accident. His demise sets up a crisis for Miley Byrne who blames himself for Damian's death. He was singularly the only character in the programme to show real concern for the welfare of Damian and Carmel. In episode seven Miley tells his wife Biddy of his sense of responsibility for Damian's death. He attempts to rehabilitate the image of Damian rejecting the community's perception of him being one of the undeserving or immoral poor.

The death of Damian allows the community off the hook in terms of their responsibilities towards the poor and unemployed. His widow Carmel is given work by the local publican to expunge herself and the community of their guilt. Miley Byrne is the only character to suffer remorse on Damian's death.

Damian conformed to the notion of the unemployed as being unreliable, lazy, untrustworthy, given to drinking alcohol excessively, willing to engage in the black economy and as a sponger on both the state and the community. This view of him is expressed by many of the series central characters with the exception of Miley Byrne. Damian's wife Carmel is viewed in a somewhat more sympathetic light, but is just about tolerated by the community's members. She is grudgingly given work by Biddy in the Byrne's vegetable shop, although as we later see in the series, some of Biddy's negative feelings towards Carmel are due to Miley's supposed involvement with her in his London days. She tries very hard to get work for her husband but is rejected by those she asks including Fr. Devereux and Miley Byrne. But Carmel, despite some people's sympathies, does not escape either. She too, as Michelle and Teasy's exchange above shows, is treated as an outsider and a sponger on the system and is thus undeserving of help.

Carmel and Damian's story has to be seen as a story about unemployment. The programme presents both of them (but particularly Damian) as exam-

ples of the Devil's poor. They are treated with indifference, hostility and suspicion. They are branded scroungers without question. Damian's character is of particular interest in that despite his obvious desire to work (he asks nearly every person in the village for employment), he is treated with distrust and references are made to whether he is light fingered or prone to drinking too much. There are echoes of the notion of the immoral poor in terms of the attitudes of Glenroe's citizens (with the exception of Miley) to Damian and Carmel.

In terms of the constraints of the programme's shape, the story is told quite quickly, receiving attention in only the first six episodes of the series. There is no real character development for Damian which disallows for audience sympathy or empathy. As the person on the receiving end of the hostility and disinterest of the Glenroe community, we learn little or nothing about Damian's feelings in the face of rejection. Unlike the treatment meted out to the fraudulent auctioneer, Dick Moran – we see him for example buckling under pressure and contemplating suicide – Damian is very much a one-dimensional character. The demands of the programme to entertain are even seen in Damian's portrayal with references to him as a 'squirrel' in the confrontation over the skip, despite the fact that Damian may have been saving the items being discarded by the rest of the Glenroe community in order to make a living.

There are of course other limitations with how *Glenroe* told this story about the unemployed. Despite seeing the desperation of both Carmel and Damian in their search for work of any kind, we get no insight into how and where they live their lives. The conditions they are forced to live in because of their unemployment and their struggle to make ends meet remain invisible. This lack of realism in their portrayal points to the constraints of dealing with social problems in the setting of fictional television. How these problems might be overcome and how these same issues might be narrated differently are discussed below.

In its treatment of the unemployed, *Glenroe* presents its viewers with two contrasting sets of messages about the poor. The narrative about unemployment draws upon a collection of negative images of the unemployed. The community's reaction to Damian's character is based on an accumulation of negative attributes sometimes given to the unemployed. Damian is an example of the undeserving poor owing to his status as an outsider as well as possessing a difficult character. It is readily believed by some of the community's members that he is dishonest, a welfare scrounger and fond of alcohol. We also see Damian as being ready to work in the 'black economy'. The lack of character development in Damian and the kind of portrayal he receives allows the programme to draw upon a stereotypical notion of the unemployed.

The programme treated another unemployed man (Kevin Haughey) much differently. The fate of Kevin Haughey is an interesting contrast to Damian's story. Kevin loses his job and is under financial pressure. He is

willing to work as a drugs courier and is also fond of betting on horses. He is saved by a major betting coup and by Dick Moran's decision to employ him. Neither Kevin's gambling or his willingness to smuggle drugs are given detailed treatment by the programme with both stories given the hot-potato treatment. It is clear that a programme like *Glenroe* has a number of choices in how it might deal with covering the issue of unemployment. It could have told Carmel and Damian's story much differently by attempting to dispel stereotypical ideas about the unemployed. It might have chosen to tell a story about unemployment with a positive outcome – for example how Glenroe as a community responded in an enlightened way to solving unemployment – or it might have allowed greater character development in Damian to allow the audience to empathise with his plight. Those in charge of producing and writing this series may argue that they are primarily interested in 'good drama' and not in solving the social problems of modern Ireland. This may very well be the case, but this position does not excuse or explain why mainly negative images of the unemployed have to be used in a programme which in fact has potentially a greater range of possibilities than stories emanating from a factual setting.

Travellers: Blackie Connors' story

Unlike Carmel and Damian, the Traveller Blackie Connors is a firmly established character in the series *Glenroe*. Having overcome the hostility of some of the locals in an earlier series, he is now broadly accepted by the community at large. We see Blackie moving with ease in the community being on friendly terms with Miley Byrne the farmer, George Manning the representative of the ascendancy and Dick Moran the auctioneer. Blackie is a member of the Neighbourhood Watch committee which in real life and in the fictional world of Glenroe is a community crime alert network. He is similarly a regular in the local pub – The Molly Malone. Such a portrayal is of particular interest in that Travellers in the real world of Irish society are regularly refused entry to pubs and are also mistakenly and unjustly branded by many as being petty thieves. Unlike the awkward and sometimes hostile character of Damian, Blackie Connors is an easy going, friendly and sometimes humorous man which has helped in his integration into the community. Blackie has been to the forefront of the campaign to get better conditions for the local Travellers (whom we only ever see fleetingly) in the form of permanent accommodation in houses.

In the 1992–1993 series of *Glenroe* the storylines which affect Blackie dealt with the issues of Traveller integration, Traveller patriarchy, and the hostilities and prejudices experienced by Travellers in their attempts to socialise or find work.

Episode one of the series sees Blackie falling foul of his Traveller friend Johnny. Blackie and Johnny are replacing a punctured tyre on Johnny's Hiace van. The exchange between the two Travellers highlight the tension between Blackie and the rest of the Travelling community because of

Blackie's acceptance by Glenroe's settled community It also serves to hint at the patriarchal dimension to Traveller culture in Johnny's reference to Blackie as being 'worse than the woman' in his complaining.

Fr. Devereux arrives at the scene and confirms the basis of Johnny's complaints by asking Blackie to get involved in the 'Clean Up Glenroe Campaign'. Later that evening in The Molly Malone pub Miley and Blackie are talking about the clean up. Miley asks Blackie whether he will be involved in the campaign and Blackie, aware of Johnny's presence, says that he is not certain. Johnny suggests to Blackie 'Maybe you should give them a hand, there might be a decent bit of scrap in it ... you could pass it on to your friends ... if they let you.'

Blackie does get involved in the campaign. In doing so he conflicts with Damian and conforms to the public perception of Travellers as being more violent than their settled counterparts. But Blackie's involvement in the campaign also shows him to be an astute scrap dealer. He takes the parts of an old threshing engine from Byrne's farm and later that day drives a hard bargain with George Manning. There are humorous touches to this story in that Dinny Byrne who offered Blackie the scrap for free is put out by the fact that Blackie has made money in selling the scrap. Similarly, we see Blackie engaging in behaviour typical of horse and scrap dealers. When George Manning gives him his payment for the scrap, Blackie spits on a £5 note and gives it back to George telling him that it is his luck money.

By episode fourteen, however, George Manning has become as astute a dealer as Blackie. George is in a dilemma. Having bought a large live turkey for Christmas, his son (Coriolan) has made a pet of the turkey and does not want him to be slaughtered. George sells the turkey to Blackie and in doing so shows that he has learnt a thing or two about dealing from the Traveller. The tone of the exchange between George and Blackie is friendly. They finish their deal by saying 'Thank you Blackie', 'Thank you George' in contrast to their earlier dealings when their relationship was on a more formal footing. Blackie's position as a Traveller again comes up for mention in this exchange. Earlier George had been showing Blackie the threshing machine which he was restoring:

George: I hope to have it ready for the Summer Fair so that you can see for yourself.

Blackie: I don't think that the Summer Fair would be my scene at all ... all them shooting sticks and flowery dresses.

George: Ahh, you must come as my guest and I promise you won't have to wear a flowery dress!

Thus the issue of the exclusion of the Travelling community is reduced to a humorous level. This approach to what is a most serious issue for Travellers is used again in the series. In the same episode a discussion takes place between Blackie Connors and David Brennan in The Molly Malone. David Brennan is wheelchair bound since he had a car accident. Blackie

and David's discussion centres on whether Travellers or the disabled have greater problems with access to public houses. They agree to test out a number of local pubs over the question of access. The scene concludes with Blackie suggesting to David that he (Blackie Connors) should write a reference for David who is in search of an apartment.

The debate over access for Travellers and the disabled is taken up in the following episode. The result of the competition between Blackie and David was a draw. In the first pub, there was no wheelchair access to the toilets. In the second pub both Blackie and David were thrown out of the pub because the barman thought that David and Blackie were both Travellers. There the story of access for both the Travelling community and the disabled finishes, with no further treatment of the story in the remaining episodes of the series.

The story of relations between the Travelling and settled communities is again taken up in episode sixteen. Teasy McDaid has opened a fast food take away and is short staffed as Carmel has returned temporarily to England after Damian's death. Nuala Brennan suggests to Blackie Connor's wife Peggy that she work in the take away. Peggy is willing to work there but is worried about what both the owner Teasy McDaid and her husband Blackie will think. She tells Nuala of her fears:

Peggy: I don't think Teasy really wants me here.

Nuala: Sure, why wouldn't she?

Peggy: Ahh, I don't know. Its the way she was looking at me. There's not many that'd give work to a Traveller.

Peggy's husband Blackie who is doing a favour for Teasy by carrying two bags of potatoes to the take away sees his wife behind the counter. He is surprised and annoyed:

Blackie: Husht Peggy, C'mon.

Peggy: Ahh, Blackie, I'm only helping out.

Blackie: You're a Buffers Lacky.[8] I don't want you doing it ... C'mon.

Exit Peggy and Blackie

Nuala: Ahh, wouldn't it make you sick!

Teasy: Don't worry yourself love, they have their ways ... we have ours.

Later in this episode, we see Blackie and Peggy in the local pub. Blackie is drinking and angrily throwing darts. He is still clearly annoyed with Peggy:

Blackie: Worried about what people would think? I notice that they had you working in the back as well.

Peggy: I was peeling spuds.

8 From the Travellers' own language *shelta* or *cant* meaning a servant or slave for settled people.

Blackie: And that's where you would be kept, you wouldn't be let out behind the counter, that's for sure.

Peggy: And why wouldn't I be?

Blackie: What would people be saying, hah, having their food served to them by Travellers.

Peggy: Nuala doesn't think like that.

Blackie: Well maybe she doesn't, but business is business.

This is an interesting scene in that it attempts to portray Traveller culture as being patriarchal, exemplified in Peggy's willingness to obey her husband's wishes. Unlike earlier scenes which looked upon the exclusion of Travellers in a more humorous light, these scenes are marked by a tone which is much more serious. The difficulties experienced by this marginalised group are given some further attention in this series. In episode thirty we see Sergeant Roche harassing Blackie about alleged 'illegal' trading. When Blackie manages to outwit Sergeant Roche on the trading issue, Roche is quick to find fault with Blackie's tax disc on his van. In the same episode we hear Blackie tell his wife Peggy about his schooldays and the ill treatment of Travellers.

Glenroe's decision to focus on some of the affairs of the Travelling community is an interesting one. In terms of the coverage of social problems generally, and of poverty in particular, the inclusion of the Travelling community raises a number of important questions. It does not present the Travellers as being destitute, rather it explores the Travellers' poverty in terms of social exclusion. These statements, however, should be qualified in that the programme does not focus on the Travelling community *per se*, rather it includes a single Traveller character – Blackie Connors – with just two other satellite characters of minor importance.

One reading of the decision to include the Travelling community might be that the programme is only interested in the more 'exotic' forms of poverty and its dramatic possibilities in terms of humour and contrast, rather than an interest in poverty issues generally. A second reading of this coverage is that the programme is attempting to be didactic. Its decision to include some Travellers may be based on the desire to show the audience that integration between the settled community and the Travellers is both possible and desirable. That these stories are being told in a fictional rural setting adds further strength to the argument that *Glenroe* has a deeper ideological agenda in presenting rural Ireland as either a place of harmony where conflict based on differences of identity can be played out and resolved or perhaps with the exception of one or two individuals, no such conflicts exist. Ethnic or class identities are therefore subsumed by a shared membership of the symbolic community of *Glenroe*, where membership is based on common values and beliefs. (See Devereux, 1993)

There are, however, constraints in terms of the overall structure of this programme which place a brake on the coverage of the issues which affect

Travellers. These issues involve the centrality of the Travellers as programme characters; the dependence on humour when exploring what are in reality very serious issues; the lack of realism in portraying the Travellers and the tendency of the programme to shy away from plumbing any of the issues raised in an in depth fashion.

With the exception of Blackie Connors, the Travelling community portrayed in *Glenroe* are minor characters of incidental importance. Blackie Connors himself has a well developed character, yet we generally only see in him in the context of stories which affect the better known characters. In the latter part of the 1992–1993 season of *Glenroe*, we saw Blackie advising Miley Byrne on his marital problems, telling him that 'The woman is just like a horse. You've got to treat her easy, but show her who is boss!'

Despite the attempts by earlier episodes of *Glenroe* to suggest a tension between Blackie and his fellow Travellers based on Blackie's supposed over integration into the *Glenroe* community, we are never offered stories about the programme's secondary characters which deal with crises of an economic or existential nature. This is in contrast to the coverage offered to the programme's central characters such as Biddy, Mary, Miley and Dick all of whom have faced into the long dark night of their respective souls.

Much of the coverage which Blackie Connors receives serves as a humorous device for the programme. In the real world, Irish Travellers experience racism on a daily basis of the most irrational kind such as being refused service in shops and public houses. Yet Blackie's identity as a Traveller is often the source of joking and humorous exchange. The scenes discussed above between George and Blackie on the Summer Fair and between David and Blackie over discrimination of the disabled and Travellers see both David, George and Blackie himself making light of Traveller identity.

From viewing the entire 1992–1993 season of *Glenroe*, there is a strong sense that the programme lacks realism in its handling of particular issues. In terms of the Travellers specifically, we have never seen their harsh living conditions in either their caravans or in the often low standard of housing provided for them by the local authorities. The Travellers in *Glenroe* do not appear to be living at a subsistence poverty level, seem to be well dressed and are not wanting for food. Inter- and intra-family interaction is similarly absent from this coverage despite the importance of family and kin networks in Traveller culture. Despite two rare exceptions in this series of *Glenroe*, the fact that the Travelling community have their own language called Shelta or Cant is neither referred to nor used by the Traveller characters.[9]

There is a further aspect to the overall structure of *Glenroe* in its narration of stories about the Travelling community. I refer above to the 'hot-potato

9 Blackie tells his wife Peggy in one scene that it is great to be 'back on the tobar', *tobar* meaning road is a derivative of the Gaelic word *bothar*.

effect' by which I mean the tendency of the programme to raise a potentially controversial issue, begin to give it coverage and then very quickly drop the story out of sight never to be seen again.

Two important stories which featured Blackie Connors and have a direct bearing on the marginalisation of Travellers seemed to adopt this approach. In the early episodes of *Glenroe* we saw Blackie being taunted by Johnny as to the extent of his acceptance by the settled middle class of *Glenroe*. The story then simply disappeared from our screens without being resolved in a satisfactory way. The issue of whether Travellers or the disabled are more likely to be excluded was the next story to be considered. This story had great potential as an eye-opener for the audience. Yet when the competition between David and Blackie took place to see who was more likely to be excluded, the result was a draw. We only saw them being excluded from two pubs and then the issue was never being referred to again.

One reading of this phenomenon might be that the issues are explored only briefly to allow further development of the characters and to provide the possibility of greater coverage later in further episodes of the series or in the following series. My own view is that the tendency of programmes like *Glenroe* to short change stories about the unemployed and Travellers is based on a shyness of concentrating on potentially controversial social issues. It is interesting that this programme does at least attempt to raise questions about our attitudes to the unemployed, the disabled or the Travelling community, yet somewhere along the line it falls short of giving these stories the full and thorough coverage which they deserve.

In terms of a message system, *Glenroe* presents us with a largely positive image of the Travelling community. Through the character of Blackie Connors we see the Travellers as a group of people who although different in terms of their ethnic identity, have the same feelings and desires as their settled counterparts. Even though the friendly interaction between Blackie and the inhabitants of *Glenroe* rings a little hollow in terms of what actually happens in the real world, the fact that the programme presents with us a fictional possibility is important.

The response (of most) of the Glenroe community to the Travellers is that they are examples of God's or the deserving poor. They have been provided with housing through a combined Traveller/settled community effort. There are, however, some shortcomings with its approach to the issue. The two most dominant messages in the series considered about the Travellers were that of prejudice and patriarchy.[10] The prejudices experienced by the Travellers remain a constant theme in the series. Yet prejudice and exclusion are not the only aspects to the poverty experienced by the Travellers. The poverty experienced by the Travellers also includes severe hardship in terms of harsh living conditions, health problems and low life

10 For a much broader perspective on Traveller issues see McCann (eds.) (1994).

expectancy. Yet none of these problems are examined by this programme. There is similarly a strong message of patriarchy in the current series, with both Johnny and Blackie conforming to the notion of male Travellers as being dominant in terms of family decision making processes. While I concede that patriarchy exists in both the worlds of the settled community and Traveller, the very strong role played by Traveller women in demanding that their culture be acknowledged and respected in Irish society is ignored by the programme. The Travellers' story therefore has the possibility of being told much differently. There exists the possibility of offering a central role to a Traveller woman allowing her to give the audience her side of the story, dealing perhaps with her views on Traveller identity, and the specific problems encountered by female Travellers in relation to housing conditions and education of a culturally sensitive kind for their children. There is a need too for greater visibility of the harsh conditions that Travellers have to deal with on a daily basis.

Glenroe is an interesting projection, however, of how both its creators and some of its audience either see or would like to see Irish society. In the main the poor are invisible, but where examples of the poor do surface in the series, an interesting treatment takes place. The programme's main characters display a varying set of attitudes to the unemployed – acceptance of the deserving unemployed or poor hinges on membership of the Glenroe community. The Travellers of *Glenroe* are also presented as the deserving poor – a status that has been earned by their apparent willingness to accept many of the norms and values of their middle-class counterparts.

Discussion: Irish fictional television and social problems – limitations and possibilities

In comparison with the production values of other soap operas and more specifically in terms of its audience ratings, *Glenroe* is evidently a quality serialised drama which is popular with a large proportion of the viewing audience. There are, however, a number of limitations within the programme's formula which militate against the coverage of social problem issues in any in-depth way. In the following discussion I wish to outline *Glenroe*'s limitations in this regard and conclude by comparing the programme's track record on the coverage of social issues with other soap operas. The chapter's main conclusion is that *Glenroe* does not provide enough room for the examination of social problems but that there are possibilities within this genre for such activity. If *Glenroe* were to cover social problems such as unemployment or poverty in an in-depth and realistic way in the future, this would involve the programme taking risks in terms of not only the storylines themselves but also in terms of challenging some of its audience. There are precedents which the programme might follow in the future, most notably in the form of Channel 4's *Brookside*.

Limitations

The reductive way in which *Glenroe* treats poverty related issues is determined by the programme's formula which emphasises characterisation, entertainment, familism and communitarianism. The programme's over-emphasis on the lives and experiences of the rural middle class as its choice of central characters ensures that *Glenroe*'s plots and storylines only occasionally touch upon the fact there are problems of a social kind to be dealt with. Invariably these problems are (temporarily) resolved by the actions of the community, individuals or families. Kindness, philantrophy and good deeds are stressed over and above causes or lasting solutions.

The makers of *Glenroe*, as our ethnography suggests, defend their failure to deal with social problems by stressing that their interests lie in developing characters and not issues. An obvious and fundamental problem with this perspective, as this chapter's analysis suggests, is that the programme does have some characters who are poor but who are relegated to the sidelines. The programme concentrates on developing its middle class and relatively comfortable characters to the detriment of any other character development. Is this because this type of character development is of a safer kind? The evidence from *Glenroe* and other soaps would seem to confirm this to be the case. (See Rose (1979)) Buerkel-Rothfuss and Mayes (1981) suggested that soap operas are not taken up with the contentious issues of poverty and inequality because their main concern is with the middle class. The defence of the programme offered by its makers fails to address the question as to why characters who are poor are not given more space to develop. The answer to this question may be partially found in the prominence the programme gives to humour and entertainment as part of its formula. This concentration is based on a perception of what the audience want from *Glenroe*. During my conversations with those who make the programme I was struck by two things in this regard. In the first instance, the programme makers talk about the audience as if it were a monolith unaffected by either class divisions or poverty; and secondly, their attitude to their audience betrays a position which assumes they know what their audience want or should get. In any event, the notion that the programme should entertain above all else automatically precludes or constrains the coverage of issues such as unemployment or the exclusion of the Travellers. As our earlier analysis suggests Blackie Connors is a Traveller of a safe kind. He is settled, involved in community affairs and can hold his own in the humour stakes. These characteristics are the ones that are stressed repeatedly by the programme which only occasionally acknowledges the difficulties which Blackie and other Travellers experience.

The programme is dominated by the twin ideologies of familism and communitarianism. (See Gibbons 1984b) Problems, whether individual or collective, when they arise are never seen as social problems. They are not solved by social or structural solutions. Thus, all problems which are to be

resolved in this fictional setting are sorted out by individuals, families or the community of *Glenroe*. Typically, these problems, whether individual or collective, are ones which affect the Byrnes or the Morans thus allowing for a concentration on how the rural middle class experience and deal with personal, business or community difficulties. Their problems are given prominence above all others. The dominant message of the programme is that certain families and the community have the capacity to deal with problems whose causes often lie beyond the confines of *Glenroe*. Those who exist outside of the community, such as Carmel and Damian, who are representative of the undeserving poor are left to their own devices. The Travellers (or more accurately a single Traveller) are deemed to be part of *Glenroe* and thus some of their problems of exclusion and poverty have been dealt with through community effort.

A crucial part of *Glenroe*'s ideology of familism and communitarianism is the way in which the programme treats the issue of social class. The programme is dominated by the rural middle class, but the other extremes of the class structure of rural Ireland are also represented. In her analysis of British and American soap opera, Geraghty (1991) suggested that there are two separate ways in which soaps use the concept of class. Class, can as in the case of *Coronation Street* and *EastEnders*, be what defines the community within which the dramatised interaction takes place – in both instances here a working class community – or else as in the case of *Brookside*, class divisions within the close itself formed the basis of numerous storylines.[11] *Glenroe* is of the former and more traditional type of soap opera. Its community is defined by a middle-class culture and value system with other class groups who exist above and below the dominant class and who function to define through difference and not opposition what the community is.

The programme adopts an interesting stance in this regard, which has a bearing on how it treats social problems. The class identities of the characters are obvious enough, but potential divisions between the characters are underplayed, thus allowing for an interaction between characters which is unrealistic. The programme's use of this unrealistic dramatised interaction between the social classes serves to feed the notion that if class divisions exist they are not important and should not form the basis for any conflict over resources or power. The dependency of the programme on this type of interaction between the social classes allows little if any space for conflict over inequality or poverty.

Glenroe does not yet use what Longhurst (1987) referred to as 'indicative' or 'subjunctive' forms of realism. Within indicative realism the working class are the main focus of attention but the possibilities for change are still outside of the frame. Subjunctive realism on the other hand offers the audience the possibility of change and goes as far as suggesting possible alter-

11 From the very beginning *Brookside* has attempted to challenge the more traditional soap
 strategy of insisting that communities exist.

natives to the existing social order. Drawing on Williams' work, L suggested that the growth of realism involved three processes:

> First, there is a 'social extension' as drama moves away from con-
> sidering 'people of rank' to include more social types in a con-
> scious fashion. Second, events begin to be set in the present:
> action is contemporary. Third, the action becomes inspired by
> and concerned with secular issues. This contrasts with earlier
> plays where a metaphysical or a religious order directly or indi-
> rectly frame, or in the stronger cases determine, the human
> actions. (Williams, 1977:64)

Glenroe exhibits aspects of all of these three features, yet is more accurately described as a naturalist, as opposed to a realist, drama. The programme is shot in natural or real time but is limited in its realism. It does occasionally acknowledge the existence of some social problems but is on the whole more concerned with melodrama and entertainment than social issues in their own right. Charitable events taking place 'out there' in the real world such as the *People in Need Telethon* will be referred to in the script as a way of promoting the Telethon and confirming the programme's naturalistic dimension but it will never be questioned or criticised.

The extent to which *Glenroe* can seriously deal with social issues is also con-strained by the ideology of those who make the programme. In some respects this ideology is best typified by the attitude amongst many in the production team that the programme has in fact no ideology. The makers of *Glenroe* talk of creating 'good drama' as if this aim was in direct contrast to dealing with social problems. In adopting this stance, the producers of the programme are making two assumptions which we should question: firstly, that the *Glenroe* attitude is an accurate reflection of the dominant Irish attitude; and secondly that 'good drama' is incompatible with going against the grain of the dominant ideology for fear of losing viewers.

An interesting shift has taken place in the thinking of the programme's cre-ator who, in his days of making *Glenroe*'s parent programme *The Riordans*, deliberately sought out social issues for examination, such as the poor working conditions of farm labourers and the problems encountered by the Travelling community. As our ethnographic account suggests, his change of heart in regard to the function of television drama has been influ-ential in shaping *Glenroe*'s agenda which has been to the detriment of social problem issues.

The production values of the programme place further limitations on how *Glenroe* explores issues relating to the Travellers or unemployed. In the series under consideration in this chapter there were no dedicated sets for either the Travellers or unemployed, thus placing a constraint on the extent to which their stories could be told in a realistic and detailed way. Our ear-lier ethnographic evidence would suggest that other informal processes are at work in the making of the series. It has been suggested to me that in the

case of the Travellers specifically, actors refused to say lines which some might find offensive and instead replaced 'politically incorrect' lines with words or phrases which might be more acceptable to a liberal, middle-class audience.

Possibilities?

There is very little middle-ground amongst researchers when it comes to the question of the relative importance of soap opera. At a general level there are many who have dismissed the genre as being nothing more than populist and trivial entertainment for the masses. There are others, however, who have recognised the importance of soaps in terms of how they cope with the portrayal of women (Geraghty, 1991); the portrayal of minorities (Seggar et al., 1985); its melodramatic qualities (Ang, 1982) and its ideological basis (Sheehan, 1985, 1987). More specifically, when it comes to examining how soaps explore social, as opposed to strictly personal problems, the field is again split between those who are critical of the capacity of soaps to deal with social problems at all (Mayet, 1984), and those who feel that it is well within the capability of this type of television programme to educate, inform as well as challenge its audience. Livingstone argued that British soaps were responsible, realistic and educative. She asserted that:

> ... those who make soap operas appear to have specific social awareness – raising aims with respect to contemporary social, moral and political issues. For example, Jack Barton, former producer of Crossroads, says that 'With some of the more serious social comments we've made and issues we have dealt with, in each case they were very carefully thought out and researched , and they have positive results to the community.' (1988:56)

For its part, Glenroe is naturalistic in style and educative in terms of certain issues. Typically, the programme has devoted its energies with some success to exploring problems which are non-threatening to the status quo. Thus in the 1992–1993 series, Glenroe dealt with the issue of the scarcity of corneas in the Irish eye-bank. There was overwhelming public reaction to the problem and within the series itself the fictional character who was affected by difficulties with his sight underwent a successful operation. What are viewed by the programme as being problems of a personal kind are explored and usually given a satisfactory treatment. That is to say the experience of the individual, the cause of the particular problem and its resolution by the community or other agent takes place. Problems of a social or structural kind are less likely to be explored and if they are, less emphasis is given to their resolution.

In terms of the possibilities which exist within this genre for the exploration of problems which go beyond the personal or the individual, there are pointers which Glenroe might take from other soaps in this regard. Glenroe belongs to the more traditional school of soap which places

entertainment and drama at the top of its priority list. A possible shift in emphasis in the programme's formula would be interesting, but not without some risk. *Coronation Street*, also a soap of the old school, attempted with little success to do this in the 1970s. Glaessner (1990) noted that *Coronation Street*'s shift to doing tougher and more contemporary storylines was a provocative move by the programme. However, audience figures dropped significantly and the appointment of a new producer saw a return to the more traditional diet of lighter stories and humour. The reconstituted *Coronation Street* saw its role as being ' in the business of entertaining, not offending.' (Temple, 1985)

A more recent lesson could be learnt from the makers of *Brookside*. (See Geraghty, 1983; 1991). Realistic in style, with an emphasis on social class, the programme deals with issues which are social as well as personal. The decline and fall of the trade union movement, inequality of employment opportunity in regional terms, the personal and social havoc caused by unemployment (most notably in the Corkhill family) and the activities of illegal moneylenders are just some of the many themes which this programme has examined over its 11-year history. Significantly, the programme has rejected the more usual soap style of dropping in on three or four stories in any one programme and instead tends to concentrate on just one story. It is quite clear in watching the serial that there are greater forces at work outside of Brookside Close such as the declining British capitalist economic system or a political philosophy such as Thatcherism, which is the ultimate cause of the problems which the programmes characters experience at a personal level. The series appears to be issue- as well as character-driven and indeed the reappearance of certain issues such as the increasing difficulties encountered by trade union activists would suggest that the programme's stories mainly come from the issues and not just the characters as in *Glenroe*. In addition to this, there is evidence that the programme has consciously taken on specific issues with which it will deal in a much deeper fashion over a long period of time. Thus issues such as Down's Syndrome, cancer or heroin addiction can be dealt with in a more comprehensive manner than is usual in soap opera. Yet in spite of the fact that *Brookside* is more engaged in dealing with issues of a social or personal nature, it does not ignore the more usual soap opera ingredients of humour and entertainment. In terms of its linguistic style specifically, the programme draws upon Liverpudlian or Scouse patterns of working class speech which is characterised in the main by the use of irony, puns and nicknames. The dole office in *Brookside* is 'The Soc', unemployed people are 'Dolies', poor people are 'Povs'. Male characters will refer to other male characters as a 'soft lad' (ie mad). It is therefore possible to balance the perceived audience demands to entertain as well as deal with social issues which affect the lives of audience members.

In conclusion, the limitations and possibilities of *Glenroe* all boil down to the kinds of decisions made amongst the programme's makers. There is no

real reason other than perhaps an ideological one which is preventing the series from placing either a Traveller or unemployed character at the centre of the programme. My fieldwork experience indicates to me, however, that there is very little commitment amongst the programme team towards developing these types of characters. The extent to which the programme will in the future engage in taking risks with the programme's form and content depends on the personnel involved and perhaps on the activities of *Glenroe*'s rival soap on RTÉ *Fair City*. Although *Fair City* is equally culpable as *Glenroe* in failing to examine social problems, a shift in the former programme's style might very well be the catalyst which could compel *Glenroe* to adopt a more realistic approach.[12] In many respects *Glenroe* is a victim of its own success in that given its constant placing at the summit of the TAM ratings, it is tied into a formula which offers little by way of space for the consideration of a wider scope of individual and social problems. In the very long-term the programme's makers will have to entertain the idea of getting beyond the humour/characterisation formula in order to make the programme more relevant to the rapidly changing society in which it is being made. As this chapter has suggested, the fact that the programme does not attract younger more socially aware viewers is a factor which will have to be addressed.

12 There is evidence to suggest this may already be happening in the competition between *Glenroe* and *Fair City* during the 1994–1995 series. See Power (1995).

7

Devils, angels and ideology

Introduction

The central point which I wish to make in this final chapter is that RTÉ's television coverage of Irish poverty is not only of a reductive kind, but in practice serves to render a significant proportion of its public invisible.[1] The chapter suggests that Golding and Middleton's (1982) dichotomy of God's and the Devil's poor be recast, to take account of the central role which television stories offer the angels or agents of the poor. The chapter contends that the concept of ideology is still relevant to the analysis of the media.

The main argument of this study is that given the true extent of Irish poverty, RTÉ's television coverage is of a reductive kind. The poor themselves remain largely voiceless and invisible across the range of programme types considered in this analysis. They are replaced by spokespersons and other angel figures who communicate with the television audience on their behalf. The study concludes that RTÉ's presentation of Irish poverty can be considered to be ideological.

It is ideological because it facilitates the continued domination of the powerful over the powerless. This is achieved through the lack of visibility of poverty, television's dependency on poverty spokespersons and because of the narrow parameters of actual poverty coverage. Such coverage helps to reproduce relations of power which are asymmetrical in character. RTÉ television's portrayal of poverty may be considered to be ideological in the sense that the dominant themes evident in the coverage uphold unequal power positions and only in a few rare situations, is the hegemony challenged. Ultimately, the shortcomings in RTÉ's presentation of Irish poverty are as a result of the fact that the television station reproduces a

1 The theme of invisibility has been developed in particular within the field of feminist history, where historians have sought to revise patriarchal accounts of history. See for example Bridenthal and Koonz (1977).

predominantly liberal[2] ideological framework in its coverage of poverty and other issues.

The ideological domination achieved by the powerful in this context is helped through television's ability to decontextualise poverty and inequality through abstracting it from its structural causes. Television coverage achieves this through individualising and personalising what is a structural problem and by drawing upon a range of constructions of the poor which exist outside of television itself. RTÉ's portrayal of the Irish poor reinforces the existence of God's and Devil's poor as well as managing to construct an important role for the powerful in the overall relationship. There are echoes of past ideological constructions of the Irish poor as deserving and undeserving in the overall make-up of RTÉ's coverage.

The hidden Ireland

The Irish poor, despite their numbers, remain largely invisible on our television screens. RTÉ's coverage of Irish poverty is narrow and does not take account of the complexity of the many facets of this social problem. The Irish poor, include the working class, the long-term unemployed, women, children, small landholders, the elderly, the disabled, the homeless and the Travelling community. Such variation and complexity is rarely visible in the sum of RTÉ's television coverage of poverty. The process of rendering the poor hidden is a result of a number of factors. There is a tendency for television programmes either to ignore the issue altogether or to atomise the problem by breaking poverty down into separate issues. The fact that the dominant codes used in producing television images of the poor render them faceless or else as being at a distance from the assumed middle-class audience is also of some significance. While there are of course individual broadcasters who are concerned with poverty and inequality, the irreconcilable twin problems of RTÉ's position in the power structure in Irish society, and the pervasive middle-class culture which dominates in the organisation result in a situation where the extent to which the problem can be investigated and reported on is restricted. The viewing and portrayal of unemployment – arguably the greatest cause of contemporary Irish poverty – as essentially being a policy issue rather than a lived experience for large numbers of Irish people has led to a separation of unemployment and its attendant poverty. The individualisation and personalisation of poverty problems allows for the effective construction of television stories but reduces the likelihood of poverty being viewed as a structural problem. television stories about poverty are largely mediated stories whereby the accent is placed on

2 Following Sheehan (1987) I take liberalism in this context to mean '... the political philosophy occupying the middle-ground between conservatism and socialism' supporters of which, she maintains, see 'whatever reforms may be necessary in isolation' and do '... not call into question the nature of the system. In this sense, liberals are distinguished from both conservatives and radicals, as those who support social reform, but tackle such issues as arise one by one by piecemeal social engineering, which can be accommodated within the capitalist system.' (1987:275)

the agents of the poor. The coverage of poverty is quite selective with a strong emphasis on the deserving or God's poor. The Devil's poor are subjected to an interesting treatment in that they are either ignored altogether, aesthetiscised, or else transformed from being the Devil's to God's poor.

Poverty may be ignored by programme makers who choose to see it as being outside the perceived remit of their programme area. This was clearly the case in terms of the makers of the fictional series *Glenroe*, who saw their prime function as being entertainment. The creators of Telethon similarly stress the entertainment and fund-raising dimensions of the programme at the expense of critical coverage of poverty, which becomes translated into stories about 'need' as opposed to poverty *per se*. Both the makers of news and current affairs programmes may be seen to ignore poverty issues, because of the competitive arena in which they operate, where poverty is reduced to being 'just another issue', to quote one newsman. Their reluctance to suggest a poverty related theme may also hinge on their expectations in terms of what they believe will be accepted as a plausible and interesting story by the programme editor.

The ethnography of media production offered in this study would confirm that RTÉ like other media organisations has its gatekeepers who, in this instance, both allow and disallow poverty issues onto the agendas of television programmes.

There is also a sense, however, of poverty being disregarded because of fears of alienating the television audience. My fieldwork within RTÉ television would suggest that the reticence of programme makers takes two main forms. In the analysis of the *Tuesday File* documentary, it is suggested that programme makers within this area are concerned about alienating the poorer sections of their audience by reminding them of their poverty.

There is also, nevertheless, evidence that programme makers in other parts of RTÉ television are shy of examining poverty issues in an in-depth way, for fear of alienating their middle-class viewership. The attempts by the maker of *Are You Sitting Comfortably?* to unnerve RTÉ's middle class audience stand in sharp contrast to the cosy and comforting images produced in fictional and Telethon television which unveil only the safer aspects of poverty. With the exception of our current affairs case study, the ideological positioning of RTÉ's television coverage of poverty identify with the views of middle Ireland.

The poor, when they are visible, are constructed as the 'other' of the middle class audience. This type of coverage is constructed in such a way as to allow for the re-affirmation of the comfortable, showing them to be actively doing something about the weaker members of society. In Propp's (1928) terms, they are the heroes of this narrative convention, cast in the role of saviours of the victimised poor.

There are parallels between Scannell's (1980) account of BBC's radio coverage of unemployment and the way in which RTÉ television

approaches the issue of poverty. Both position their coverage in terms of a middle-class audience and draw upon narratives, which effectively conceal the true nature of the problem, while also managing to legitimise voluntarist solutions.

Television coverage of poverty is constrained further by the fact that programme makers are driven by the need to produce fictional and factual stories, not about poverty as a phenomenon in its own right, with its many causes and effects, but largely about singular aspects of poverty. The net result of this atomisation of poverty is a collection of disjointed texts which, taken together, show how media coverage of poverty works to frame poverty as a problem without either causes or long-term solutions.

Following Sorenson (1991) and Barthes (1973), we can say that RTÉ's coverage of Irish poverty occasionally admits to the occurrence of 'accidental evil', but also manages to construct these stories as being cause-less.

A further dimension to the marginalisation and shrouding of the poor comes about through the use of particular codes in the production of poverty texts. The dominant codes used by RTÉ television work in four main ways. These are - the portrayal of the poor as faceless and voiceless. The representation of the poor as being socially distant. The replacement of the poor through the use of spokespersons and the use of symbols to connote meaning about poverty, rather than focusing on individuals who are poor.

The codes used by broadcasters to render the poor both faceless and voiceless were shown to take on a number of forms in this study. Although it lacks a set of formal rules, television news repeatedly portrays the poor as being faceless. It draws largely on a style of filming, which shows headless shots, vague/distorted images of the poor or else welfare queues filmed from behind. In the Telethon, although the needy are clearly identifiable in the appeal films, the sole examples of the Devil's poor – the homeless boys, are hooded, while engaged in 'deviant' behaviour.

The separateness of the poor from the assumed middle-class audience is also emphasised through the use of filming styles, which indicate social distance and exclusion. This approach structured the making of the *Tuesday File* documentary, which stressed the gulf between the comfortable and the struggling. Although numerically scarce within fictional television, the minimal existence and visibility of the Irish poor is countered by the fact that while some of the poor are visible as characters, their material living conditions are almost entirely absent from the screen. Within television news, the portrayal of the Travelling community in particular re-affirms the social exclusion experienced by Travellers in Irish society. Chapter Five noted that news coverage of the Travellers emphasises the problematic nature of their poverty. Their separateness is reinforced through the use of images which are ambiguous, shot from a distance or where Travellers are entirely absent.

A constant, which exists in all four genres analysed in this study, is the proclivity of television programmes to depend on spokespersons rather than the poor themselves to articulate the nature and extent of their difficulties. This finding would seem to confirm the arguments put forward by O'Gorman (1994), who criticised Irish journalists for depending too heavily on those who act as spokespersons for the poor.

For broadcasters, this may seem like the only practicable way of constructing stories which will be reliable and which stand a chance of being accepted by programme editors. I am willing to concede that there are some broadcasters who feel that there are dangers involved in using some of society's more vulnerable members as interviewees. This was clearly the case with the maker of the *Tuesday File* documentary, as well as with at least one of the news journalists to whom I spoke.

The problem could be partially resolved by widening the scope of what those in television see as representative examples of the Irish poor. While acknowledging that there may very well be a reluctance by some people to appear on the national airwaves as the poor, the over-dependency on middle men and women creates its own difficulties. The greatest problem with this practice is that it serves to reaffirm the positions of those who are already relatively powerful.

At the extreme end of the scale, in the Telethon, the owners of capital are projected as being the benign benefactors of the poor. Within news and current affairs television the politically powerful, the professionals and the volunteers are the focus of poverty stories. The ideology of voluntarism is carried forward into fictional television where the community is seen to have the capacity to cope with poverty problems. The dependency by broadcasters on spokespersons creates difficulties for lobbyists themselves in that those who see themselves as being representative of the poor have to compete with one another for airtime.

A fourth code used by the makers of poverty stories is that of the use of symbols to connote meanings about poverty. Symbols are used not only to make a story more interesting visually, but also to replace the harsher aspects of poverty. Following Hall (1974) and Hall *et al.* (1976), who suggested that media texts have dominant codes which suggest a preferred reading to viewers, we can say that the use of symbols within poverty texts functions to propound a preferred reading, which can also conform to the dominant views within a society. This allows for the occasional acknowledgement of a problem – what Barthes (1973) referred to as inoculation.

The use of symbols can also function to abstract problems from their root cause. Thus, a starving African child may be used by the media to tell a story about the poverty crises in the Third World. Yet despite the fact that using the image of a child may be effective in communicative terms, and in provoking a temporary audience response, the use of the child as symbol also serves to mask the causal factors of poverty. Missing from the frame

are the exploitative nature of the world economic order, specifically in terms of the role of the First World banks and the unequal relationship between the First and Third Worlds.

While economic policy issues dominate television news coverage about unemployment, the unemployed themselves when referred to in the visual text are replaced by logos and queues. The harsh poverty experienced by the Travellers is also articulated symbolically through the use of images which serve to replace that poverty. In a number of the news reports considered in this study, the image of a single tap spilling its water into the wind was substituted for the actual poverty experienced by the Travellers.

It is also possible to identify the use of images and symbols of deprivation which function to narrow the horizons of poverty coverage. Buildings were identified in this study as an important signifier of both poverty and wealth. But in supplanting the poor through the use of dilapidated buildings or housing schemes, the resultant coverage locates poverty in a frame which excludes many. Following Baudrillard (1983), we can say that the use of images in this way exhibits the '… perversity of the relation between the image and its referent, the supposed real'. (1983:13)

Images which purport to make texts more realistic in fact serve to mask the true nature of the problem. Irish poverty affects more than just the destitute, homeless or unemployed. There are also large numbers of working-class people who are poor and socially excluded. Although they may have homes of their own and be in (usually poorly paid) employment, they are poor in the sense of having fewer life-chances, most noticeably perhaps in terms of access to education, but also in terms of general health/well being and life expectancy. These aspects of Irish poverty are generally ignored by the media at the expense of what seem to be more pressing poverty issues. Television's concentration on the dramatic, exotic and immediate, facilitated through the use of set images of poverty, serve therefore to conceal more than they reveal. This study's analysis of news about poverty showed how selective television can be in its reporting of poverty. The ignoring of working class poverty stands in sharp contrast to the focus by television news on the threat of poverty on the middle classes or the new poor.

Indeed, absent from all of this coverage is any reference to the make-up of the social order which is responsible for much of the deprivation and poverty experienced by large numbers of Irish people. When we talk therefore about the invisibility of poverty in the media, it is important to note that social class is also hidden. The myth of Ireland being a classless society, evident in popular belief, is reinforced by Irish television's portrayal of social problems.

Devils, angels and God's poor: The construction of poverty stories on RTÉ television

The analysis undertaken in this study would indicate that a re-casting of the dichotomy of God's and the Devil's poor, as suggested by Golding and

Middleton (1982), is necessary to understand fully the way in which television constructs narratives about poverty.

The greatest emphasis is still by far on what RTÉ television determines to be the deserving poor, but cognisance also needs to be given to the dependency of television on the agents of the poor, many of whom it casts in the role of angel or saviour of those on the margins. In the context of the apparent reticence of Irish television to confront the harsher side of Irish poverty, the way in which the Devil's poor are treated is of particular interest.

The Devil's Poor

With the exception of *Six-One News*, all programmes considered in this study gave scant attention to the plight of those poor whom some in Irish society would see as undeserving of assistance. The news programme was shown to have dwelt on the perceived problematic nature of two poverty groups – the homeless and the Travelling community.

Although the documentary *Are You Sitting Comfortably?* gave space to the cause of some of those on the margins, their story was a mediated one with the emphasis being placed on the narrator of the programme as being the saviour of the Irish poor. In the Telethon, the homeless boys who were also solvent abusers underwent a catharsis to become God's poor. Our analysis of the production context of the Telethon also noted that one of the filmakers involved deliberately edited out a reference to the fact that the home of the Traveller would probably be burnt down in a funeral pyre. A self-consciousness about alienating middle-class viewers ensured that the story was sanitised.

But perhaps the most interesting construction of examples of the Devil's poor take place in fictional television. *Glenroe*'s treatment of poverty stories, despite their relative scarcity, manage both to differentiate between the deserving and undeserving unemployed, as well as to aestheticise the poverty of the Travelling community. *Glenroe*'s inhabitants, with the exception of one, base their decision to assist the unemployed on the criteria of their membership of a spatial and symbolic community. Those who are outsiders are defined as welfare scroungers and parasites.

There are, interestingly, some connections between the portrayal of some of the unemployed as undeserving in this fictional setting, and in the measured public opinion of Irish society towards the problem of poverty. The *Eurobarometer* survey (1990) demonstrated that in Ireland, while 30 per cent of the sample explained poverty as a result of social injustice, there was also a residual 14 per cent which saw poverty as a result of laziness and lack of will-power. When asked to explain why people are poor, the respondents blamed long-term unemployment (64 per cent), alcoholism/drugs (39 per cent), sickness (25 per cent) and laziness (16 per cent). *Glenroe*'s treatment of unemployment mirrors this duality. The programme managed to show how some of the Irish public construct two separate categories of unemployment related poverty.

Glenroe's treatment of the Travelling community is an example of how Irish fictional television chooses to aestheticise the poverty of a group of people demonised by most settled people. A 1984 paper by the ESRI argued that a majority of the settled population exhibited negative attitudes towards the Travelling community: 62 per cent said they were untrustworthy, 75 per cent said they were careless, 68 per cent claimed that they were noisy. The research was in agreement with MacGreil's (1977) study of Irish prejudice and intolerance. In that work, 70 per cent of the sample interviewed said that they would not marry a Traveller, with the majority (62 per cent) saying that Travellers were not socially acceptable.

Glenroe has in fact converted the Travelling community into the deserving or God's poor. Through the main Traveller character Blackie Connors, the programme has managed to balance some instruction of its audience about Traveller ways, with an acute shyness in showing the harsher side of the Traveller experience. This is achieved by locating the Traveller character outside of the main action of the series, and by constructing Blackie Connors as one of what Thomas and Callanan (1982) referred to as the happy poor. This abstraction of the Travellers from their cultural and material context works to placate audience members, as well as render significant aspects of people's lives invisible.

God's poor

There is evidently a blurring of distinctions taking place between the Devil's and God's poor. In both the Telethon and in fictional television, the demarcation between both categories is becoming less certain. God's poor, however, remain the dominant group who are given coverage. All of the segments, with the temporary exception of one, conform to the criteria of being deserving. Thus the focus is on children, the handicapped, the elderly and the unemployed who are willing to work. The documentary analysed in this study is a further example of the growing complexity of poverty coverage in that it manages to give attention to both God's and the Devil's poor within the confines of one programme. The McVerry documentary ties together the experiences of both the homeless and the handicapped, whom it sees as being unified through their marginalisation. Television news also exhibits the tendency to cover both the deserving and undeserving poor. News, like the Telethon and television drama, exhibits the tendency to be able to temporarily transform the poor from being Devil's to God's poor. Thus the annual story of checking out how the homeless or needy have fared on Christmas Day sees television news temporarily adopting the position that these down-and-outs are, for one day at least, to be treated with sympathy. This practice of portraying the homeless as God's poor on Christmas Day functions to reassure and absolve the audience.

Agents and angels

A third and most significant theme in RTÉ's construction of poverty stories is its reliance on those who act on behalf of the poor. While the assertions of Whiteley and Winyard (1990) and Mawby *et al.* (1979) are confirmed in terms of how the media set the poverty agenda, none more evident perhaps than in how television news determines the seasonality of poverty as a story, the relationship between the media and those who purport to represent the poor is an important part of the equation. It is this relationship above all others which determines the final outcome of television coverage of poverty.

These intermediaries may be divided into the 'agents' and the 'angels'. The agents of the poor are typically either formal statutory or voluntary organisations which seek to represent either the poor in general or a specific social group who may be poor. The angels, on the other hand, include individuals who are already well known to the public in another role or ordinary people, who have, to quote Monaco (1978), been made strangely important. The use of these agents by television can be explained in terms of established relationships, which agent groups may have with individual journalists or producers or, as in the case of Telethon television, through their connections with the organisation responsible for the bi-annual event.

The tendency to use spokespersons, rather than actual members of the poor, may be driven not only by a concern for those affected by poverty but may also simply be determined by the practical exigencies of producing television stories under pressure of time. It is interesting to note that, in three of the programme areas examined in this study, producers and reporters commented on the inarticulacy of the poor and noted the difficulties which this presented them with in the production of television reports or features.

The use by the media of agent groups brings with it a further set of problems. Groups which represent the poverty lobby in either general or specific terms are in competition with one another to gain access to the airwaves. Their success or failure in getting their cause on to programme agendas may be determined by the following features - the extent to which journalists may view their research findings or charity appeal as being sufficiently newsworthy or novel. The fact that they may be in competition with each other and other more powerful lobby groups for airtime and the nature of their working relationship with the journalist or producer concerned.

My fieldwork would indicate that poverty is not treated any differently from a range of other topics by programme makers. The urgency which many outside of the media might feel about the problem is (with some exceptions) not that evident within the world of Irish television. In addition to this, there is evidence to suggest that journalists and producers adopt what they see as a pragmatic stance in relation to poverty stories. In the case of news and current affairs, they will only suggest a story of this

kind if they see it as a 'safe bet', which is likely to be accepted by the programme editor.

The likelihood of the demands of those who seek to represent the poor being met by programme makers is qualified further by both the activities of more powerful groups with greater resources at their disposal and the nature of the relationship between agents and journalists. In at least three instances during my fieldwork, I encountered poverty stories being rejected because of a poor relationship between the journalist and relevant poverty organisations. Common to all three rejections was the fact that the poverty groups wished to determine the agenda of the reports. In one of these three cases, the journalist opted to do a similar story with another 'more co-operative' poverty group.

But perhaps the second category of intermediary used in television stories about poverty is of even greater significance. The evidence from news, current affairs and Telethon television would suggest that a significant role is offered to individuals whom the media construct as the saviours of the poor. Harrison and Palmer's (1986) references to the angels of mercy stories constructed by the British tabloid media can equally be applied to Irish television. The analysis offered in this study would confirm Harvey's (1984) assertions that the media focus on the personalities involved in helping the poor rather than the poor themselves.

Poverty issues seem more likely to become newsworthy when elite figures are involved. Disability, unemployment and Third World hunger became news stories owing to the actions of President Mary Robinson. Like Fr. McVerry in the *Tuesday File* documentary and Fr. Rock in the homeless boys segment in the Telethon, she is cast as an heroic Christlike figure who is shown to be the saviour of the poor. This focus on the elite is replicated in both Telethon and fictional television. The rural middle class are the ones who solve *Glenroe's* social problems. In the Telethon, the broadcasters and other personalities are projected as those who can save the day. But, as is evidenced in the Telethon, there is room also for ordinary people to become heroes, albeit temporarily. Through their involvement in the unusual and the bizarre, ordinary folk become fundraisers, and by extension heroes, who help what the Telethon safely refers to as the needy. Following Propp (1928) and Sorenson (1991), we can say that the elite, who are shown to help the poor, are mythologized into heroic characters who become synonymous with assisting the poor.

These angels appear to be immune from any form of questioning themselves as to their status or actual culpability for social inequality. On the rare occasions that television texts go against the hegemonic grain to question the roles of the powerful, it is done, as in the *Tuesday File* documentary, in such a way as to question the powerful without running the risk of censure. Thus in our case study in Chapter Four, while blame is apportioned to the rich and powerful for the poverty of a large proportion of Irish society, the rich and powerful remain safe in their anonymity, facilitated through the use of symbolic imagery of wealth and power.

Television stories about poverty are therefore mediated stories, which are framed in such a way as to focus on the good works of the relatively comfortable. All of the programme areas considered in this project gave a primacy to the agents and angels of the poor. This type of coverage serves to legitimise solutions to poverty problems, which are the result of actions by heroic individuals or statutory/voluntary organisations. The prospect of structural changes of a more permanent nature to the problems of poverty and inequality are conspicuous through their absence from television texts.

Explanations

A range of explanations for the nature of the material presented in this study were offered in earlier chapters. The key explanations were ones which were economic, biographical, organisational, production-value oriented and ideological. While the first four criteria are clearly important in our consideration, the greatest weight must be given to the ideological character of the material analysed.

Economic shifts in Irish society and specifically the retreat of the Irish state in terms of public spending were shown to underlie the emergence of the Telethon programme *People in Need*. An important aspect of the special time relations within the make up of the Telethon has been to allow the corporate sector a pivotal role in terms of sponsorship opportunities. This move has served to delimit the programme's possibilities in terms of actual poverty coverage. Economic changes in the form of state cutbacks have had a direct bearing on the activities of RTÉ itself with a decreasing amount being spent on such programme areas as television drama, thus resulting in less space for the consideration of poverty and other social issues.

In addition to the recent rationalisation of programming, increasingly scarce resources within RTÉ's current affairs division have resulted in fewer programmes being made which might be critical of the status quo. Economic factors of a commercial kind are also important in setting limits upon how RTÉ television covers the issue of poverty. A recurring explanation offered by many within RTÉ in terms of its lack of a critical coverage of poverty is that programmes operate in a commercial sphere and cannot run the risk of alienating viewers and ultimately advertisers.

Biographical reasons were also cited as being partially responsible for the kinds of television coverage of poverty on RTÉ. The extent to which an individual producer or director may be committed to a particular poverty issue and ultimately her ability to get around any barriers which the broadcasting organisation may place in her way was shown to be crucial. There exist sharp contrasts between the maker of the *Are You Sitting Comfortably?* documentary and the creator of *Glenroe* in terms of their commitment to covering poverty themes. Indeed the apparent change of heart by the latter over his long career in television drama in the coverage of social issues serves as a reminder of the relative importance of the role of the individual producer or director.

In terms of our consideration of RTÉ's poverty coverage the importance of biographical factors perhaps rest in the ability of an individual broadcaster to place his or her stamp on a particular story or report. Following as it did a model which combined a production-based approach with a critical content analysis, this study found that as a first step towards appreciating a particular television text, some cognisance had to be given to the intentions of an individual producer or reporter in the making of a story or report. This approach helped to go some way in explaining why individual producers or reporters resorted to particular filming styles which drew heavily upon symbolisation techniques in order to convey a preferred reading to their viewers about a specific poverty issue.

It is important to note however that individuals working in television operate in organisational and ideological contexts. Thus while some of the material presented in this study can be attributed to biographical factors, these should not be overstated. The ability of an individual working in broadcasting to get a story on air may in the end depend upon the acceptance of the story by others in the broadcasting organisation. Their acceptance of the story and its ultimate broadcast may very well hinge on the ideological mood of the time both within and without the broadcasting organisation.

In comparison to economic and biographical factors, the organisational context in which RTÉ's poverty stories are produced is of even greater importance. This study has attempted to trace the organisational pressures which may be brought to bear on the production of stories about poverty. Although the documentary *Are You Sitting Comfortably?* was eventually broadcast by RTÉ, our analysis of its history and content would suggest that any attempt to understand the implications of its content in terms of poverty coverage must begin with an appreciation of the organisational context in which it was created.

The range of perspectives of those who work within a broadcasting organisation like RTÉ and indeed the occasional conflicts which occur amongst these personnel point to the fact that ideological clashes do happen between broadcasters over the content of particular stories or reports. This study documented significant differences of opinion amongst those involved in current affairs, Telethon and fictional television. Media organisations like RTÉ may be seen to be the sites of ideological struggles in which particular versions of reality win out over others.

The importance of the organisational context of the material analysed in this study cannot be overstated. Those who work in the four programme areas examined in this study are part of an organisational culture which to varying degrees is resistant to examining poverty in a critical light. The ethnographic data presented in this study would suggest that the individuals who work within RTÉ are well aware of what is acceptable within particular programme areas. The culture of the organisation and its routines of production exist outside of the individuals involved. A broadcaster will

often consciously or otherwise reproduce production practices such as seeing poverty stories as seasonal or using an agent of the poor in the creation of a story or report. All programme areas within the organisation have their norms and values when it comes to creating stories or reports, and ones concerning poverty do not prove to be the exception to the rule.

The production context of the material presented in this study is also an important explanatory variable. The invisibility of poverty can to a certain extent be explained with reference to the production values of specific programmes. At least two of the programmes analysed in this study saw poverty as being outside of their perceived remit. *Glenroe* saw its function as entertainment while the *People in Need Telethon* argued that fund-raising and not unveiling actual poverty was its core task. The remaining programme areas of news and current affairs saw poverty as but one of many social issues which deserved coverage.

The routines of production engaged in by programme makers, especially in the area of television news, also help to explain why on one level poverty stories are largely populated by the agents of the poor. Reporters may 'tag' a poverty report on the activity of some elite figure in the expectation that she is newsworthy and may therefore help to ensure editorial acceptance and ultimately the broadcast of a story. The pressures of production, the limited amount of time for research, filming and editing ensure that reporters resort to using what they see as 'reliable' spokespersons for the poor. It has to be conceded that the problem is compounded by the fact that the poor are in themselves a disparate group and largely underesourced which might allow them to speak for themselves. To a certain extent their invisibility may be explained through their lack of resources and the fact that many of their underesourced agents are in competition with other more powerful interest groups in the competition for airtime.

The codes and conventions used by RTÉ television in the making of reports and stories about poverty also function to delimit coverage of poverty in a particular way. RTÉ's presentation of Irish poverty is not only selective and narrow, but also resorts to using a set of dominant codes in the production of poverty reports and stories. The poor remain largely faceless and voiceless, stories are mediated ones and the social distance between the assumed comfortable viewer is emphasised. There are parallels across all of the four programme areas considered in this study in terms of construction of poverty stories.

Ideological dimension

The way in which poverty stories are ideologically constructed is their most significant feature. Taken collectively, the programmes examined in this study are reflective of the changing ideological mood in Irish society *vis-à-vis* poverty and other social problems. With the possible exception of our current affairs case-study, the programmes considered in this project

reproduce a liberal ideological framework which views poverty as a containable problem and which further divides the poor into the deserving and undeserving. The latter functions to set clear limits as to who society should feel responsible for in terms of relieving poverty and inequality.

There is a long history of differentiating between God's and Devil's poor in Irish society. Within the make-up of RTÉ's coverage of poverty there are echoes of late Nineteenth Century thinking which both divided the poor into deserving and undeserving and also fashioned a special benign role for those engaged in philantrophy and charity. RTÉ's coverage also offers significant and often benign roles to the powerful. But because it draws upon the dominant liberal ideology which is in circulation in Irish society, television coverage of poverty is defined by limits which disallow any reference to the unequal social structure (itself a key cause of poverty) and never challenges those who occupy positions of power and domination.

That television programmes play an ideological role is a central contention in this study. But to what extent are programme makers aware of their roles in this regard? There was some variation in the views of those engaged in the production of television programmes as to whether they were being consciously ideological or not. Both the maker of the *Tuesday File* documentary and one of the Telethon's producers saw their creations as flying deliberately in the face of the dominant ideology in RTÉ and Irish society more generally. Both men wished to produce reports which went against the hegemonic grain.

But there were other programme makers who protested at the suggestion that their work contained and reproduced dominant ideology. The notion however that a programme such as *Glenroe* or the Telethon can tell stories about the Travellers or the unemployed without being ideological is not something which I accept. In either the refusal to acknowledge the existence of the unequal social structure or in the often circumscribed ways in which the above programmes tell poverty stories, they are patently ideological. They are ideological because they help to maintain unequal power relationships through either a refusal to challenge the basis of such relationships or indeed to suggest possible alternatives. They are also ideological because they treat inequality in a 'taken for granted' fashion and thus contribute to the reification of poverty and inequality.

Television, ideology and the coverage of poverty

If we apply the range of criteria as suggested by Thompson (1990) to RTÉ's poverty coverage we can see how it operates at an ideological level. Ideology may be seen to function through legitimation, dissimulation, unification, fragmentation and reification.

In its presentation of poverty RTÉ's coverage manages to legitimise the existing social structure. It does so by either not acknowledging that such a structure exists in the first place or through presenting the social structure

as being obvious or inevitable. The powerful in Irish society (individuals, the state, class groups, multi-nationals, the Church) are further legitimised in the types of role which they are offered by the media in their 'good works' for the poor.

There is a strong message across the range of poverty coverage considered in this study that the answers to poverty and inequality are not to be found in structural change but rather in the piecemeal activities of individuals or groups. By giving the powerful greater legitimacy as a result of their activities for the poor, a media organisation like RTÉ sets up limits for its presentation of poverty. Coverage which might seek to explain poverty in broader structural terms could very well create a crisis of legitimacy for the powerful. It is interesting to note that in the one rare example in this study where a programme attempted to raise some critical questions about Irish poverty the powerful refused to participate and there was some insecurity within RTÉ as to the content of the programme.

RTÉ's poverty coverage may also be seen to be ideological through its use of dissimulation. By dissimulation Thompson (1990) meant that relations of domination were hidden, denied or obscured. This is achieved through forms of media representation which deflect attention away from asymmetrical relations of power and domination. Thus the economic relations between the poor and the powerful become human relations. In fictional television class relations become community relations. While selective examples of poverty and inequality are alluded to in *Glenroe* the focus is on how the more powerful groups in the community can respond to the individual needs of the poor. The status quo is not interfered with and no reference is made to either the class structure or the probable causes of poverty.

The *People in Need Telethon* is another important example of how RTÉ's poverty coverage resorts to dissimulation. This type of programming not only affords a special role for the powerful and wealthy in their activities to alleviate poverty, but does so in such a way as to ignore the relations of domination which exist between the needy and the powerful. In its portrayal of the powerful the Telethon successfully manages to obscure the dominant power positions which these individuals and companies hold *vis-à-vis* the poor or needy. This is achieved through situating a programme about poverty and inequality within the realm of entertainment.

In addition to the dissimulation which is a feature of the dominant styles of RTÉ's presentation of poverty, further dissimulation takes place through RTÉ's failure to report on the true extent and diversity of Irish poverty. The invisibility or narrow portrayal of poverty is in itself an important feature of how television engages in the reproduction of ideology through dissimulation.

Thompson (1990) further suggested that ideology operated through the use of unification and fragmentation. There are elements of unification in

the Telethon programme whereby it is asserted that 'everybody' can and should get involved to alleviate need. The supposed commonality of aims and objectives of ordinary people and the more powerful interests such as multi-national companies and the individual wealthy, works to weld individuals into a collective identity in the face of poverty. The unification of those involved even for a short period of time serves to deflect attention away from unequal power relations or the causes of poverty.

The fragmentation evident in RTÉ's coverage takes on a variety of forms. RTÉ's presentation of poverty tends to break up the poor into various subgroups and not view them as being part of a greater collective entity. Poverty stories become personalised and individualised and indeed in certain instances groups who represent the poor may end up competing with one another for airtime. The Irish poor are presented as being members of specific groups such as the homeless, the unemployed or Travelling community. They are never presented as members of either the underclass or working class. The coverage further divides the poor into categories of deserving and undeserving by constructing them as either God's or Devil's poor.

Further fragmentation is apparent in the dominant ideology which governs the coverage of poverty on RTÉ. This ideology draws upon liberal economics, Catholicism and voluntarism. Although each set of ideas are distinctive in their own right, all are used to serve the interests of the powerful. While some broadcasters might defend their coverage of poverty through reference to the composite and diverse nature of that coverage, the fact that each of the above sets of ideas help maintain unequal power relations cannot be refuted.

Thompson (1990) also argued that dominant ideology was reproduced through the process of reification. He asserted that asymmetrical relations of domination were created and reproduced through the representation of these unequal relations as being unrelated to social structure or history. In short, he meant that unequal relations of power were represented as being natural and inevitable. The way in which poverty stories are framed within RTÉ's coverage would suggest that the process of reification is at work. The coverage starts from a position that takes poverty for granted. The contradictory relationships evident in the coverage between the powerful and the poor goes largely unquestioned. Consciously or otherwise the routines of production which govern the creation of poverty stories turn poverty into a story or report which reoccurs on a seasonal basis or when the powerful see fit to engage in good works or social engineering.

Theoretical implications of main findings

The main findings have a number of important theoretical implications. These concern the continued use of the concept of dominant ideology, the media's role in reproducing ideological hegemony and the future direction which research into the media's ideological role might take. The project has

attempted to prove that television is an important source of ideology in the late twentieth century. It has reflected upon how RTÉ's television output about poverty in the period 1992–1993 is indicative of bigger ideological shifts in Irish society.

This study would support the viewpoint that the concept of ideology within social theory generally and within media analyses specifically should be retained. As I argued in Chapter Two the continued use of the concept of ideology should rest upon accepting Thompson's (1990) revised definition of ideology which emphasises the notion of dominant ideology. The findings of this study underline the necessity to reject a simplistic materialist conception of ideology and by implication such a rejection involves its replacement by a more critical version of the concept. It is the contention of this study that the media does indeed have a central role in the reproduction of dominant ideology.

The task facing those who wish to theorise about the media's ideological role in late capitalist society is one which involves recognising that not all media messages are ideological in the sense of reproducing asymmetrical relations of power. The job which those interested in analysing the media's ideological role are faced with then is one which involves determining which media messages are in fact supportive of the status quo and the reproduction of unequal power relations. This position involves accepting the fact that within the multiplicity of media messages are competing sets of ideas some of which are ideological and some which are not.

Nevertheless it is possible to identify the existence of hegemonic ideology within television texts. Through combining content analysis with an understanding of the production context of a range of television programmes it is feasible to identify the ideological positioning of media messages. This research strategy is based upon a critical understanding of the make-up of media texts themselves and an appreciation of the ideological world view held by their creators.

The evidence put forward in this study would support the view that the media are potent sources of ideological hegemony. But there is also room for a limited amount of dissension within the overall make up of media messages. Such space for views and opinions which go against the grain of a society's dominant ideology may in fact contribute to the continued existence of a dominant social order. This may be achieved through creating the illusion that the media in fact represent all viewpoints in society. The existence of ideas which challenge the status quo however means that those who wish to theorise about the media's ideological role cannot readily assume that the media simply reproduces dominant ideology all of the time. There are occasions when such ideology is challenged in either a moderate or radical way.

If television's reproduction of ideology is to be effective it hinges ultimately upon the acceptance of its ideology by significant numbers of the

audience. Future research into the area under scrutiny in this study might opt to include a hermeneutic dimension to its research model. Specifically, in addition to production and content analyses it might ask how audiences make sense of television's ideology. This approach would not only help counter some of the doubts raised about ideological analysis of the media but also provide some further insights into how ideological messages are variously read by their audiences.

The poor must wait … the limits of liberalism

The society in which RTÉ television operates is characterised by high levels of unemployment, significant levels of dependency and increasing levels of poverty. The class divide has been accentuated in recent times, with the benefits of the so-called economic recovery reaching only the powerful. Ireland's wooing of multi-national capital has brought some employment, but at a cost. Multi-nationals have come and gone, paid little or no tax on their profits, and have employed largely non-unionised labour. State policy has ensured both rural decline, and an increasing urban population where many of the social problems, such as poor housing, crime and drug problems, common to cities in other parts of the world, persist.

In economic terms, the dominant ideology at work in Irish society is that of liberalism. Even those on the left who once favoured state enterprise and publicly owned industry have succumbed to the lure of the mixed economy. The watchwords of the economically and politically powerful are those of 'enterprise culture', 'tax incentives', 'market forces' and 'slimming down the state'. Meanwhile, the poor are being told to wait, and unemployment has been accepted as an inevitable feature of the economy for the foreseeable future.

Guided by a watered down version of monetarism, the Irish state has retreated from its provider role. Both privately and publicly owned media have accepted this turn of events as a *fait accompli*. Economistic interpretations of a liberal or right-wing hue dominate media coverage of economic issues. There is a decided lack of connectivity in how the media analyse the various aspects of the crisis in which we find ourselves. The media ignore the links between the various parts of the poverty/inequality chain, and treat unemployment, poverty, educational disadvantage or health cuts as separate and distinct problems. The bigger picture of these problems as part of a process of capitalism in crisis is hidden from view. Thus, in the case of RTÉ, poverty and economic crisis are cleanly divided between programmes such as *The Late Late Show*, which annually devotes an entire programme to resolving economic problems through 'entrepreneurship', and the bi-annual *People in Need Telethon*, which locates the alleviation of poverty and need within the realm of entertainment.

Although the political elite do occasionally acknowledge that there are pressing problems for society, in terms of poverty and unemployment, their failure to respond to these issues, in an imaginative or radical way,

indicates that they are taken up with the containment of these problems rather than eliminating their root cause. The pain is being massaged while in fact radical surgery is necessary.

Ireland is an example of a late capitalist society, which is lurching from crisis to crisis. Although the much-heralded success of government policy in relation to inflation and spending is frequently referred to by politicians and the media alike, the inequality in terms of who benefits from these policies is ignored. Within mainstream politics, there is a noticeable absence of a critique of the capitalist system, with the main left- and right-wing political parties all scrambling for the centre and the support of the middle class.

In addition to these ideological shifts, the state has increasingly supported the notion that much of its own activities can be replaced by the voluntary activities of individuals and community groups. Thus the long tradition of voluntarism, most associated with the Roman Catholic Church in Ireland, has been incorporated by the state in terms of its own liberal economic agenda. So to what extent are these ideologies evident in RTÉ's coverage of poverty?

With very few exceptions, the ideology which governs RTÉ's coverage of social and economic affairs is in line with the liberalism which pervades Irish society. More specifically, the dominant ideological position identifiable in RTÉ's coverage of Irish poverty is that it is a containable problem which is to be left in the hands of the relatively comfortable. RTÉ's reproduction of a decidedly hegemonic interpretation of poverty is to be explained through reference to the dominant images and messages of the coverage and also through an appreciation of the codes of practice which govern the production of poverty stories.

Poverty is individualised, personalised and poverty problems are not as a rule portrayed as having structural causes. What are occasionally portrayed as crises for individual members of the poor are seen as being resolvable through the actions of the comfortable. In tandem with poverty coverage in the Irish print media (Gibbons, 1984a), television legitimises the ideology of voluntarism and charity. Telethon television places the onus on the audience to respond; fictional television suggests that solutions lie in the actions of family and community; news coverage relies on the interventions made by the powerful and even the more critical current affairs documentary suggests moderate social reform as the answer to poverty.

Economy and society are largely invisible in this form of coverage, which sees poverty as an individualised problem with largely individualised solutions. The relative invisibility of poverty coverage itself is in turn complicated by the fact that Irish television is quite selective in whom it chooses to represent as the poor. This functions to randomise the problem of poverty and again serves to avoid any real examination of poverty as a societal or structural problem.

An important set of threads running through this coverage is that of religious imagery and ideology. McVerry is portrayed as a Christ-like figure, who is cast as a lone saviour of the poor. This theme which is replicated in the news coverage of President Mary Robinson in the Third World. It is the Christian ethos of the centre for homeless boys, which is seen in the Telethon as their redemption. News coverage of the deaths of the homeless in 1992 also drew on Catholic iconography to narrate their stories. Pathos replaces cause, and functions to absolve the more powerful in the audience of their real responsibility.

There are strong parallels here between how RTÉ treats Irish poverty and the way in which television in general has dealt with the poverty of the Third World. While he does indicate some reservations with the position, Ignatieff notes that Marxist analysis of media images of Ethiopia suggest that '… the shame of the Ethiopian images … lie not in what they show, but in what they suppress.'(1985:62)

Economic and political relations become human relations, which serve to produce images without either a cause or a history. This position can without doubt be applied to poverty coverage in both Telethon and television drama. Both types of programme are examples of how poverty coverage takes place in a setting which abstracts the individual examples of poverty problems from having either an historical or social context. Indeed, in the case of the Telethon, the medium itself has, as Tester (1994) points out, begun to outweigh the messages of the genre. Thus the focus is as much, if not more, on the technological possibilities which make the Telethon feasible than the very reason why the media need to repeatedly intervene to resolve problems of need and poverty.

While I am prepared to concede that news coverage in particular may be somewhat more ambiguous in that it occasionally points to *some* causal factors of poverty, the evidence to support the Marxist position holds firm (Ignatieff, 1985). The occasional unveiling by television of the contributory factors which help to create poverty is, however, easily outweighed by the roles which television offers the powerful and comfortable in ritualised alleviation of some people's poverty.

Across all of the four genres considered in this study, the ideology of charity and voluntarism dominates. This must be seen in the context of both Irish Catholicism, and the more recent conversion which the Irish state has undergone in terms of encouraging community and voluntary activity. The emphasis on this type of response to structural problems serves to decontextualise poverty in terms of its causes. It also, as Gibbons (1984a) points out, serves to reaffirm the status of those who give and those who must wait. Taken collectively, there is an unambiguous message in all of this coverage, which says that poverty problems can be resolved through minor adjustments, social engineering and good deeds. Change of a radical nature in societal terms or for those who decide to give is deemed to be outside of the frame. The poor are thus left waiting until the next Telethon

or next documentary which touches upon aspects of their lives in a super-ficial manner.

Outside the palace …

This research was undertaken at a time of great change in Irish broadcast-ing. The environment in which RTÉ operates as a public service broad-caster has been changed in a radical way in recent years. At home, it faces increasing competition from the private radio sector and an even more serious challenge from external terrestrial and satellite television stations. Technological and ideological developments on the whole have raised seri-ous questions about the viability and sustainability of relatively large pub-licly owned broadcasting companies.

RTÉ has responded to these shifts in two contrasting ways. Its main radio station, *RTÉ Radio One*, has reaffirmed its public service credentials in the face of a private local radio sector which has largely chosen a programming style which is heavily formatted, relying on a middle of the road music style, with little or no current affairs programming. RTÉ's two television channels have, however, shifted to a programming form which emphasises 'family entertainment' and 'lifestyle' programmes. This observable change in the orientation of RTÉ's television programming does not bode well for coverage of poverty or indeed many other social and political issues.

It is interesting to note at this juncture that the two key Irish political scan-dals,[3] one of which led to the fall of the government and the other which showed clear evidence of corruption amongst the politically and economi-cally powerful, were brought to light by UTV in Northern Ireland and Granada TV in Britain. RTÉ's reticence to produce programmes which are critical of the status quo may be partially explained by reference to its cho-sen path of producing entertainment and lifestyle programmes, but the threat of privatisation and a reduction in its resource base also looms large in the background.

A key variable in all of the programmes analysed in this study has been the assumption that broadcasters know what audiences want. Future research on the media–poverty question might address this issue in a number of ways. An investigation is needed into audience interpretations of existing poverty texts as well as audience expectations about television coverage of social issues. More specifically, some critical analysis of how poorer audi-ence members interpret and react to coverage of their poverty would be an interesting addition to the analyses undertaken in this work. Are they com-forted by their invisibility on television drama? Do they find Telethons to be patronising? How do God's Poor react to coverage of the Devil's Poor? I would suggest that RTÉ needs to know much more about the tastes of its audience in terms of programmes which cover issues which some might like to see kept under wraps.

3 The Fr. Brendan Smyth affair and the abuse of EC intervention schemes in the beef industry.

The assumptions that the lives of the poor are neither of interest to the audience nor the most suitable subject matter of factual or fictional television should be seriously questioned. The success and ensuing debate about the BBC/RTÉ co-production of Roddy Doyle's *Family* in May of 1994 is proof that audiences are interested in the lives of the marginalised. Essentially a BBC production, *Family* attracted record numbers of viewers when broadcast on RTÉ television.[4] The series managed to stimulate a debate amongst the public about – among other things – media representation of poverty and working class life, and violence against women and children.

The public debate which followed the broadcast of the series demonstrated that the Irish television audience was divided into those who were supportive and those who were critical of the series in terms of its realism, 'bad language' and vivid portrayals of the underclass. This position was best exemplified perhaps by a middle-class female caller to a phone-in radio programme who said 'Yes, these things [violence, poverty] do happen, but I don't want to see them on my television screen'. The opposing camp, made up of an amalgamation of women's and community groups, argued that RTÉ needed to show much more of these things so that proper debate could be stimulated in Irish society. Audience reaction to *Family*, whether positive or negative, gave a clear signal to RTÉ that there is a hunger amongst many audience members for realistic drama which examines the harsher side of Irish life.

In conclusion, the invisibility of poverty and the poor on RTÉ television is symptomatic of a greater invisibility, namely the lack of transparency of the social structure. On the few occasions when inequality and deprivation are alluded to on factual, fictional or fund-raising television, this is done in a way which abstracts the poverty 'story' from its root cause. Much of the coverage represents poverty as being classless and portrays the relatively powerful as being the benign helpers of the less fortunate. In this sense, the coverage offered by RTÉ may be said to be ideological, facilitating as it does the continuation of capitalism.

This study is also illustrative of the inadequacies of television as a cultural form. It is not only engaged in the production and reproduction of ideology, but as it is presently organised, is limited in the way in which it can reflect on social problems such as poverty.[5] The constructions which television place on poverty serve to decontextualise and atomise what is a complex phenomenon. In attempting to encapsulate how RTÉ treat of the question of poverty, I am reminded of one of the *Lutheran Letters* written by

4 The second episode of *Family* attracted 1.2 million viewers to RTE 1.

5 Television is not on its own in this regard. Hill (1985: 37) in his evaluation of the British 'social problem' film suggested that 'It is possible to show how the poor live on the screen. It is rather more difficult [remaining within the conventions of realism] to demonstrate how such poverty is the effect of a particular economic system or socially structured pattern of inequality. It also helps throw light on Russell Campbell's complaint that social

Passilini. In his essay entitled *Outside The Palace*, Passilini considered the workings of the contemporary newspaper industry. He viewed the newspaper world as a palace, which has as its inhabitants, those who write for the paper and those the paper writes about. According to Passilini the palace was made up of:

> ... the lives of the most powerful people there, those who occupy the peaks of power. To be 'serious' means, apparently, to be concerned with these people, their intrigues, their alliances, their conspiracies, their strokes of luck, and finally, *also*, with the way in which they interpret the reality that exists *outside the Palace* – the boring reality which, in the last analysis everything depends on, even if it is unsmart and unsmart to bother with. (1993:8)

Save for the occasional action by one of the inhabitants of the palace *vis-à-vis* those beyond the palace's walls, those who exist on the outside are characterised by their invisibility. Their stories are either ignored or seldom told. Passilini's metaphor can be usefully be applied to RTÉ and, indeed, other forms of mainstream media.[6]

Finally, this study was not intended to be an exercise in what some might term political correctness. Nowhere do I suggest that the poor should never ever be portrayed in a negative light. What this study has achieved however is to identify the narrow and clearly ideological way in which RTÉ tells stories about the Irish poor. That construction is much more complex than has been imagined heretofore in that there are clear examples of God's and Devil's Poor as well as their saviours evident in television coverage of poverty.

consciousness movies repress 'social and political dimensions' in favour of 'private, personal dramas' For not only is individualisation implicit in the conventions of narrative whereby it is individual characters (and very often one central character] whose desires and ambitions structure the story's forward flow, but also a consequence of the conventions of realism with their dependence on the 'empirically' observable and hence the interpersonal rather than the structural.'

6 There is growing evidence to suggest that certain sections of the poor are responding to this media marginalisation through using platforms of their own such as *The Big Issues* newspaper. Poverty lobby groups are likewise seeking alternative avenues for the dissemination of information about poverty. In 1994 the Combat Poverty Agency took the unusual step of publishing a full colour supplement with *The Sunday Tribune* newspaper entitled *Against The Odds*. This allowed them to set the agenda and have greater control over how poverty was explained as well as inform the public of their work.

Appendix

A

Analysing content and production

The methodological model employed in this project is best viewed as a synthesis of qualitative content analysis and an ethnography of the production/organisational context of poverty texts. This dual approach was chosen as it allowed us to address the two interrelated research questions which governed this study, namely to ascertain the ideological make up of the dominant themes of RTÉ's poverty coverage, and to examine the production/organisational contexts from which that coverage emerged.

Following some pilot work undertaken in May 1991, it was decided to focus on the content and production/organisational context of factual, fictional and fund-raising television. In designing the research framework, a number of methodologies were utilised. Firstly, I used qualitative content analysis to examine the composition of the chosen television programmes. Secondly, a range of methods, which included observation, participant observation, structured and semi-structured interviews was applied to collect the ethnographic evidence. Further data was gathered through the analysis of secondary materials.

Ethnography

Although its roots lie within traditional anthropology the ethnographic approach has increasingly been used as a methodological tool within the field of communications studies. It has been put to good use in the analysis of audience reception of media messages and it has also been utilised by researchers who wished to understand more about the influences of the organisational or production context on media message production. Fetterman has argued that:

> The ethnographic study allows multiple interpretations of reality and alternative interpretations of data throughout the study. The ethnographer is interested in describing a social and cultural scene from the emic, or insider's perspective. The ethnographer

is both storyteller and scientist; the closer the reader of an ethnography comes to understanding the native's point of view, the better the story and the better the science. (1993:12)

Zaharlik (1992) suggested several reasons as to why a researcher might opt for the ethnographic approach. He argued that it allowed for the development of social relationships between the researcher and researched; it facilitated the gathering of first hand information through direct contact with respondents; it required long-term observation and assumed that access was possible to those being researched. In addition, he argued that the ethnographic approach was both eclectic and naturalistic. It allowed for respondents to be investigated in their natural setting and was also characterised by the range of methodological tools used by researchers. Sarantakos noted that the ethnographic model was characterised by an 'interactive-reactive' approach. He maintained that:

> Ethnographic research employs a dynamic form of data collection and analysis that is based on flexibility, reactivity and self-correction. Initial questions that generate response and information act as an instrument of regulation and result in correction and re-direction of the initial design and methods. New knowledge and information are used not only for understanding and explaining the research object but also for adjusting the approach, design and methods so that the research topic can be studied most effectively. (1993: 267)

As a collection of research methods the ethnographic approach is marked by its flexibility and reactivity to the subject(s) under scrutiny. However, in order for ethnography not to degenerate into mere description or at best, 'good journalism', the researcher must follow tried and tested rules in the gathering of her data. The ethnographer has to equal the rigour of the researcher who has adopted a quantitative approach such as the survey or structured interview.

As the following account of my fieldwork at RTÉ shows, the ethnographer has to give due consideration to (a) negotiating access to the organisation or community under study; (b) which methods are most suitable for the refinement and exploration of her research question; (c) the gathering and analysis of usually large amounts of qualitative data and (d) the identification and checking of consistent patterns of behaviour or thought.

Stage One
Access

My fieldwork involved accessing both the organisation itself as well as individual departments within RTÉ. General access to the organisation had been promised to me when negotiating my fellowship which RTÉ funded. This permission meant that I could move about the RTÉ campus with relative freedom, frequenting its library, audience research department and

restaurants. This general type of access meant that I could renew acquaintances and could freely undertake informal observation and interviews throughout the duration of my fieldwork.

Entry to individual departments to observe the production of stories in the areas of news, current affairs, television drama, and entertainment had to be individually negotiated. Typically, I gained access through writing a letter which explained the project and made a follow up telephone call to answer any queries which arose. In the case of the Telethon, where I wished to undertake covert participant observation, access was negotiated through a senior RTÉ figure who was supportive of my research project.

In the majority of instances, I had to reassure those contacted that I was undertaking this project for a PhD and that I was working independently of RTÉ management. In asking to be allowed to undertake some initial observation of programme meetings and the production of poverty stories, I also had to promise that I would not get in the way. Thus, permission was given for me to attend meetings in a non-participatory role. It should be stated from the outset that other than the concerns noted above, my prospective subjects welcomed both my project and myself as researcher. Trust was built up over the course of my fieldwork allowing me to gather data both formally and informally. Perhaps the best example of the positive side of the social relationship which I developed with my subjects was evidenced in the fact that I managed to gain access to unpublished reports and other data which were not in the public domain but were important for my study.

Overt observation

Observation of an overt kind was undertaken from September 1992 to April 1993. I was given permission to observe all of the weekly planning meetings for *Tuesday File* and the daily meetings for *Six-One News*. In addition, I was allowed to be present on a regular basis in the news and current affairs production offices. I was introduced to production teams by programme editors, each of whom briefly outlined my intended project. My decision to be honest with the majority of those under study from the beginning was based on both ethical and common-sense reasoning. Within current affairs in particular, I was already known to a small number of the production team as an ex-employee, who had moved into the academic world. In addition, the fact that staff numbers in these areas were relatively small meant that a new person who wasn't accounted for in attending programme meetings might very well have raised suspicions and hostilities amongst programme teams.

I recorded my data by writing up notes soon after meetings had finished, or if in the production office, I was usually able to make rough notes as things happened. These notes were then transcribed to a file on my personal computer and stored. I began to build data 'piles' for each of the programme areas under observation. Fieldnotes were reviewed on a weekly basis in order to ascertain specific patterns and to note issues which would

form the basis of later questioning in the semi-structured interviewing stage of the fieldwork. The observation stage of my fieldwork allowed an insight into the workings of RTÉ both at the general organisational level and at the individual departmental level. Such insights allowed me to take informed decisions in the selection of specific programme areas and individual programmes for analysis. I knew, for example, that the *Tuesday File* documentary *Are You Sitting Comfortably?* was atypical in terms of the reactions it provoked within RTÉ and therefore stood out to me as being potentially an important revelatory case study about how current affairs television handles poverty issues.

The initial observation phase of my study also allowed me to identify potential interviewees for both formal and informal interviewing. Stage one of my fieldwork therefore allowed me to adopt what Zaharlik (1992) has referred to as an 'interactive-reactive' approach. The observation undertaken in the project's first nine months helped me in terms of clarifying my research question, understanding more about the context in which poverty stories were produced and in the identification of potential interviewees. The data gathered from my observation of production meetings was subsequently compared with the other ethnographic data gathered through participant observation and interviews.

My chosen role as observer of production began to shift somewhat as my fieldwork progressed. Near the end of my observation work, I began to conduct informal interviews with my subjects. It is possible that their subsequent behaviour at production meetings was influenced by their increasing knowledge of my research project. This possibility was however countered in my subsequent semi-structured and retrospective interviews where I checked for consistencies in people's views.

Stage Two
Semi-structured and informal interviews

The main stage of the ethnographic study involved using both semi-structured and unstructured interviewing techniques. A total of 35 semi-structured interviews were carried out with those whom I had identified in my observation and content analysis work as being important to my study. Requests for the semi-structured interviews were made both formally and informally and were by and large responded to positively.[1] Thus, the sampling of interviewees was largely based upon their involvement in my preselected programmes or reports and my observation of their production activities within RTÉ. The interviews were based on a schedule of questions and prompts but also allowed for some degree of open-endedness. Interviewees were allowed to expand on particular themes which the interviewer felt to be germane for the project.

1 There were three refusals for interview which came interestingly from higher up in the organisation.

Typically 90 minutes in length, the interviews were tape-recorded and transcribed for later analysis. These interviews allowed me to talk to those directly involved in the production of poverty stories as well as facilitating some comparisons between genres and individual production styles. The semi-structured interviews were done after programmes or reports had been broadcast. Questions about the making of poverty stories ranged from the very general, dealing with how the interviewee viewed poverty as an issue, to how individual reports/stories were made. Several of the questions which I posed were concerned with the production values used in the making of poverty stories.

In my observation and unstructured interviews I had discovered evidence of intra-organisational conflict over the content of particular poverty stories. The semi-structured interviews were used to gain further information on these disputes and to compare the accounts of individual informants. These interviews helped in constructing a deeper understanding of the production processes which surrounded the making of poverty texts. They helped in the validation and clarification of the data gathered through both observation and participant observation.

Informal interviews were used in all three data collection stages of the fieldwork. A total of 60 informants from all four departments under study were spoken to informally. However, these interviews were not simply 'conversations' in that I deliberately used a series of embedded questions on a consistent basis in my discussions with informants. I found that as I developed a rapport with those under observation they were quite willing to speak to me on an 'off the record' basis. Informal interviews allowed me gather firsthand information from my informants – much of which they were unwilling to put on record – and to check out their individual versions of stories.

Fieldnotes were written up immediately after the informal interviews had taken place and subsequently transcribed to the relevant computer file for analysis. As with my research strategy during the observation phase of my fieldwork, these data piles were reviewed on a weekly basis in order to check for both regular patterns and consistencies. In any instance where I was unsure about what an informant had told me, I spoke to them a second time to confirm or clarify my interpretation of their account. These interviews, both formal and informal, assisted me in understanding the production context of poverty stories from an emic perspective. They furthered my understanding of the organisational structure from which the stories emerged and, more specifically, of the journalistic codes and practices which framed their production.

Stage Three
Participant observation

In the third and final stage of my fieldwork I used covert participant observation in order to understand the background production processes of the

1994 Telethon. This was possible, as I was up until then, unknown in the variety department. The Telethon involved over one hundred volunteer workers and I found it possible to go unnoticed in this context. Although I had formally and informally interviewed those responsible for the 1992 Telethon in my earlier fieldwork, this did not present a problem as there were different production personnel for the 1994 Telethon .

I adopted two potentially conflicting roles in my participant observation endeavours. From past knowledge of previous Telethons I correctly anticipated that there would be protests from an unemployment action group at the gates of RTÉ. During a two hour break from my role as a runner on the Telethon programme, I managed to join the protesters to hear about their perspective on the event.

As a protester, I witnessed how the police treated those on the picket line as well as gathering first hand information on their views. My main role however was that of runner for the event itself. This task involved the collection and delivery of faxes donating money to the programme's fund. It allowed me direct access to the broadcast and production studios. Even in the context of a busy fourteen hour programme I found that this type of covert observation was useful in terms of furthering my understanding of the making of the Telethon programme.

Participant observation both within and without RTÉ on Telethon day gave me a unique insight into the views of those involved in the making of the programme and those who opposed it. In terms of data collection, fieldnotes were taken covertly and as in the earlier overt observation phase of the project, they were transcribed on to a computer file and reviewed when writing up the overall project.

Retrospective interviews

In addition to the formal and informal interviewing undertaken in earlier stages of my fieldwork, I also carried out a series of retrospective interviews with three news reporters. I selected three stories from the *Six-One News* programme, two dealing with homelessness and one concerned with the Travelling community. In each instance my strategy was to organise a repeated viewing of the report and to get the reporter to talk me through the report's words and images. Given my particular interest in the codes and conventions used by journalists in the symbolisation of poverty, I placed an emphasis on these questions in my interviews. As in the semi-structured interviews in stage two, these interviews were tape-recorded and transcribed on to a computer file.

Stage Four
Triangulation and analysis of findings

Following standard triangulation procedures, all of the data gathered in the various stages of the fieldwork using different research methods was

compared. In the case of specific accounts of disputes over particular reports or storylines, for example, I cross-checked the veracity of accounts from the variety of data sources which I had at my disposal. This allowed me to build a complete picture of particular events which I had deemed to be revelatory in terms of my understanding of production processes. In addition, further triangulation of the ethnographic data was undertaken through the cross-referencing of reported production styles and the actual qualitative content analysis of the four types of television programme. Particular attention was paid to the ways in which broadcasters explained their uses of symbolisation in their attempts to construct stories about poverty.

Qualitative content analysis

Citing Lamnek (1988), Sarankantakos (1993) asserted that unlike its quantitative relation, qualitative content analysis was defined by methodological and theoretical differences which stressed naturalism; openness; communicativity and interpretativity. Sarankantakos argued that qualitative content analysis allowed for the objects of research to be studied in their natural setting. This type of research strategy was also characterised by an openness which allowed a researcher to gather data which was required by the study instead of being prescribed by a particular research design of a quantitative kind. Communicativity was also seen to underlie the selection of qualitative content analysis as a research method. Sarankantakos defined communicativity as:

> ... the way in which qualitative theorists see the structure of social reality, which they perceive as being constructed through interaction and communication. The centre of study here is the communicative act and the meaning assigned to it. Content analysis is therefore expected to study the contents of communication and to explain their meaning. (1993:214)

A further distinguishing feature of qualitative content analysis as outlined by Sarankantakos was the idea of interpretivity. In short, he meant that social reality only became societal through interpretation and that it was constructed through the assignment of meaning and was not given objectively. Sarankantakos' notion of interpretivity, however, while it acknowledged the importance of the polysemic nature of texts, did not rule out the possibility of a researcher being able to identify the preferred meanings of a text. Thus the possibility of identifying dominant ideologies remained.

As a research tool, Sarankantakos contended that qualitative content analysis should be used as part of a wider research framework. He proposed that the method was best utilised in conjunction with other forms of data analysis such as semi-structured interviews or participant observation. This revised form of content analysis was heralded as a method which could both deconstruct a text and be revelatory in terms of the thinking of those who produced the text. Taken in conjunction with the ethnographic

approach, where those who created texts could be investigated in their own environment, qualitative content analysis of media texts continued to represent an important methodological tool for researchers. Mayring (1983) argued that qualitative content analysis could proceed in one of three ways. Sarankantakos (1993) summarised these three options as summary, explication and structuration.[2] In undertaking a content analysis of the four selected television genres I drew upon various aspects of these research procedures.

Analysis of RTÉ programmes

In the light of these procedures four types of RTÉ television programme were subjected to a qualitative content analysis. The documentary *Are You Sitting Comfortably?* was examined as follows. The programme was initially viewed eight times prior to deciding on the means by which it would be analysed. As with all of the other programmes considered, just *who* the documentary considered to be poor and the various statements about poverty and the poor were noted. The text of the programme (both aural and visual) was fully transcribed on a 'frame by frame' basis on to a computer word processing file. This transcript was then further analysed in terms of a range of criteria including: (1) The form and structure of the programme in terms of existing codes and conventions of current affairs programming. (2) The discursive elements of the programme between, for example, verbal and visual messages about poverty. (3) The recurrent themes used in the documentary to articulate a particular set of messages about poverty to its audience members. (4) Particular attention was paid to how the programme functioned at a symbolic level. Lists were constructed of all of the signifiers evident in the programme's text. The semiotic analysis of the text of *Are You Sitting Comfortably?* was grounded in apriori knowledge of the intentions of the programme's producer. (5) Cognisance was also given in the analysis to the production values used by the programme team in the creation of the documentary. Like the semiotic dimension to the analysis, the examination of the programme's production values in the use for example of incidental music, dramatisation or particular film locations was based upon information received from the programme team during the ethnographic phase of the research.

The 14 hour long *People in Need Telethon* was originally viewed six times in order to gain a broad appreciation of the genre in question. These repeated

2 Sarantakos (1993) explains these as follows:

Summary, in which analysis will mean a reduction of the data, as well as integration, generalisation and classification of the data into categories. Explication, in which analysis will aim at explaining the text or parts of it. This can be done in two ways, namely through using information from the same protocol (narrow context analysis); or using sources outside the protocol (wide context analysis). Structuration, which involves development of structures by putting the material in some kind of order, for example by means of already defined criteria (Mayring, 1988:75). Such structuration may be related to formal criteria (formal structuration), content criteria (content structuration), type or dimension criteria (type structuration), or criteria related to dimensions of scales (scaling structuration) (1993:215).

viewings allowed me to note the specific features (such as intertextuality) of this hybrid television genre, as well as the make up of its form and structure. The overall analysis of the programme centred on an examination of all of the references to why a Telethon was necessary as suggested by the programme's presenters and also on any particular reference to poverty or the poor. All of these statements were listed and what were deemed to be representative examples were chosen for inclusion in the chapter in question.

The second stage of analysis of the Telethon involved a more detailed content analysis of the appeal films used to raise subscriptions from audience members. All nine appeal films were edited from the Telethon programme. Like the previous analysis of the documentary, the text of the film appeals (both aural and visual) were fully transcribed on a frame by frame basis on to a computer word processing file. This allowed for an effective comparison between what was said about the selected poverty groups. The contents of the film appeals were in turn summarised noting the length of the appeal and the poverty group(s) in question. The use of and time allotted to agent groups or spokespersons *vis-à-vis* poverty groups was also noted. The content analysis of each film segment focused on examining both the verbal and visual messages of each segment. The frame by frame analysis allowed us to identify the discursive elements of the texts between for example the use of specific images and incidental music. The film segments were repeatedly viewed and lists were created of the signifiers used in each one. Particular attention was also paid to the production values of the appeals, noting for example the use of particular filming styles (real time or slow motion, close-up or wide angle shots) in the construction of the texts.

Six-One News was recorded over the period 1 January 1992–31 December 1992. All episodes were viewed and as I discuss in greater detail in Chapter 5 it was decided to concentrate on stories broadcast in the period 1 September – 31 December 1992 given the greater amount of coverage at that end of the calendar year. All stories which specifically referred to poverty or identified particular groups as being poor were singled out for analysis and edited from the master tapes. Each story was then analysed following the schema used in the examination of the Telethon appeals. The content of each news report was fully transcribed and considered in terms of its form and structure; and narrative convention. Particular attention was paid to the production values of each report in relation to how individual poverty groups and their agents were presented and the extent of their visibility.

The entire 1992-1993 season of *Glenroe* was recorded and viewed. All of the programmes were watched in their entirety four times prior to a more detailed analysis of the storylines which were considered to be germane for this project. The general viewing resulted in a decision to examine the only two sets of characters – the Travellers and the unemployed – who were rep-

resentative of the poor. Any passing references made to poverty, inequality or class structure were noted in the general viewing. All of the storylines directly concerned with either the unemployed or Travelling community were edited from the series and their contents were examined in closer detail.

All of the edited stories were transcribed. The transcripts recorded what each character said, and the use of particular production values was also noted. The data was reorganised to allow for a more coherent examination of the outcome of specific storylines. Storylines were summarised and their contents in terms of the discursive interaction between characters was examined. A close consideration was made of the language used by the various characters who populated the selected stories. What were considered to be revelatory statements in terms of the poor and poverty were listed and representative statements were noted for inclusion in the relevant chapter.

Appendix B

Glenroe characters referred to in Chapter 6

Character	Role
Miley Byrne	Farmer; shopkeeper
Biddy Byrne	Farmer; shopkeeper
Dinny Byrne	Semi-retired farmer
Dick Moran	Auctioneer
Mary Moran	Housewife
Stephen Brennan	Golf course owner
David Brennan	Stephen's son; disabled
Blackie Connors	Settled Traveller
Peggy Connors	Blackie's wife
Johnny	Traveller; Blackie's brother-in-law
George Manning	Anglo-Irish gentry
Teasy McDaid	Publican
Fidelma Kelly	Biddy Byrne's cousin
Mynah Timlin	Priest's housekeeper
Carmel O'Hagan	Unemployed; returned emigrant
Damian O'Hagan	Unemployed; returned emigrant
Fr. Devereux	Catholic parish priest
Michelle Haughey	Barmaid
Kevin Haughey	Michelle's husband; unemployed
Sergeant Roche	Local policeman
Nuala Brennan	Stephen Brennan's daughter-in-law

Bibliography

'Affairs of The Nation' (1992)*The Phoenix*, 30 October p.3. Dublin: Phoenix Publications.

Altheide, D. L. (1984) 'Media Hegemony: A Failure of Perspective', *Public Opinion Quarterly*, Vol. 48 pp. 476–490.

Ang, I. (1982) *Watching Dallas*. London: Methuen.

Barthes, R. (1973) *Mythologies*. London: Paladin.

Baudrillard, J. (1983) *The Evil Demon Of Images*. Paris: Foreign Agents Series.

Benthall, J. (1992) *Disasters, Relief and The Media*. London: I.B. Tauris.

Boggs, C. (1977) *Gramsci's Marxism*. London: Pluto Press.

Breed,W. (1955) 'Newspaper 'opinion leaders' and processes of standardisation', *Journalism Quarterly*, Vol. 35 pp. 277–284.

Bridenthal, R. and C. Koonz, (eds.) (1977) *Becoming Visible: Women in European History*. Boston: Houghton Mifflin.

Buerkel–Rothfuss, N.L. and S. Mayes (1981) 'Soap Opera Viewing: The Cultivation Effect', *Journal of Communication*, Summer pp. 108–115.

Burnell, P. J. (1991) *Charity, Politics and The Third World*. London: Harvester and Wheatsheaf.

Burrowes, W. (1977) *The Riordans: a Personal History*. Dublin: Gilbert Dalton Publishers.

Cairns, M. (1985) 'Band Aid', *Ten–8*, Vol. 8 No. 19.

Campbell, R. and J.L. Reeves (1989) 'Covering the Homeless: The Joyce Brown Story' *Critical Studies in Mass Communication*, Vol. 6 pp. 21–42.

Cater, N. (1985) 'The Hungry Media'*Ten–8*, Vol. 8 No. 19.

Chalmers, S. (1993) 'Is The Bear a Necessity?' *The Scotsman* 26th November.

Combat Poverty Agency (1994) 'Against The Odds' Supplement to *The Sunday Tribune* , 4th December.

Combat Poverty Agency (1995) *Broadcasting, Poverty and Social Exclusion: A Response to the Green Paper on Broadcasting*. Dublin: Combat Poverty Agency.

Commission of The European Communities (1990) *Eurobarometer: The Perception of Poverty in Europe*. Brussels: Paper V/467/90–EN.

Corner, J. (1995) *Television Form and Public Address*. London: Edward Arnold.

'Cross Currents' (1983) 'Job a Thons'*Channels*. (May –June).

Cubitt, S. (1993) *Videography – Video Media as Art and Culture*. London: Macmillan

Dahlgren, P. and S. Chakrapani (1982) 'The Third World in TV News: Western Ways of Seeing The 'Other" in W. C. Anderson (eds.) *Television Coverage of International Affairs*. George Washington Press.

Dahlgren, P. (1987) 'Ideology and Information in the Public Sphere' in J. D. Slack and F. Fejes (eds.) *The Ideology of The Information Age*. New Jersey: Ablex.

Dahlgren, P. (1992) 'Viewers plural sense–making of TV News' in P. Scannell et al (eds.) *Culture and Power*. London: Sage.

Davis, E.E., J.W. Grube, and M. Morgan, (1984) *Attitudes Towards Poverty and Related Social Issues in Ireland*. Paper No. 117 Dublin: Economic and Social Research Institute.

Dawson, K. (1992)'Today Tonight, No Tomorrow', *The Sunday Tribune* 5 April.

Devereux, E. (1993) 'Negotiating Community: The Case of a Limerick Community Development Group' in C.Curtin, H. Donnan and T. Wilson (eds.) *Irish Urban Cultures* Belfast: Institute of Irish Studies.

Dorr, D. (1983) *Option For The Poor*. Dublin: Gill and MacMillan.

Dublin Travellers Education and Development Group (1992) *No Place To Go*. Dublin: Pavee Point Publications.

Dutton, B. (1986) *Sociology in Focus: The Media*. London: Longmans.

Eagleton, T. (1991) *Ideology: An Introduction*. London: Verso.

Ericson, R.V., P.M. Bavanek and J.B.L. Chan (1989) *Negotiating Control: A Study of News Sources*. Toronto: University of Toronto Press.

Fahy, T. and B. O'Connor (1988) 'Ireland and Great Britain' in A. Silj (eds.) *East of Dallas*. London: British Film Institute Publishing.

Fennell, D. (1986) *Nice People and Rednecks*. Dublin: Gill and MacMillan.

Fetterman, D. (1993) *Ethnography: Step by Step*. London: Sage.

Fiske, J. and J. Hartley, (1978) *Reading Television*. London: Methuen.

Fiske, J. (1987) *Television Culture*. London: Methuen.

Fisher, C. (1993) *Informal Survey of Attitudes to RTÉ and Current Affairs Programming*. Unpub'd. Internal RTÉ Document, Current Affairs Department.

Foley, M. (1994) 'Departure of O'Leary shows RTÉ unease' *The Irish Times* , July 13th.

Frazer, E. (1992) 'Teenage Girls Reading Jackie' in Paddy Scannell *et al* (eds.) *Culture and Power*. London: Sage.

Galbraith, J.K. (1992) *The Culture of Contentment*. London: Penguin.

Galtung, J. and M. Ruge (1965) 'The Structure of Foreign News' *Journal of Peace Research* , Vol. 1 pp. 64–91.

Gamson, W.A. and A. Modligani, (1987) 'The Changing Culture of Affirmative Action' *Research in Political Sociology*, Vol. 3 JAI Press.

Gamson, W. A. (1989) 'News As Framing' *American Behavioural Scientist*, Vol. 33 pp. 157–161.

Gans, H. (1979) *Deciding What's News*. New York: Vintage Books.

Geraghty, C. (1983) 'Brookside – No Common Ground' *Screen*, Vol. 24, No's 4–5.

Geraghty, C. (1991) *Women and Soap Opera*. London: Polity Press.

Gibbons, L. (1984a) 'Catherine The Great's Villages' *Ian Hart Memorial Lectures*. Dublin: Simon Community.

Gibbons, L. (1984b) 'From Kitchen Sink To Soap' in M. McLoone and M. McMahon (eds.) *Television and Irish Society*. Dublin: RTÉ /Irish Film Institute.

Gibbons, L. (1987) 'Romanticism, Realism and The Irish Cinema' in K. Rockett, L. Gibbons and J. Hill (eds.)*Cinema and Ireland*. London: Croom Helm.

Giddens, A. (1979) *Central Problems in Social Theory*. London: Macmillan.

Gitlin, T. (1970) 'Media Sociology – The Dominant Paradigm' *Theory and Society*, Vol. 6 No. 2 pp. 205–253.

Gitlin, T. (1979) 'Prime Time Ideology' *Social Problems* , Vol. 26 No. 3.

Gitlin, T. (1980) *The Whole World is Watching*. California: University of California Press.

Gitlin, T. (1982) 'Prime Time Ideology' in H.Newcomb (eds.)*Television: The Critical View*. Oxford: Oxford University Press.

Gitlin, T. (1983) *Inside Prime Time*. New York:Pantheon Books.

Golding, P. and G. Murdock (1978) 'Theories of Communication and Theories of Society' *Communication Research*, Vol. 5 pp.339–356.

Golding, P. and P. Elliot, (1979) *Making the News.* Longmans: London.

Golding, P. and S. Middleton, (1979) 'Making Claims: News Media and the Welfare State' *Media, Culture and Society*, Vol. 1 pp.5–21.

Golding, P. (1981) 'The Missing Dimensions – News Media and the Management of Social Change' in E. Katz and T. Szecsko (eds.) *Mass Media and Social Change.* London: Sage.

Golding, P. and Middleton, S. (1982) *Images of Welfare, Press and Public Attitudes to Poverty*. Oxford: Basil Blackwell.

Golding, P. and G. Murdock (1990) 'Screening Out The Poor' in J.Willis and T. Woolen (eds.) *The Neglected Audience.* London: British Film Institute.

Golding, P. (eds.) (1986) *Excluding the Poor.* Child Poverty Action Group: London.

Golding, P. (1991) 'Poor Attitudes', in S. Becker (eds.)*Windows of Opportunity, Public Policy and the Poor*. London: Child Poverty Action Group.

Goodwin, A. and G. Whannel (199O) *Understanding Television*. London: Routledge.

Gramsci, A. (1971) *Selections From The Prison Notebooks*. Q. Hoare and J. Nowell Smith (eds.) New York: International Publishers.

Habermas, J. (1989) *The Structural Transformations of The Public Sphere*. Oxford: Polity Press.

Hall, S. (1972) 'The Social Eye of Picture Post' *Cultural Studies*, Vol. 2 pp. 71–120.

Hall, S. (1974) 'Encoding and Decoding in the TV Discourse', *Education and Culture*, Vol. 25.

Hall, S., I. Conell and L. Curti(1976) 'The Unity of Current Affairs Television' *Working Papers in Cultural Studies*, Spring. University of Birmingham, Centre for Contemporary Cultural Studies.

Hammersley, M. and P. Atkinson (1982) *Ethnography Principles in Practice.* London: Tavistock.

Harrington, D. E. (1989) 'Economic News on Television, The Determinants of Coverage' *Public Opinion Quarterly* , Vol. 53 pp.17–40.

Harrison, P. and R. Palmer (1986) *News out of Africa, Biafra to Band Aid.* London: Hilary Shipman.

Harvey, B. (1983) 'Simon and The Media' *Simon Community Newsletter* No. 82 April. Dublin: The Simon Community.

Hill, J. (1985) 'The British "Social Problem" Film – "Violent Playground"and "Sapphire"' *Screen*, Vol. 26, No. 1.

Hill, J. (1986) *Sex, Class and Realism, British Cinema 1956–1963.* London: British Film Institute.

Hobson, D. (1982) *Crossroads.* London: Methuen.

Holland, P. (1981) 'Save The Children' *Multiracial Education*, Vol. 9 Part 2 Spring.

Horgan, J. (1986) *Images of Africa: A Research Report For Trocaire.* Dublin: Trocaire/School of Communications, Dublin City University.

Horgan, J. (1987) 'Africa and Ireland: Aspects of a Media Agenda' *Trocaire Development Review.*

Ignatieff, M. (1985) 'Is Nothing Sacred? The Ethics of Television' *Daedelus*, Vol. 4 pp. 57–58.

Iyengar, S. (1979) 'Television News and Issue Salience' *American Politics Quarterly*, Vol. 7 pp.395–416.

Iyengar, S. (1991) *Is Anyone Responsible? How Television Frames Political Issues.* Chicago: Chicago University Press.

Jackson, J. (1992) 'The Correspondent' *Hot Press* , Vol. 16 No. 2 December. Dublin: Hot Press Publications.

Katz, E. (1980) 'Media Events: The Sense of Occasion' *Studies in Visual Anthropology*, Vol. 6 pp. 84–89.

Katz, E. and T. Szeckso (1981) *Mass Media and Social Change.* London: Sage.

Kerr, C. (1994a) 'Scrap *Prime Time* say senior RTÉ personnel' *The Sunday Tribune* 6 June.

Kerr, C. (1994b) 'Little work for independents at RTÉ' *The Sunday Tribune* 6 March.

Kelly, M. (1981) 'Media Images of The Deprived' *Papers of The Kilkenny Conference on Poverty 1981.* Dublin: The Council For Social Welfare.

Kelly, M. (1984a) 'The Poor aren't News' *Ian Hart Memorial Lectures.* Dublin: Simon Community.

Kelly, M. (1984b) 'Twenty Years of Current Affairs on RTÉ' in M. McLoone and J. MacMahon (eds.) *Television and Irish Society*. Dublin: RTÉ/Irish Film Institute.

Kitzinger, J. (1993) 'Understanding AIDS: researching audience perceptions of Acquired Immune Deficiency Syndrome' in J. Eldridge (eds.) *Getting The Message*. London: Routledge.

Kumar, K. (1977) 'Holding The Middle Ground: the BBC, the Public and the Professional Communicator' in J. Curran *et al* (eds.) *Mass Communication and Society*. London: Sage.

Lamnek, S. (1988) *Qualitative Sozialforschung. Band I: Methodologie; Band 2 : Methodenund Techniken*. Munich: Psychologie Verlags Union.

Langer, J. (1981) 'Television's 'Personality System" *Media, Culture and Society*, Vol. 4 pp.351–365.

Leat, D. (1990) 'Broadcast Appeals: quantitative measures of success' in *Charity Trends: 13th Edition*. Charities Aid Foundation, p. 148.

Livingstone, S. M. (1988) 'Why People Watch Soap Opera: An Analysis of the Explanations of British Viewers' *European Journal of Communication*, Vol. 3 pp.55–80.

Livingstone, S.M. (1990) 'Interpreting a Television Narrative: How Different Viewers See a Story' *Journal of Communication*, Vol. 40 No. 1.

Longhurst, B. (1987) 'Realism, Naturalism and Television Soap Opera', *Theory, Culture and Society* Vol. 4 pp. 633–649.

Lull, J. (1980) 'The Social Uses of Television' *Human Communications Research*, Vol. 6 pp.197–209.

Lull, J. (1995) *Media, Communication, Culture: A Global Approach*. Oxford: Polity Press.

MacGreil, M. (1977) *Prejudice and Tolerance in Ireland*. Dublin: College of Industrial Relations.

McCann, M., S. O'Siochain, and J. Ruane (eds.) (1994) *Irish Travellers: Culture and Ethnicity*. Belfast: Institute of Irish Studies.

McDonnell, T. (1992) 'Protest Plans over Telethon Fund–raiser' letter to *The Irish Press* May 5th.

McVerry, P. (1994) 'The Summerhill Option' in P. O'Dea (eds.) *A Class of Our Own: Conversations about Class in Ireland*. Dublin: New Island Books.

Marx, K. (1958) *Selected Works* cited in A. Giddens, (1971) *Capitalism and Modern Social Theory*. Cambridge: University Press.

Mayet, G. (1984) 'Poverty and The Media' in S. Buxton (eds.) *Social Action Through Television*. Thames Television, Conference Proceedings Mimeograph. London: Thames TV.

Mayring, P. (1988) 'Qualitative Inhaltsanalyse' in U. Flick *et al* (eds.) *Hanbuch Qualitative Sozialforschung*. Munich: Psychologie Verlags Union.

Mawby, R.I., C.J. Fisher, and A. Parkin (1979) 'Press Coverage of Social Work' *Policy and Politics*, Vol. 7, No. 4. pp.357–376.

Monaco, J. (1978) *Celebrity: The Media as Image Makers*. New York: Delta Books.

O'Connor, B. (1984) 'The Representation of Women in Irish Television Drama', in M. McLoone and J. MacMahon (eds.) *Television and Irish Society*. Dublin: RTÉ /Irish Film Institute.

O'Connor, B. (1990) *Soap and Sensibility: Audience Response to Dallas and Glenroe*. Dublin: RTÉ.

O'Gorman, P. (1994) *Queuing For A Living*. Dublin: Poolbeg Press.

O'Neill P. (1992) 'Woman, Man Died From the Cold' The Irish Times 4 December pg. 2.

O' Nuallain, S. and M. Forde (1992) *Changing Needs of Irish Travellers: Health, Education and Social Issues*. Galway: Woodlands Centre.

O'Shaughnessy, M. (1990) 'Box pop: popular television and hegemony' in Goodwin, A., and Whannel, G., (1990) *Understanding Television* London: Routledge.

O'Shea, J. (1992) 'Stick Your Charity–Jobless lash Telethon Bash' *The Star*, 6 May.

Passilini, P. (1983) 'Outside the Palace' cited in D. Bolger (eds.) *Invisible Cities*. Dublin: Raven Arts Press.

People in Need Trust (1993) *Grant Allocations Resulting from the 1992 People in Need Telethon*. Dublin: People in Need Trust.

Philo, G. (1993a) 'From Buerk to Band Aid: the media and the 1984 Ethiopian Famine' in J. Eldridge (eds.) *Getting The Message*. London: Routledge.

Philo, G. (1993b) 'Getting The Message: Audience Research in the Glasgow University Media Group' in J. Eldridge (eds.) *Getting The Message*. London: Routledge.

Power, B. (1995) 'Rural Realism Under Pressure From 'Fair City'', *The Sunday Tribune*, January 8.

Propp, V. (1928) *Morphology of The Folktale* (trans. L. Scott.). Austin, Texas: University of Texas Press.

Raftery, M. (1991) 'The Irish Family –The Gallaghers and Ireland', in D. Bolger (eds.) *Letters From The New Island*. Dublin: Raven Arts Press.

Rapping, E. (1983) 'The Magic World of Non–fiction Television' *Monthly Review* , New York Vol. 35 pp. 28–43.

Regan, C. (1986) 'Live–Aid: A Challenge To The Experts' *Trocaire Development Review.*

Rockett K., L. Gibbons and J. Hill, (1987) *Cinema in Ireland*. London and Sydney: Croom Helm.

Rose, B. (1979) 'Thickening the Plot' *Journal of Communication*, Vol. 29 No. 6 Autumn pp. 85–88.

Rosenthal, A. (1971) *The New Documentary in Action*. California: University of California Press.

Rosenthal, A. (1980) *The Documentary Conscience, A Casebook in Film Making*. Berkeley: University of California Press.

Ruddle, H. and J. O'Connor, (1993) *Reaching Out – Charitable Giving and Volunteering in the Republic of Ireland*. Dublin: Policy Research Centre.

Ruddy, C. (1987) *Media Coverage of The Poor in Ireland.* Upub'd. BA Thesis, School of Communications: Dublin City University.

Said, E. W. (1978) *Orientalism.* New York: Pantheon Books.

Sarantakos, S. (1993) *Social Research.* Sydney: Macmillan Australia.

Scannell, P. (1979), 'The Social Eye of Television, 1946–1955' *Media, Culture and Society,* Vol. 1. pp.97–106.

Scannell, P. (1980) 'Broadcasting and the Politics of Unemployment 1930–1935' *Media, Culture and Society,* Vol. 2 pp.15–28.

Seggar, J F., J. K. Hafan, and H. Hannonen–Gladden, (1981) 'Television Portrayals of Minorities and Women in Drama and Comedy Drama 1971–1980' *Journal of Broadcasting* Vol. 25 pp.277–288.

Sheehan, H. (1985) 'Is Television Drama Ideological?' *The Crane Bag,* Vol. 9 No. 1.

Sheehan, H. (1987) *Irish Television Drama: A Society and Its Stories.* Dublin: RTÉ.

Sheehan, H. (1993) 'Biddy, Bella and The Big Issues' Paper presented to *Imagining Ireland Conference. Soap Opera and Social Order, Glenroe, Fair City and Contemporary Ireland.* October 13th. Irish Film Centre, Dublin.

Sheehan, R. with photographs by B. Walsh (1984) *The Heart of the City.* Dingle: Brandon Press.

Shoemaker, P. and S. Reese (1991) *Mediating the Message.* London:Longman.

Shoemaker, P., T. Chang and N. Brendlinger, (1987) (eds.) 'Deviance as a Predictor of Newsworthiness: Coverage of International Events in the U.S. Media' *Communication Yearbook,* Vol. 10.

Silj, A. (1988). *East of Dallas.* London: BFI Publishing.

Simpson, A.(1985) 'Charity Starts At Home' *Ten 8* , Vol. 8 No 19.

Sorenson, J. (1991) 'Mass Media and Discourse on Famine in the Horn of Africa' *Discourse and Society* , Vol. 2 No. 2 pp. 223–242.

Temple, J. (1985) 'Broadcast' 20 December 1985 cited in V. Glaessner, (1990) 'Gendered Fictions' in A. Goodwin and A. Whannel (eds.) *Understanding Television.* London: Routledge.

Tester, K. (1994) *Media, Culture and Morality.* London: Routledge and Kegan Paul.

The Irish Times (1992) 'Two Bodies Found in Laneway' *The Irish Times,* 3 December.

'The Sunday Times Rich List' (1997) Supplement to *The Sunday Times* 6 April.

Thomas, S., and B.P. Callanan, (1982). 'Allocating Happiness: TV Families and Social Class' *Journal of Communication,* Vol. 32 No. 3 pp.184–190.

Thomas, S. (1993) 'Bidding Goodbye to Baths of Jelly: Telethon is to be dropped.' *The Northern Express,* 17th June.

Thompson, E.P. (1978) *The Poverty of Theory.* London: Merlin.

Thompson. J.B. (1990) *Ideology and Modern Culture.* Cambridge: Polity Press.

Tuchman, G. (1978). *Making News.* New York. The Free Press.

Tuchman, G. (1991) 'Qualitative Methods in The Study of News' in K. Bruhn Jensen and N. W. Jankowski (eds.) *A Handbook of Qualitative Methodologies For Mass Communication Research.* London: Routledge.

Waters, J. (1994) *A Race of Angels: The Genesis of U2.* London: Fourth Estate.

Waters, J. (1995) *Every Day Like Sunday.* Dublin: Poolbeg Press.

White, D.M. (1950) 'The Gatekeeper: A Case–Study in the Selection of News', *Journalism Quarterly* 27: 383–90.

Whitley J. and J. Winyard (1990) *Pressure For The Poor.* London: George Allen and Unwin.

Williams, R. (1976) *Key Words.* London: Routledge.

Williams, R. (1977) 'A Lecture on Realism' *Screen*, Vol. 18 No.1.

Zaharlik A. (1992) 'Ethnography in anthropology and its value for education' *Theory into Practice*, Vol. XXXI No. 2 pp. 116–25.

Zaharlik A. and J. L. Green (1991) 'Ethnographic Research' in J. Flood et al. (eds.) *Handbook of Research on Teaching the English Language Arts.* New York Macmillan.

Zizek, S. (1994) 'The Spectre of Ideology' in S. Zizek (eds.) *Mapping Ideology.* London: Verso.

Index